Whose Muse?

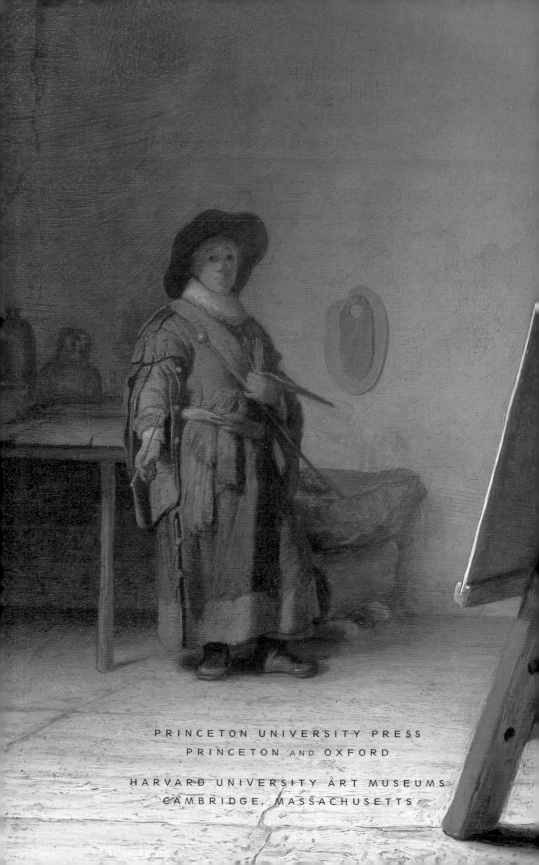

PRINCETON UNIVERSITY PRESS
PRINCETON AND OXFORD

HARVARD UNIVERSITY ART MUSEUMS
CAMBRIDGE, MASSACHUSETTS

Whose Muse?

ART MUSEUMS AND THE PUBLIC TRUST

EDITED BY James Cuno

With essays by
James Cuno,
Philippe de Montebello,
Glenn D. Lowry,
Neil MacGregor,
John Walsh, and
James N. Wood

FRONT COVER Thomas Struth, *Art Institute II, Chicago*, 1990. Chromogenic print, 73 1/4 x 87 1/4 in. (186 x 221.6 cm). Marian Goodman Gallery, New York

FRONTISPIECE Rembrandt, *The Young Rembrandt in His Studio*, 1629. Oil on panel, 9 3/4 x 12 1/2 in. (24.8 x 31.7 cm). Museum of Fine Arts, Boston. Zoë Oliver Sherman Collection; given in memory of Lillie Oliver Poor. Photograph © 2003 Museum of Fine Arts, Boston

Published by Princeton University Press and Harvard University Art Museums

Princeton University Press, 41 William Street, Princeton, New Jersey 08540
In the United Kingdom: Princeton University Press, 3 Market Place, Woodstock, Oxfordshire OX20 1SY
pup.princeton.edu

Harvard University Art Museums
Cambridge, Massachusetts
www.artmuseums.harvard.edu

These essays were first presented as lectures, October 2001–June 2002, under the auspices of the Harvard Program for Art Museum Directors, which is funded by an anonymous donor.

Designed by Laura Lindgren
Composed by Tina Thompson
Printed by South China Printing

Manufactured in China

10 9 8 7 6 5

Fourth printing, and first paperback printing, 2006
Paperback ISBN-13: 978-0-691-12781-1
Paperback ISBN-10: 0-691-12781-6

*The Library of Congress has cataloged the cloth edition
of this book as follows*

Whose muse? : art museums and the public trust / James Cuno, editor ; with essays by Neil MacGregor . . . [et al.].
p. cm.
Includes bibliographical references and index.
ISBN 0-691-03215-7 (cloth : alk. paper)
1. Art museums—Public opinion. 2. Art museums—Public relations.
I. Cuno, James B. II. MacGregor, Neil, 1946–

N430.W48 2003
708—dc21 2003050432

British Library Cataloging-in-Publication Data is available

Contents

For Aggie Gund

Preface and Acknowledgments

James Cuno

OVER THE COURSE of ten months, from October 2001 through June 2002, the Harvard Program for Art Museum Directors and the Harvard University Art Museums, of which at the time I was director, organized a series of lectures on the subject of the public's regard for and trust in art museums. The participants and I suspected that we would approach the topic from different points of view, and we did not discuss our papers with one another before hand. But we did read each paper along the way, and a month after Philippe de Montebello's lecture, we gathered together in his office at the Metropolitan Museum (except for Neil MacGregor, who was unable to join us) to revisit our topic and discuss it among ourselves with the benefit of hindsight. An edited (but not censored) version of this round table discussion closes out this book.[1]

In the round table discussion, James Wood remarked that he sensed an almost "suspicious consensus" and wondered if we might not have had more varied viewpoints if we had asked other people to contribute. No doubt we would have. But I was not looking for representative viewpoints from across the profession; I thought other views and voices had been heard often enough. One knows what the aggressive, risk-taking, expansionist directors think; they have expressed their opinions in print and in speeches many times. Equally one knows what the audience-building, community-activist directors think; they, too, have written and spoken widely on their beliefs. I wanted to offer an alternative to these viewpoints. I did not want

to present a debate, nor a sampling of current opinion. I wanted it to be focused on first principles, as it were, on the basis of the contract between art museums and their public. I wanted to know if we could articulate those first principles and if they could be the building blocks for a case for public support for art museums.[2]

Since the conclusion of the lecture series, I have moved to London, where I am director of the Courtauld Institute of Art, Britain's oldest and largest center for the study of the history and conservation of art. The Courtauld also has a renowned collection of paintings and drawings. My responsibility for those collections has brought me into conversation with the directors of London's museums. Not to my surprise, the issues explored in our Harvard lecture series are very much on the minds of British museum directors.

Numerous people helped make possible the lecture series published in this book. At the outset, Agnes Gund challenged us to found the Harvard Program for Art Museum Directors, which since 1995 has gathered in small groups art museum directors and Harvard faculty to discuss topics bearing on the leadership of today's art museums. Yve-Alain Bois, Philip Fisher, Peter Gomes, Ronald Heifetz, Mark Moore, Peter Sacks, Elaine Scarry, Helen Vendler, and others were generous with their time and challenging in their questions, as were the museum directors who participated in the program. It was in our luncheon and dinner discussions that the idea for this lecture series was proposed. We found ourselves returning again and again to the question of the purpose of an art museum and its contract with the public. None of us was comfortable with the image of the art museum in the press as either (or oddly, both) an immensely popular and varied educational and cultural center or an arrogant and greedy hoarder of ill-gotten goods gathered in league with dishonorable people. Nothing of this rang true with the art museum as we knew it. So we organized the lecture series "Art Museums and the Public Trust" to explore the topic further and present its contents in published form.

Richard Benefield, Stephanie Schilling, Sharon Wing, Ann Starnbach, and Evelyn Rosenthal of the Harvard University Art Museums were

central to the planning and execution of the lecture series and this publication. We thank them and all others who helped on this project.

NOTES

1. Anne d'Harnoncourt participated in the round table discussion and lectured in our Harvard series although her essay is not included here.

2. Examples of the public airing of differing views on these subjects include discussions with Thomas Krens and Philippe de Montebello in "Hip vs. Stately: The Tao of Two Museums," *New York Times,* 20 Feb. 2000; Malcolm Rogers and James Cuno in "Cuno vs. Rogers," *Boston Herald,* 15 Dec. 2000; and T. J. Medrek, "Considering Form and Function of Museum of the Future; Museum Directors Pose Tough Questions about Future of Arts," *Boston Herald,* 18 Dec. 2000. The trajectory of the fate of the art museum (specifically the Guggenheim) as multinational corporation can be tracked by comparing Alex Prud'homme, "The CEO of Culture, Inc.," *Time,* 20 Jan. 1992, with Deborah Solomon, "Is The Go-Go Guggenheim Going Going ...," *New York Times Magazine,* 30 June 2002.

Introduction

James Cuno

OVER THE YEARS at meetings of the Association of Art Museum Directors, around the seminar table at the Harvard Program for Art Museum Directors, or in one or another of our offices, we, the authors of this book, found ourselves frequently discussing the nature and foundation of the public purpose of art museums and wondering why art museums, which are more popular than ever before, are also more at risk and are more vulnerable to public criticism than ever before.

In the early 1990s we discussed financial and political challenges to art museums as the U.S. economy was stalled and the federal government was debating whether or not to reduce or even eliminate funding for the National Endowment for the Arts and the National Endowment for the Humanities (NEA and NEH).[1] William J. Bennett, then recent chairman of the NEH, complained that the endowments were less interested in creating art or fostering knowledge and more interested in "ridiculing, provoking, and antagonizing mainstream American values."[2] Lynne V. Cheney, then chairman of the NEH, declared that "many academics and artists now see their purpose not as revealing truth or beauty, but as achieving social and political transformation."[3] And Newt Gingrich, Speaker of the U.S. House of Representatives, assailed the NEA as comprising "self-selected elites using tax money to pay off their friends."[4] By implication, museums were accused of aiding and abetting radical academics by publishing their ideas, and peddling pornography by purchasing and

exhibiting the work of such artists as Andres Serrano and Karen Finley, the bêtes noires of anti-NEA conservative politicians.[5]

Then in the middle 1990s, with the declassification of previously secret government documents, there was the publication of Lynn Nicholas's *The Rape of Europa* and Hector Feliciano's *The Lost Museum*, which documented the looting of private and public art collections in Europe by German officials during the Nazi era and questioned the current ownership of works of art from that period. Museums were accused of hoarding such ill-gotten goods.[6] Articles appeared in national and international magazines, newspapers, and news Web sites with headlines like "Museum Art Buyers Rarely Check Work's Past" (*Boston Globe*, 18 May 1997), "Suspicious Pasts Cloud Some Local Artworks of the Fogg, MFA" (*Boston Globe*, 9 November 1997), "Family Sues for Return of Matisse Painting Looted by Nazis: Seattle Art Museum Holds 'Odalisque' Donated in 1990" (CNN Interactive, 4 August 1998).[7] And in June 1998, the Association of Art Museum Directors (AAMD) held a press conference and released the report of its Task Force on the Spoliation of Art during the Nazi/World War II Era, four months after a few of its members testified before the U.S. House of Representatives Banking and Financial Services Committee.[8] Still, questions persist. In 2000 the Presidential Advisory Commission on Holocaust Assets in the United States notified museums that it was beginning to compile a report that "will document the historical development of U.S. museums' policies and procedures ... that deal with the investigation of provenance and legal title of artworks acquired by museums." And in February 2000 a representative of the AAMD was again called to testify before the Banking and Financial Services Committee about art museums' progress in identifying Nazi-era looted art in their collections.

At the same time, art museums were being accused of holding antiquities illegally exported from foreign countries. With headlines like those concerning Nazi-era looted art, museums were linked to the trafficking in stolen cultural artifacts from Latin America, Africa, Italy, Greece, and Turkey: "Turkey's War on the Illicit Antiquities Trade" (*Archaeology*, March/April 1995), "Objects of Desire: Contested Artifacts Are the Prized

in an International Culture Clash" (WashingtonPost.com, 14 December 1997), "Recently Acquired MFA Works Lack Documentation" (*Boston Globe*, 27 December 1998). And they were linked to museum donors who were charged in lawsuits with possession of improperly imported antiquities: "Collectors are the Real Looters," (*Archaeology*, May/June 1993), "Judge Rules Ancient Sicilian Golden Bowl Was Illegally Imported" (*New York Times*, 18 November 1997), and " 'The World Cannot Afford Many More Collectors with a Passion for Antiquities' " (*Art Newspaper*, October 1994). Public conferences were held everywhere, it seemed—at art museums, on university campuses, in law school fora—with such titles as "Who Owns Culture?" and "Reports from the Front Lines of the Art and Cultural Property Wars." Art museums, collectors, and art dealers were regularly pilloried in editorials in *Archaeology*, the popular magazine of the Archaeological Institute of America.

And then, as the decade came to a close, art museums were being criticized in the press for improper associations with moneyed interests. In 1999 the mayor of New York, Rudolph Giuliani, held a press conference to criticize the Brooklyn Museum of Art for mounting an exhibition that included works of art he believed offensive to his constituents. He specifically targeted a painting by Chris Ofili, *The Holy Virgin Mary* (1996), which depicted a dark-skinned woman of African features; on its surface were affixed globs of elephant dung and cutouts from pornographic magazines. The artist called the painting reverential. The mayor called it blasphemous and demanded its removal from the exhibition. The museum refused and a public debate ensued. The mayor sought to cut off city funds to the museum and revoke its license but was forbidden to do so by a federal judge. He then charged that since the exhibition comprised works from a single private collection, the museum was actually in cahoots with the collector to enhance the value of his collection (through its public exhibition) at the expense of taxpayers whose taxes went in part to subsidize the museum.[9]

The fight played out for months until the court ruled against the mayor. The museum appeared victorious in defense of free speech and the First Amendment to our Constitution, but it had been sullied in the

process. Over time it was revealed that the exhibition had in fact been underwritten in part by the collector, even though the museum director had at first denied this. Then it was revealed that the collector was making what some saw as excessive demands on the museum to show his work a certain way and the curator in charge went on record asking that the museum get "a bit closer to the driver's seat—or at least [that] we can all have a hand on the steering wheel." Commercial houses got involved with galleries representing artists in the exhibition donating money and with Christie's auction house, through which the collector had recently sold more than one hundred works by artists represented in the exhibition, making its "most significant financial commitment to an external exhibition to date." The museum even provided a link on its Web site to the pop star David Bowie's Web site, where one could find mention of the exhibition; see an image of painting Bowie made with Damien Hirst, one of the celebrated artists in the exhibition; join Bowie's fan club; buy fan club products; and even use his online banking service. The museum seemed desperately and intimately connected to a network of for-profit ventures seeking to capitalize on its exhibition. It didn't help that one of them, Christie's, was at the time involved in a high-profile federal anti-trust investigation for allegedly fixing the prices it charged to buyers and sellers.[10]

Charges of blasphemy, pornography, and financial corruption were made against the Brooklyn Museum and for months stuck to the public image of museums as such. Museums appeared elitist, both in the sense that they decided what was and what was not art, even at the expense of the feelings of the public, and because they partied and even perhaps partnered with the rich and famous. Former Congressman Newt Gingrich's earlier charge against the NEA came to mind: "self-selected elites using tax money to pay off their friends."

And then in 2001 the Guggenheim Museum announced its partnership with the State Hermitage Museum in opening two museums at and with the Venetian Resort Hotel-Casino in Las Vegas. In its press release, the Guggenheim's director, Thomas Krens, explained:

Las Vegas is changing, to be sure; today the profile of a typical Las Vegas visitor increasingly approximates the profile of the visitors upon which every major museum in the world—including the Hermitage and the Guggenheim—depends, and to which they communicate. Las Vegas is no longer a city of gambling as much as it is an unparalleled tourist destination, with uniquely evocative vernacular architecture and many other attractions ranging from the natural splendor of its desert and mountain ranges, to its sophistication and popularity as a convention center. To locate a Russian-American cultural joint venture in the fastest growing city in the U.S., and perhaps the world—this notion stimulates the mind.[11]

And of course there was the hope of considerable income through admission fees, product purchases, and the investment of the casino. Alas, the September 11 terrorist attacks on New York and Washington intervened, and the museums opened on the very weekend in October that the war in Afghanistan began. In their first month of operation, attendance at the Las Vegas museums was only about 40 percent of expectations. Two months later, the *New York Times* published an article announcing that the Guggenheim would lay off almost 20 percent of its staff from almost every department of the museum in what the museum described as only an initial round of layoffs. It also noted that the museum had been shifting money from its endowments to meet operating costs and debt payments: $23.3 million, of which $10.5 million was taken just in the year 2000 to help reduce the museum's outstanding debt from $42 million to $28 million. This left the museum's endowment at just $37 million, having increased only 54 percent over the 1990s despite the surging stock market and when other museums' endowments were increasing by as much as 300 percent.[12]

The plight of the Guggenheim attracted considerable attention. A *New York Times* article reported that its director "has always been something of a high roller, a larger-than-life character who rides around on a

BMW motorcycle and challenges conventional notions about art, money and museum management." And, it quoted others as describing the museum's ambitions as "a house of cards, a global empire with colonies in Venice, Bilbao, Berlin and, most recently, Las Vegas that is fatally addicted to new streams of revenue to cover debts and risky gambles."[13] The director courted such attention. In a lecture in Vienna, he declared that "in many ways, what I do now is that I manage a brand and that brand is the Guggenheim."[14] Recent events have weakened the brand. In a *New York Times* article critical of recent museum exhibitions, Roberta Smith concluded that "A few more shows like 'Armani' [mounted by the Guggenheim after a reported $15 million donation from the clothing designer] and it won't matter how many architectural masterpieces the Guggenheim can afford to build; they will just be rentable exhibition halls. Buildings don't make museums; art and only art does. It is art, speaking unequivocally for itself, that creates a museum's imprimatur in the first place."[15]

The more art museums look like multinational corporations and the more their directors sound like corporate CEOs, the more they risk being cast by the public in the same light. And in 2002 that was a harsh light indeed. The dramatic, multibillion-dollar collapses of Enron and WorldCom and the concomitant charges of unethical and even illegal behavior by their chief executives and chief financial officers have shaken the confidence of world markets. In July the Dow Jones industrial average fell below 8000 for the first time in four years. Accounting firms and financial companies were charged with helping failed companies cover up their losses. The founder and former CEO of Adelphia, one of the nation's largest cable companies, was arrested with two of his sons for looting the company of more than $1 billion, and photographs of them being taken away in handcuffs appeared on the front pages of newspapers all across the country. Not long afterward, the U.S. Congress overwhelmingly passed legislation, which the president signed, instituting harsh penalties for executives who mislead the public on the financial condition of their companies. Newspaper headlines read, "Two Former WorldCom Executives Face Federal Fraud Charges" and "The Imperial Chief Executive Is Suddenly in the Cross Hairs" and "A Sudden Rush to Declare Bankruptcy Is Expected." A cartoon appeared in

the *New Yorker* with the caption, "Yes, I am a C.E.O., but not, I trust, in the pejorative sense."

It was with all of this in mind, and while acknowledging the extraordinary popularity of our art museums—attendance at American art museums rose from twenty-two million in 1962 to over one hundred million in 2000; more than half of our art museums were founded after 1970 and new museums are opening and existing museums are getting bigger and bigger; more than $3 billion is currently projected for museum expansion in the next few years—that we organized the lecture series "Art Museums and the Public Trust," documented in this publication.[16] We wanted to step back for a moment, after all the go-go optimism and rhetoric of the 1990s, focus on the public purpose of art museums, and reflect on the nature of the public's trust in our institutions. We were aware of the loss of public trust in so many public institutions, from the courts to the church to government to publicly traded companies. In October 2001 the search engine Google revealed a list of 1,800,000 results for the topic "public trust," (by July 2002 it was up to 2,820,000), while a search of Lexis-Nexis's "Academic Universe" found over 330 entries for the same topic. In the latter, we found the articles "Trusting Doctors: Tricky Business When It Comes to Clinical Research," "Can Public Trust in Nonprofits and Governments be Restored?" and "Committee to Promote Public Trust and Confidence in the Legal System Releases Report"—the latter included the sentence: "While a decline of public trust in the legal system may appear to be of recent origin, it has a long history."

Books on the topic began to appear with titles like *Why People Don't Trust Government*, while a lead Op-Ed piece in the 28 July 2002 edition of the *Boston Globe* was titled "The Plunge of Public Trust."[17] From 1997 to 2001 the John C. Whitehead Forum of the Council for Excellence in Government sponsored a series of lectures "Government and Public Trust: Views from the Top" with such titles as "Finding Trust in Unexpected Places" and "Restoring Public Trust in Government." In his lecture "Improving Public Trust in Government," Lee H. Hamilton, director of the Woodrow Wilson International Center for Scholars and a former U.S. Congressman, reminded us that in the mid-1960s, "three-quarters

of Americans said they trusted the federal government to do the right thing most of the time," while in 1999 the number was down to 29 percent.[18]

At the same time, in May 2001, the American Association of Museums released the results of an AAM-commissioned national survey showing that Americans view museums (of all kinds) as "one of the most important resources for educating our children and as one of the most trustworthy sources of objective information." Museums were judged trustworthy by 87 percent of the respondents, while books were judged trustworthy by only 61 percent and television news by only 50 percent. Perhaps this is because museums present the hard facts of things; indeed, things themselves. But, in this respect, are art museums different than other kinds of museums? After all, works of art are enough out of the ordinary that we have to trust the experts to tell us that this drawing is by Rembrandt but that one is by Gerbrand van den Eeckhout. Attributing works of art requires (or seems to require) more judgment and expertise than identifying a cooking utensil, for example. The AAM-commissioned survey generalized on museums of all sorts, from aquariums to history museums to children's museums to (we suppose) art museums. It would have been helpful to have been told which type of museum Americans trusted most. One suspects that art museums would have been rather further down the list for the reasons I have mentioned: by the nature of their objects, they require, and one would like to think *inspire*, a greater degree of trust among their visitors, who entrust museum staff with the responsibility to decide what is and what is not by this or that artist and what is not important to keep in the permanent collection. And it is by placing this trust in museum staff that the public grants the museum its authority as a public institution. We organized our lecture series "Art Museums and the Public Trust" in lieu of commissioning a poll or releasing a report on the promotion of public trust and confidence in our art museums.

We have all heard cases made for art museums as centers of broad-based community education. In 1992 the American Association of Museums issued a report called *Excellence and Equity: Education and the Public Dimension of Museums* that was based on three principles:

The commitment to education as central to museum's public service must be clearly expressed in every museum's mission and pivotal to every museum's activities. Museums must become more inclusive places that welcome diverse audiences, but first they should reflect our society's pluralism in every aspect of their operations and program. Dynamic, forceful leadership from individuals, institutions, and organizations within and outside the museum community is the key to fulfilling museums' potential for public service in the coming century.

Five years later the President's Committee on the Arts and the Humanities issued a report called *Creative America* emphasizing, among other things, that "many communication, thinking, and management skills are enhanced by the arts and the humanities." Earlier reports of the committee emphasized other ways the arts can have powerful effects in education that may extend from and beyond the arts.[19] Others have claimed that they improve basic learning and even standardized test scores.[20]

About 1998 the National Endowment for the Arts published a book-length account of its multiyear "national discussion" on the arts and their legacy for our communities and concluded, among other things, that "the arts are important as a subject in themselves. The arts enhance the study of other areas of the basic curriculum. The arts are relevant to the acquisition of vocational skills. The arts contribute to family unity and growth. The arts offer skills that will be useful as we move further into the Information Age. The arts serve those with special needs, including those who are in danger of falling through the cracks of our educational system."[21] Others simply said that museums have gone "from being *about* something to being *for* somebody."[22]

I hoped that our essays would make a case for art museums on more fundamental grounds. I did not want to suggest causal links between the arts and other "goods" in our communities. I wanted to articulate the "good" of art in itself as the foundation of the public's trust in art museums, and then to charge art museums with the responsibility of

identifying, preserving, and presenting works of art as a means of promoting that "good," even if we cannot testify to its improving social behavior, enhancing the acquisition of work skills, or increasing scores on standardized tests.

Equally, I wanted to make a case for art museums in contrast to the premise that museums have to offer a pronounced and discursive thesis in their exhibitions and installations to be educational. As an example of the "discursive museum," I had in mind the Los Angeles County Museum of Art's exhibition, *Made in California: Image and Identity, 1900 to 2000*. *New York Times* critic Roberta Smith described the exhibition as text-heavy and manipulative of works of art, quoting the curator as writing that "by exposing the museum going audience to exhibitions that present art in relation to its social, political, and historical context, the public will grow to value artworks as more than timeless, transcendental or universal objects of beauty that speak for themselves." To which Smith replied: "What [the curator] doesn't say is that rather than contextualize things in a way that might allow them to speak for themselves, or the viewers to think for themselves, [the exhibition] favors labels that provide explicit, heavily biased interpretations, often putting words in the artworks' mouths and then judging them accordingly."[23]

 Made in California is an example of the museum exhibition as a discursive text. In academic literature *discursive* means something like "critical" or "interpretive," something engaging with ideas, real meaty intellectual stuff, not merely a descriptive accounts of things. The museum as a discursive text would then be not a collection of objects but a site of competing discourses *about* objects, objects being necessary only in so far as they occasion debate and provoke discourse.[24] The art historian Michael Baxandall once pointed out that "we don't explain pictures: we explain remarks about pictures"; that is, we explain pictures only in so far as we have considered them in some framework of verbal description or specification.[25]

 We have all had the experience of being in an exhibition before a work of art and forgetting the "thesis" of the exhibition (except of course in the most obvious sense: it is an exhibition, say, of one artist's work, or

work collected by one person, or produced in one city in one century) in favor of the power of the individual work of art that stands before us. Stephen Greenblatt calls this singular, powerful experience "wonder," as in "the power of the displayed object to stop the viewer in his or her tracks, to convey an arresting sense of uniqueness, to evoke an exalted attention."[26] I wanted to recover this sense of wonder as part of the museum's purpose and as integral to its contract with the public.

In the first essay in this volume, Neil MacGregor, until recently director of the National Gallery, London, and now director of the British Museum, emphasizes that the National Gallery is almost unique among European museums for not having been a royal collection or for having been created as an educational institution. Rather, it was a public collection, assembled simply so that the public could see great pictures. As its founders emphasized, all economic classes of the public have a basic right to seek "consolation" from works of art.

My essay is second; in it I draw attention to some often-overlooked details of works of art as a way of illustrating how permanent collections — even the fragmentary and unfinished things within them — repay long looking, a pleasure to which art museums are dedicated as a fundamental part of their contract with the public.

John Walsh, director emeritus of the J. Paul Getty Museum, approaches the subject similarly. Citing James Elkins's book, *Pictures and Tears: A History of People Who Have Cried in Front of Paintings,* and a lecture by Philip Fisher, he considers how individual works of art can move people deeply, that museums are places where the public can have that experience as a public experience, and that museums should be careful not to compromise those moments with too many distractions. He offers suggestions as to how we can offer people the chance to look hard and respond to the works of art to help make "an audience of happier, wiser, more complete people."

James Wood of the Art Institute of Chicago reflects on the idea of authority as central to the concept of public trust. After inquiries into the source, nature of, and challenges to the American museum's authority, Wood identifies and discusses at length eight types of museum authority,

concluding that the authorities of mission and leadership are the bases of the public's trust in museums.

Glenn Lowry, director of The Museum of Modern Art, questions what is appropriate behavior for a museum that behaves more and more like a for-profit corporation in its programs of marketing, fundraising, programming, and in ambition. He points out that there are actually few firm guidelines for how a museum should act in the public trust, and it is up to each institution to establish, for example, whether it will let commercialism influence its public, collections-driven mission.

Finally, Philippe de Montebello of the Metropolitan Museum of Art reflects first on the meaning of "public trust," arguing that the basis of any trust in a public institution is its integrity. For museums, this should derive from their collections and comprise an absolute commitment to authenticity and to the museum's authority, which should never be compromised. He addresses the growing size and complexity of many museums today and the issues concomitant with those changes.

As I was preparing this introduction I found myself recalling a lecture Michael Brenson gave before the members of the Association of Art Museum Directors in February 1997. There, reflecting on the lack of mention about the arts or culture in the recent U.S. presidential campaign (Clinton *vs.* Dole), Brenson lamented:

> Culture is no longer considered essential to government policy-making; it is no longer seen as a necessary part of our argument to other countries about what democracy is and how it works. . . . The fear of art and culture reflects a loss of confidence in the idea of democracy. I'm not saying people do not believe in democracy, even desperately. It remains the defining idea in America's sense of itself. But there is a hollowness in the way the word is used in our political life. . . . The timidity I see in many museums disturbs me. By this I mean much more than any reluctance to show art that provokes. What I mean most of all is a fear of engagement.[27]

We hope the ideas and sentiments expressed in this book make a case for the role of art museums in a democratic culture; a case based on the very purpose of an art museum as an *art* museum, intent on its fundamental purpose and with a high regard for the nature, conditions, and responsibility of the public's trust.

NOTES

1. See *The Economics of Art Museums*, ed. Martin Feldstein (Chicago: University of Chicago Press, 1991). Of the participants in our lectures series, Philippe de Montebello, Anne d'Harnoncourt, John Walsh, and James Wood participated in the discussions documented in this study.

2. Robert Pear, "Funds for Arts under Attack in the House," *New York Times*, 25 Jan. 1995.

3. See Lynne V. Cheney, *Tyrannical Machines: A Report on Educational Practices Gone Wrong, and Our Best Hopes for Setting Them Right* (Washington, D.C.: National Endowment for the Humanities, 1990) and Lynne V. Cheney, *Telling the Truth: Why Our Culture and Our Country Have Stopped Making Sense, and What We Can Do about It* (New York: Simon and Schuster, 1995).

4. Through the NEA funding debates in the house, 1995–97, Gingrich was frequently quoted referring to the endowment as "elitist," as in "the endowment is a sandbox for the nation's affluent cultural elite." The pejorative use of the term was meant to isolate the arts (whether the endowment or art museums) as against the mainstream and fundamentally undemocratic. In this, Gingrich was answered by Edward Rothstein in an Op-Ed piece for the *New York Times*, 26 Feb. 1995: "The N.E.A. Is Elitist, True. It Should Be." A book-length defense of the arts and culture as inherently elitist (i.e., as demanding and rigorous yet available to all who wish to pursue them rigorously and in a demanding way) is William A. Henry, *In Defense of Elitism* (New York: Doubleday, 1994).

5. See Richard Bolton, ed., *Culture Wars: Documents from the Recent Controversies in the Arts* (New York: New Press, 1992) and Michael Brenson, *Visionaries and Outcasts: The NEA, Congress, and the Place of the Visual Artist in America* (New York: New Press, 2001).

6. Lynn H. Nicholas, *The Rape of Europa: The Fate of Europe's Treasures in the Third Reich and the Second World War* (New York: Alfred A. Knopf, 1994)

and Hector Feliciano, *The Lost Museum: The Nazi Conspiracy to Steal the World's Greatest Works of Art* (New York: Basic Books, 1997).

7. For a detailed explication of a case dealing with a collector close to the Art Institute of Chicago, see Howard J. Trienens, *Landscape with Smokestacks: The Case of the Allegedly Plundered Degas* (Evanston, Ill.: Northwestern University Press, 2000).

8. Among the members of the task force were our participants James Cuno, Anne d'Harnoncourt, Glenn Lowry, Philippe de Montebello, and James Wood; among the directors testifying before Congress were Glenn Lowry, Philippe de Montebello, and James Wood.

9. See *Unsettling "Sensation": Arts-Policy Lessons from the Brooklyn Museum Controversy*, ed. Lawrence Rothfield (New Brunswick, N.J.: Rutgers University Press, 2001).

10. James Cuno, " 'Sensation' and the Ethics of Funding Exhibitions," in ibid., 165.

11. Guggenheim Museum Press Release, 1 Aug. 2001.

12. Celestine Bohlen, "The Guggenheim's Scaled-Back Ambition: A Museum Director's Risk-Taking Approach Gets a New Look in Hard Times," *New York Times*, 20 Nov. 2001: sec. E, p. 1. For example, over the 1990s, the endowment of the Harvard University Art Museums increased from $90 million to $360 million.

13. Ibid.

14. Thomas Krens, "Developing the Museum for the 21st Century: A Vision Becomes a Reality," in *Visionary Clients for New Architecture*, ed. Peter Noever (New York: Prestel, 2000), 67.

15. Roberta Smith, "Memo to Art Museums: Don't Give Up on Art," *New York Times*, 3 Dec. 2000. On 4 December 2002 the Guggenheim announced a $12 million gift from its chairman, Peter B. Lewis, given to offset the museum's deficit. Lewis remarked at the time that the museum's financials were "a mess," since the museum "had first used yesterday's reserves and then used tomorrow's optimism." And he gave his gift on the condition that the museum put its financial house in order. The director responded by cutting the staff by half, from 391 to 181. Three weeks later it announced that it was closing, at least temporarily, its Las Vegas branch and would no longer pursue development of a second New York site. See Michael Kimmelman, "An Era Ends for the Guggenheim," *New York Times*, 6 Dec. 2002, sec. B, p. 39.

16. "Museums Galore," *The Economist*, 19 Feb. 2000, and Blake Eslin, "The Incredible Growing Art Museum," *ArtNews*, Oct. 2001, 138–49.

17. Joseph S. Nye, *Why People Don't Trust Government* (Cambridge, Mass.: Harvard University Press, 1997).

18. See John H. Trattner, ed. *Government and Public Trust: Views From the Top* (Lanham, Md.: University Press of America, 2002).

19. Elizabeth Murfee, "The Value of the Arts," President's Committee on the Arts and the Humanities (Washington, D.C.: National Endowment for the Arts, 1993) and "Eloquent Evidence: Arts at the Core of Learning," President's Committee on the Arts and the Humanities (Washington, D.C.: National Endowment for the Arts, 1995).

20. For a critique of this view, see Elliot Eisner, "Does Experience in the Arts Boost Academic Achievement?" *Art Education* (1998): 7–15, and "Getting Down to Basics in Arts Education," *Journal of Aesthetic Education* (winter 1999): 145–59. For a book-length review and critique of these positions, see Ellen Winner and Lois Hetland, "The Arts and Academic Achievement: What the Evidence Shows," a special issue of *Journal of Aesthetic Education* (fall/winter 2000).

21. Gary O. Larson, *American Canvas: An Arts Legacy for Our Communities* (Washington, D.C.: National Endowment for the Arts, n.d.), 16.

22. Stephen E. Weil, "From Being *about* Something to Being *for* Somebody: The Ongoing Transformation of the American Museum," *Daedalus* (summer 1999): 229–58.

23. Smith, "Memo to Art Museums."

24. See the collection of lectures, *The Discursive Museum,* ed. Peter Noever (Ostfildern-Ruit, Germany: Hatje Cantz, 2001).

25. Michael Baxandall, *Patterns of Intention: On the Historical Explanation of Pictures* (New Haven, Conn.: Yale University Press, 1987), 1–11.

26. Stephen Greenblatt, "Resonance and Wonder," in *Exhibiting Cultures: The Poetics and Politics of Museum Display,* ed. Ivan Karp and Steven D. Lavine (Washington, D.C.: Smithsonian Institution Press, 1991), 42–56.

27. Michael Brenson, "The Culture Wars: What Are They, How Do They Affect Us, and What Can We Do about Them?" Remarks delivered as part of a panel discussion on this topic before the meeting of the Association of Art Museum Directors held in St. Louis on 23 Jan. 1997.

A Pentecost in Trafalgar Square

Neil MacGregor

DIRECTOR, BRITISH MUSEUM, LONDON
FORMER DIRECTOR, NATIONAL GALLERY, LONDON

I WOULD LIKE to address some of the problems related to the kinds of responsibilities that we, as directors, curators, or trustees of public collections, have with regard to our collections. Specifically, how, for whom, and to what purpose do we present our collections? What are our obligations to the public? What to the artist? What to truth, to beauty, or—more prosaically—to the government that funds us?

These are particularly relevant questions for the National Gallery in London because, almost uniquely among European collections, it was never a royal collection. All of the other great museums—whether those in Madrid, Florence, Paris, or St. Petersburg—once belonged to the collections of those cities' ruling houses and only later were made available to the public. Because in England we had neither revolution nor Napoleonic invasion, our royal collection remained private and remains so to this day.[1] Indeed, at the end of the Napoleonic wars in 1815, London was the only major European capital where the public had no right to see Old Master paintings. To address this fact, Parliament in 1824 decided to set up the National Gallery quite specifically as the place where the public—all the public—could see great pictures. And throughout the nineteenth century and beyond, the National Gallery, the first parliamentary collection of

paintings in the world, has been the focus of articulate debate about why and whether we need public collections.[2]

A number of these different—and conflicting—aspirations can be tracked in the example of Niccolò di Pietro Gerini's *Baptism of Christ* of c. 1387 (fig. 1).[3] Acquired by the National Gallery in 1857, it had come from the collection of the Lombardi-Baldi in Florence. It is a picture that has charming moments—like the fish swimming around Christ's feet—but nothing that would, I think, claim it as a supreme work of art. It is, however, an excellent historical representative of an important town at a significant moment— Florence between Giotto and Masaccio. And it was in part as a historical document that it was bought. Its acquisition (along with the rest of the collection of which it was part) precipitated a violent debate.

All acquisitions in the nineteenth century had to be funded by a vote of Parliament, who was initially reluctant to vote the money to buy pictures like this on the simple basis that they were not beautiful and the public would not enjoy them. They would be of interest only, it was thought, to the likes of Prince Albert and his friend Sir Charles Eastlake (who was then the first scholar-director of the National Gallery), who had both been contaminated by recent developments in German art history. Members of Parliament were appalled: they did not want the National Gallery in London to look like the gallery in Berlin, which sought chronological thoroughness in its collections and emphasized pedagogy and scholarship over aesthetic pleasure in its presentations.[4] Eastlake did ultimately win the day, however, but only by arguing that it was important to have pictures like this in the National Gallery so that when people came to the later pictures of the High Renaissance they would see how much better those paintings were, and enjoy them all the more, because earlier paintings like the Gerini were so clumsy. In other words, the purpose of buying fourteenth-century art was so that people could see just how vastly superior sixteenth-century art— especially Raphael—really was. It was a clear, if disingenuous, debating ploy, and it worked.

At its foundation in 1824 the National Gallery was intended quite clearly to have beautiful objects. There was not a hint of education, not a hint of scholarship in its founding principles. As Sir Robert Peel, the great

prime minister and the gallery's great champion through its first quarter of a century, put it, its purpose was simply to ensure that the poor could have the consolation of pictures just as the rich did. Peel argued forcefully that the purpose of the National Gallery was "to cement the bonds of union between the richer and the poorer orders of the state." And so when a permanent home had to be found for the pictures in 1838, it was decided after

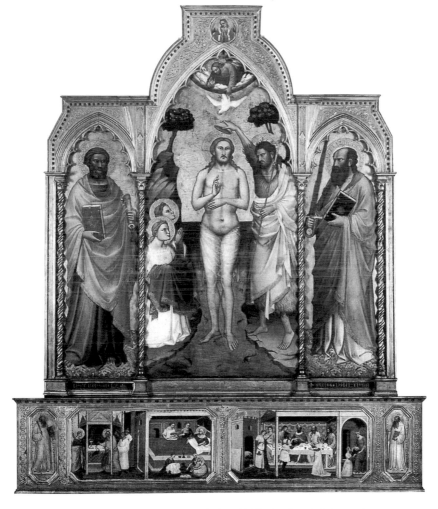

FIG. 1 Niccolò di Pietro Gerini (active 1368–d.1415), *Baptism of Christ*, c. 1387.
Egg tempera on wood, 93¾ x 78¾ in. (238 x 200 cm). National Gallery, London

much debate in Parliament that it must be located in Charing Cross and Trafalgar Square, where the rich would be able to drive in their carriages from the West End and the poor would be able to walk from the East End, and the two meet in front of a painting—preferably a beautiful picture from the High Renaissance. The fact that the gallery acquired Gerini's *Baptism of Christ* shows that the tension between the beautiful and the pedagogical was not only recognized very clearly in 1857, it was also seen that it could be resolved: that is, one could actually enjoy pictures and learn about them. Eastlake believed firmly that once people came to know pictures like the Gerini, they would come to love them.

The National Gallery, like almost every major public collection, has tried ever since to keep this balance between being a place of learning and knowledge and a place of enjoyment—between a *museum*, like the British Museum, where specimens are put together to reveal a progression or a pattern, and a *gallery*, where the individual work of art is meant to be seen and enjoyed on its own. It can be said that the gallery has tried to have it both ways. Its collection is hung broadly chronologically, and pieces are hung among similar works. The visitor does not, for example, see the Gerini next to Titian's *Noli Me Tangere* (fig. 2).[5] He sees the Titian, which was painted probably about 1514, in the context of other pictures to make exactly the point that Eastlake would have made by grouping pictures chronologically. The Titian is hung beside a Giorgione, that is probably slightly earlier in date and shows how much Titian owed to Giorgione, and with other pictures by Titian of about the same date. Such a hanging raises questions of the artist's handling of paint, the attribution of authorship, and date of his pictures from the same period, as well as their relationship to slightly earlier pictures from the same general geographical and cultural area.

This particular installation encourages the pursuit of a truth of cataloguing, attribution, dating, and comparison. If one changes it and puts the Titian with another set of pictures, the pursuit of a different kind of truth is encouraged. For example, in the gallery's *The Image of Christ* exhibition in 2000, when we were looking at how images of Christ have been treated and have evolved over the centuries, we hung the Titian beside Bernardo Strozzi's *Incredulity of Saint Thomas* (private collection) to focus

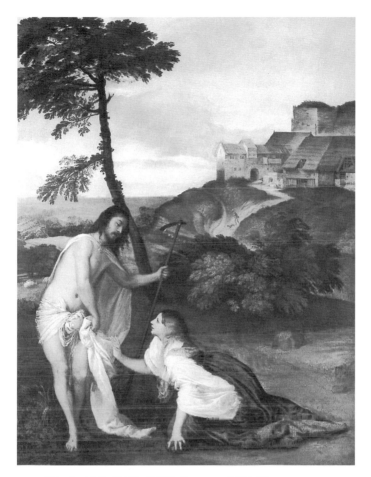

FIG. 2 Titian (c. 1481–1576), *Noli Mc Tangere*, c. 1514. Oil on canvas, 42⅞ x 35¾ in. (109 x 90.8 cm). National Gallery, London

the visitor's attention on these two totally contradictory comments about the risen body of Christ as written in the gospel of John. Christ directs Thomas to thrust his hand into the wound but tells Mary Magdalene not to touch him: two completely different responses to the body are treated by artists a century or more apart. They are stylistically very diverse, but that installation forces from the visitor a different kind of question.[6]

It would be a mistake to presume for our visitors only one truth about a picture. The obligation on those of us who hold art in trust for the

public is to try to allow our public access to different truths about our pictures—about *their* pictures—to allow the artists to speak in as many different ways and reach as many different audiences as possible, and to explore the richness of potential meanings implicit in great work of art— meanings both historical and contemporary.

Through scientific examination we can show the artist speaking or changing his mind as he made his picture. Through photography and computerization we can show rejected stages of paintings side by side with the artist's final decisions, encouraging still different questions and evincing different kinds of truth. But what if that final state has itself changed because of the properties of its paint? The brown tree in Titian's *Noli Me Tangere* was once painted to be as green as the foliage next to it, but its copper resinate has oxidized. Should we do anything about it? What are our responsibilities with regard to the condition of our paintings and their relations to the intentions of the artist? After all, Titian's paint is all still there on his canvas. Its changed condition has nothing to do with the interventions of conservators. The perplexing question of whether to "correct" such mutations complicates our obligation to present the truth about the artist's intention to the public.

The most striking example I know of such a misleading discoloration is Jean-Baptiste Greuze's *Girl Weeping over Her Dead Canary* of 1760 in the National Gallery in Edinburgh. When it was first shown at the Salon in Paris, it is only a slight exaggeration to say that people were led sobbing from the Salon because of the impact of this picture, the paroxysms of public grief, evidence of private virtue in the spectator. But now if you go to the gallery in Edinburgh—and there is the label with the painting's title, *Girl Weeping over Her Dead Canary*—you will hear every honest Scottish visitor turn to the friend they're with and say: "I thought canaries were yellow." Of course they were, and they are, and this one once was. But Greuze used a fugitive yellow vegetable pigment that is very sensitive to light. The canary has become white, and the ivy—which the canary has eaten and is, I presume, the cause of the disaster—was also covered with the yellow to make it green. So now we have a white canary on blue ivy. The great difficulty about this is that if you describe these changes in the label text next

to the painting, it will make it almost impossible for the public to focus on the emotion of the girl, the quality of the paint elsewhere—anything but the changed colors of the paint.

This is, I think, a central problem of presentation: how do we give our visitors access to earlier states of a painting without having one compromise the experience of the other? New technologies help. For example, Paolo Veronese's *The Vision of Saint Helena*, 1560–65, in the National Gallery, London, shows Saint Helena experiencing her vision of the cross. It is a picture that has always appealed to the English because of the muted, faded-chintz quality of its color: the sky is now immaculately British in its grayness. Indeed, only in 1988, a major scholar of Veronese wrote about this picture: "Color here is muted to a restrained harmony of earth tones against the pallid sky of a slightly lilac hue, an unusual device and often used by Paolo in 1550 to reduce the suggestion of deep, empty space, and to focus attention on the foreground figures."[7] Well, in this case we can be certain that this was *not* the artist's intention. The sky is in fact painted in smalt, a blue pigment material used often in Venetian glassmaking. The light-sensitive pigment has faded to this pale gray. If you were to go slightly below the surface of the painting, you would discover that it is actually bright blue, and that Veronese originally depicted—as you would expect—a Mediterranean blue sky. With digitized imagery we can reconstitute the picture and show a result closer to the artist's intention. We can see that the color of the sky was clearly not an unusual device to focus our attention, as has been suggested, but has changed over time, thus misrepresenting the artist's intentions. And we can, of course, show this digital image beside the painting. But there is a limit to how much one can show without keeping people from responding to the painting as it now is. We do not want our visitors to see the painting as diminished and requiring the aid of a reconstructed surrogate. In its current state, the painting is still beautiful and wholly arresting, and we do not want to discourage our visitors from seeing this.

How far, then, should we intervene in our visitors' experience of a picture? How do we balance information about a picture with the desire to experience it as it is—a painting physically present in a gallery with other

paintings? What are our obligations in this regard, and to whom? The three examples I have just cited are all in extremely good condition; only the materials have, over time, betrayed the artist. All we can do in these cases, I think, is to alert our visitors to the failure of the medium. The bigger problem, and one of the most difficult in terms of the public's trust in the museum, comes when the image has actually been damaged.

Take three paintings by Duccio, all in the National Gallery. The three panels are from the predella of the Duccio altarpiece, the *Maestà*, made for the cathedral in Siena.[8] In one, the *Transfiguration*, the central apostle is horribly damaged: a whole chunk of paint is totally missing, leaving an enormous hole in the paint surface. What is our obligation in this case? If you leave an absolutely blank hole, then of course the only thing that immediately leaps to the eye is the absence. But to reinvent a central apostle to look like the figures on either side would be dishonest, because there is no basis for any reconstruction of his gesture and drapery. We struck a compromise and used a different color to fill in the upper part of the body with the intention that it should not disturb the viewers, nor should it deceive them into thinking that this part was painted by Duccio. I think it is perfectly obvious to the visitor what has gone wrong. But in the next panel, which depicts the moment of Christ healing the man born blind, the problem was different, and so was the solution. The blind man appears twice, before and after healing. In the healed figure, the whole of the man's head was lost. Here we felt that it was essential for the picture's narrative that it should be totally reconstructed. We assumed that the man's facial features would not have changed during his healing, and so we simply copied the intact head. It is, of course, difficult and dangerous ground to embark on, but to leave this section of the painting blank, making its absence the focal point of the picture, would be to destroy the narrative and seriously compromise the viewer's access to the painting and its meaning. Given that we could be confident about what would have been shown, I think here our intervention was justified. And our third panel from the predella presented yet a different kind of problem, one not caused by damage, but rather where the artist has clearly forgotten to do something that he intended. As with the others, the panel's background is meant to

be completely covered in gold leaf. But in one place, below the angel's wing and behind the angel, the artist forgot to put on the gold leaf—it has never been on the panel. It would, of course, have been perfectly possible to add the gold leaf and complete the painting but we decided that its absence wasn't damaging to the narrative and although it was no doubt the artist's intention to cover the entire background with gold leaf, it does not disturb the experience of the painting not to have it. So we did nothing.

What these examples illustrate is, I think, the difficulty of squaring the different truths about paintings that we want to mediate for the viewer. We are responsible to the pictures, their artists, and the public. If we cannot meet these responsibilities equally, how do we decide which to meet? How is the public's trust in our decision preserved? The examples I have discussed thus far are fairly straightforward, being obvious distortions of the artist's work that still allow us to recover something of his intention. A much more complicated kind of damage is when the work of art itself has been split up and distributed among many collections. The three Maestà predella panels are still in one place, at the National Gallery. They were of course originally part of an enormous altarpiece made for the Siena cathedral, most of which is still in Siena, and thus represent a fragment of the painting or painted ensemble. How can we recover the totality of the work of art when its parts are in more than one collection?

There is one case—the only one I know—where it has actually been possible to put together almost everything of a dismembered work of art. The fate of many High Renaissance altarpieces was that as they went out of fashion, they were moved away from the main altar and put to one side. And then when the monasteries were secularized at the end of the eighteenth century, and particularly under the French invasions of Italy around 1800, the panels were often split up and the pieces sold separately, many winding up in different museums. An altarpiece by Pesellino, *The Trinity with Saints Mamas and James, Zeno and Jerome* (fig. 3), begun in 1455, two years before he died in 1457, and finished by his pupil, Filippo Lippi, is astonishingly well documented.[9] It came to the National Gallery in the most extraordinary way. Purchased by Eastlake in 1863, the central *Trinity* had been carved out at the time of the French invasions into an isolated lozenge

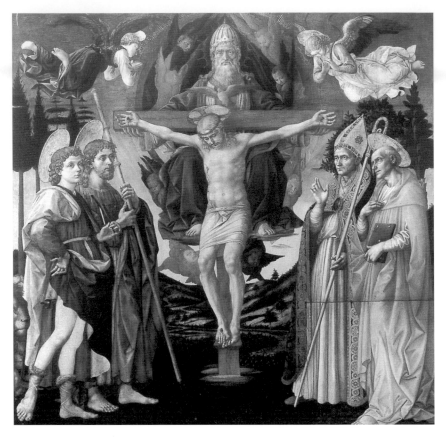

FIG. 3 Francesco Pesellino (c. 1422–1457), *The Trinity with Saints Mamas and James, Zeno and Jerome*, 1455. Egg tempera and oil on wood, 72⅜ x 71½ in. (184 x 181.5 cm). National Gallery, London

shape and made its way separately to England. It hung on its own in the National Gallery from 1863 until 1917, when another fragment, a flying angel, was given to the gallery, which then was able to buy a third piece, the pendant flying angel. With that, the king was persuaded to put his fragment of the picture (showing Saints Mamas and Jerome) on loan; the gallery then had enough of the painting to try to reassemble the parts. In the late 1920s the exiled German kaiser sold his pictures, among them the painting's right-hand side with Saint Zeno and Saint Jerome. This was then acquired by the gallery, even though the panel had actually lost its lower half, show-

ing the saints' feet and drapery. Then in the 1930s Felix Warburg, the great benefactor of the Fogg Museum, acquired the painting's predella and very generously gave it to the gallery. And so all the saints in the upper panels were reunited with their mates in the predella below. The picture was shown in this form until four years ago, when a scholar noticed that there was something very odd: each one of these saints had his predella partner—a scene from his life, a martyrdom—but the *Trinity* did not. So there must be something missing.

After a great deal of hunting, the missing panel was indeed found—in the Hermitage in St. Petersburg. It was the *Legend of Saint Augustine and the Trinity* by Filippo Lippi. We inquired whether the Hermitage would make this a long-term loan in order to reconstitute the painting in the National Gallery, since we had all but the one piece. But the Hermitage, after reflection, decided it could not. This is an example of where the question of public trust becomes very complicated. Trust for whom? The public or the artist? And if it's the public's trust, which public, the one likely to come to London to see the painting or the one in St. Petersburg? The Hermitage felt—entirely correctly—that it had an obligation to the Russian public to show the painting, which belonged to them; that obligation ultimately overrode the other obligations to the artist's intentions or to a public who wanted to see the painting reconstituted. As it was clear that the whole painting could not be shuttled indefinitely between London and St. Petersburg, a very honorable and reasonable decision was made to bring the Hermitage panel to London for a temporary exhibition, where the painting was shown in its entirety, for a few months, and photographically recorded. The picture was put back together, if only temporarily, and the artist's original intention—as far as possible—was recovered and recorded. Both the National Gallery and the Hermitage, I believe, met their obligations to their publics and to the artist.

In the same room in the National Gallery as the Pesellino hangs a group of pictures from a large altarpiece of the life of Saint Francis by Stefano di Giovanni, called Sassetta. They are extraordinarily beautiful images and popular with our public; they show Saint Francis's dream, his vocation, his giving his cloak to a beggar, his baptism, the fury of his father,

his stigmatization, and other episodes. Although most of the component parts survive, it would be impossible to attempt to reconstitute the altarpiece because one of the most beautiful pieces is in the Musée Condé, Chantilly, which it cannot leave because of the terms of its gift. This raises the very big question of whether we are content that the will of the person who once happened to own a work of art should be allowed to stand in the way of reconstructing a painting, even temporarily, for the greater enjoyment and education of the public and in order to fulfill the artist's intention? To whom are we ultimately obligated and whose trust are we keeping?

Take just one more example: Masaccio's *Virgin and Child* of 1427, which has been in the National Gallery since 1917 (fig. 4).[10] It is the central element from the altarpiece of the Carmelite church in Pisa and, although it is now quite damaged, it is clearly one of the great moments of Florentine painting of the 1420s. The Virgin is sitting on what appears to be a sarcophagus and holds on her lap the Christ child, the child himself eating the eucharistic grapes, a wonderful, real, chubby child, set in the volume of the throne, shown to us as the child born to die, the future savior slain. All this can easily be seen in the picture as it now hangs in the gallery on its own. But we know that the London panel was part of a large altarpiece. So for the six hundredth anniversary of Masaccio's birth we were keen to try to reunite the various surviving pieces of this great and important painting. The London panel is the largest by far. Since it is made of several pieces of poplar, it could not safely travel, while all the others are on single panels and are, by good fortune, safe to travel. With amazing generosity we reunited the panels from Berlin, the Getty Museum, Pisa, and Naples with ours, and a totally different truth about the picture emerged and was experienced by our visitors. Originally, below our *Virgin and Child* would have been the Berlin *Adoration*, showing the profound physical reality of the Christ child matched and intensified by the contemporary reality of the donors, in modern Florentine dress. It would also have reinforced the sacramental meaning of the grapes in the child's hand by connecting them not only with the sarcophagus but to the old king in the *Adoration* offering myrrh, the gift of death. The *Virgin and Child* panel would equally have been transformed by the presence above it of the *Crucifixion* from Naples, surely one

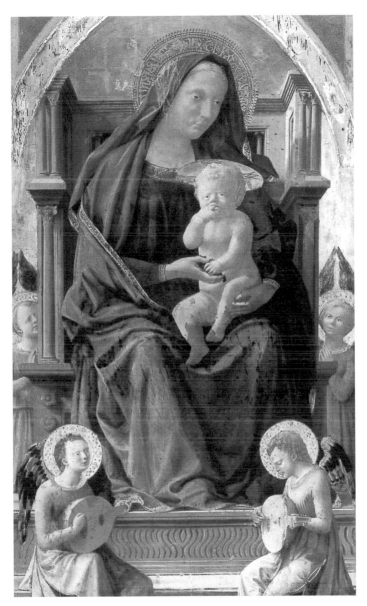

FIG. 4 Masaccio (1401–1428), *Virgin and Child*, 1427. Egg tempera on poplar, 53⅜ x 28¾ in. (135.5 x 73 cm). National Gallery, London

of the most astonishing achievements of painting in the fifteenth century, exploring three quite different responses to grief. In the central London element the Virgin sits serenely looking at us over the head of her child born to be sacrificed. But in the Naples panel she stands rocklike at the foot of the cross, while a very feminine John weeps, and the overwhelming grief of the Magdalene is so great that no facial expression can carry it— her face is completely concealed, all the grief carried in her body and hands. As three responses to destruction and loss, it is one of the most powerful images ever painted. To make this easily visible, we decided to hang these pictures not as they were intended to be seen, in vertical alignment, but on the line, at eye level, so that people could see up close the measure of the artist's achievement in each panel. A full, photographic reconstruction of the ensemble was on the wall of the exhibition to show the original placement.

The press viewing of this exhibition was very crowded, and naturally this picture and the borrowed panels attracted enormous attention. But in this case, the picture took on a completely different meaning. For the date of the viewing was the afternoon of September 11, 2001, and it was while we were gathered in that room, in front of that *Crucifixion*, that we learned of what had just happened in New York.

This experience only confirmed the sense that one of the key responsibilities of those of us with pictures in our charge is to make it possible for such meaning to happen, to bring people into contact with powerful paintings in ways that deepen their access to the pictures' historical and contemporary meanings. We could not, of course, have predicted the events of September 11 and would never have guessed that they could have been so much a part of the new meaning of these paintings. But we knew that the paintings are about grief, grief over the loss of life, and grief over not understanding the purpose for that taking of life. We had already known that Masaccio's *Crucifixion*, like all great paintings, had both historical and contemporary significance. But to be there together with those paintings on that day was especially powerful. It confirmed our conviction that we are obliged to present our pictures in ways that encourage access to their different meanings and truths: physical, aesthetic, contextual, and moral.

I should mention a problem that arose in the final week before exhi-
bition. By then every museum had agreed that its panel was safe to travel.
After all, we who keep pictures are above all trustees for their safekeeping
for future generations. But the Italian Minister of Culture suddenly refused
the export of the Naples *Crucifixion* on the basis that it was an outrage to
Italian dignity that the exhibition should occur only in London and not in
Italy. Once it was made clear that the London panel could not safely travel,
however, the Italian Minister of Culture finally agreed to the loan. His hesi-
tation had raised another key question.

The obligation of museums to care for the works of art in their
charge is always paramount, and was an issue that became very acute in
London as early as the 1840s. The National Gallery moved to Trafalgar
Square in 1838. On Whitmonday in 1840, 14,000 people visited the five
rooms of the gallery. Parliament was very concerned about the safety of
the pictures and the possible consequences of so many visitors, especially
so many poor people. The director of the National Gallery was summoned
to Parliament at regular intervals through the nineteenth century to describe
how the public behaved, why they went, and whether they were endanger-
ing the pictures. The documents reveal a pattern of phrases like "the labo-
rious and responsible classes" go to the National Gallery "to forget their
cares." It was said that the enormous numbers were going above all for
pleasure. Yet Parliament was worried that the pictures might be in danger
from the crowds; they were certainly in danger from the fact that every room
in the gallery had a coal fire, and even more so because the pictures were
in central London, then the dirtiest, most polluted city in the world. Parlia-
ment faced this issue of preservation head on: how are we going to keep
the pictures safe for the future if they are being destroyed by being shown
in the dirt of the city center to the public now? The suggestion was that they
should be moved to Kensington or Highgate, where the air was clean and
where they would be, as a consequence, safe. But it was equally clear that
there the poor would not be able to see them. So in 1857 Parliament set up
an inquiry to ask the major employers of Westminster how many times
in 1856 their laborers had gone to visit the British Museum, the National
Gallery, and the Natural History Museum.

This endeavor was an extraordinary example of public opinion research. Would it matter if they moved the pictures? Would the poor see them anyway? Did the poor actually see them now? The results of the poll were simply astonishing. In 1856 Jackson the Builders had 338 men who had made 583 visits to the National Gallery. Hooper the Coach Makers had 46 employees who had made 66 visits. And Cloughs the Printers had 117 employees who had made 220 visits to the National Gallery. Linen drapers, butchers, and hairdressers were disappointing—only one visit out of 25 employees. The only firm that registered no visit at all was sadly, the publisher Murray, who is, of course, the only one surveyed that is still in business today. But the question was answered: the poor did use their pictures.

With that point established, there was debate over what to do next. A conservative member of Parliament argued that if the gallery were moved to Kensington, the poor would have all the benefit of a walk as well as the pictures, and would probably enjoy the pictures more when they got to them. But the most extraordinary and cogent argument, one absolutely at the heart of our theme, "Art Museums and the Public Trust," came from a high court judge, Mr. Justice Coleridge: "But after all, if it were demonstrable that the pictures in their present position must absolutely perish sooner than at Kensington, I conceive that this would conclude nothing. The existence of the pictures is not the end of the collection but a means to give the people an ennobling enjoyment. If while so employed a great picture perished in the using, it could not be said that the picture had not fulfilled the best purpose of its purchase or that it had been lost in its results to the nation."[11] This is an extraordinary idea, a picture perishing in the public service in the smog of Trafalgar Square, and Parliament deciding they should stay there to serve their purpose of the public's ennobling enjoyment. The National Gallery therefore had to find a method through science for keeping the pictures safe.[12]

The nineteenth-century debate became most critical in the Second World War. In 1939, when it was certain that war was imminent and there would be heavy bombing of Central London, the trustees of the National Gallery had to decide what to do with the collection. It was decided that the whole collection should be evacuated, sent to Wales with the intention of

being shipped to Canada. Then in June 1940, as the collection was waiting to go to Canada, and in the middle of the Battle of France, Churchill found time to send an astonishing telegram to Kenneth Clark, the director of the gallery. On no account were the pictures to leave the country. "Bury them in caves or in cellars," he said, "but not a picture shall leave these islands" (even his telegrams were Churchillian). The pictures were put into slate mines in Wales. But two years later the public began to complain. There were concerts in the National Gallery every day. There were exhibitions of contemporary art, but there were no Old Master paintings. On 2 January 1942 there was a letter in the *Times*. "Because London's face is scarred and bruised these days, we need more than ever to see beautiful things. Like many another one hungry for aesthetic refreshment, I would welcome the opportunity of seeing a few of the hundreds of the nation's masterpieces now stored in a safe place. Would the trustees of the National Gallery consider whether it were not wise and well to risk one picture for exhibition each week? Arrangements could be made to transfer it quickly to a strong room in case of a bomb alert. Music lovers are not denied their Beethoven, but picture lovers are denied their Rembrandts just at a time when such beauty is most potent for good. I know the risk, but I believe it would be worth it."

The trustees' debate that followed was probably the most serious they ever had on the topic. They eventually decided that one picture a month should come to London and hang as the only Old Master picture in the National Gallery. When there was a bomb alert, it would go down to the basement, to be brought up again at the all-clear. Kenneth Clark began finding out what the public wanted, and he was astonished. He thought they were going to want pictures that would show the power of the human spirit, the achievement of man—a Renaissance portrait, for example. He was prepared to consider they might want something Dutch, which would be domestically reassuring. (You can almost hear the curl of the lip in the letters when he talks of Dutch paintings.) Then he wrote to the National Gallery staff in Wales who were looking after the pictures in the slate mines and said that the picture the public wanted most of all was Titian's *Noli Me Tangere* (fig. 2).

What is it about this picture that made the gallery's public want to see it most in January 1942, during the worst moment of the war in London, when the city was subject to nightly bomb attacks, when the whole of the Continent was occupied by Germany, and the British Empire in the Far East had just been lost with the taking of Singapore? Almost certainly it was not the historical or physical truths of the picture that really mattered, but its poetic truth, which is of course what matters most in all great art. In the story from the gospel of John, Mary Magdalene has come to the tomb with her ointment to anoint the body of Christ, who had been taken down from the cross and buried hurriedly in a borrowed tomb because of the requisite preparation for the Sabbath. Having lived through the body, having loved with the body as the former prostitute, she comes to care for the body of Christ. She finds the tomb disturbed. The body has disappeared. An angel confirms that Christ has gone. Saddened, she wanders in the garden and meets a man she mistakes for a gardener. She tells him that someone has taken Christ her Lord away and she knows not where they have laid him. The man turns around and, of course, he is Christ. In Titian's painting we witness the encounter between the living and the dead. As the Magdalene reaches out to touch Christ and he draws away, he leans over and blesses her. It is an investigation of what happens to physical love after death, of how physical love and spiritual love meet or don't meet, but can be reconciled.

We can speak confidently of Titian's intentions in *Noli Me Tangere*. The ground on which the Magdalene kneels is barren and brown, the ground on which Christ stands is green with new life. The tree goes from the barren ground into green life (of course, it was meant to be green all the way up, and you can see why that mattered so much). X-rays reveal that Titian switched the picture's background to emphasize the symbolic content of the picture's landscape: the fortified town was moved from the left-hand side to the right, behind the Magdalene, to show her coming from the security of the world, while the realm of Christ is new, the ultramarine blue of the sky of Heaven. Further, Titian chose to portray the moment in the gospel that reveals Christ as the Great Shepherd. Christ turns to the Magdalene and says, "Mary," and she recognizes him, just as ten chapters

earlier Christ had said that he is the shepherd who knows his sheep by name and calleth them by name. This must be the moment shown here: Christ in the garden after death as he was in life, the Good Shepherd. It is surely the deepest investigation in Western painting of a love that survives death, that is transformed but not destroyed by it. It is an incomparable meditation on love continuing without physical contact, without physical proximity, as Christ protects, blesses, and loves without allowing physical touch.

What did this picture mean in 1942, in the middle of that dark, harrowing time? I think it was similar to our experience before Masaccio's *Crucifixion* that September 11. We can only guess, but I think what it meant to the war-torn Londoners must have been close to the central poetic truth that Titian was originally trying to express—the reassurance of a love so strong that it can survive death—but in a way Titian could never have imagined. And this surely is what lies at the foundation of the National Gallery and of every public collection like it: the principle that these pictures exist to enable the public to explore through them their own personal and shared experience, as generations have done before us and will do in the future. We who are charged with keeping such pictures are obliged to deepen our visitors' access to them, to encourage their investigations of the many truths of these paintings—historical, physical, *and* poetic.

I conclude with a letter I received recently from a visitor that, I think, makes clear that this is indeed happening in our collections today:

A couple of weeks ago, I attended a lunchtime lecture by Ivan Gaskell and have bought and have since read his book, *Vermeer's Wager*. As an ordinary visitor to the Gallery, I was fascinated to learn something of the complexities of curating and gallery management. And I shall come to the refurbishment of the Sainsbury Wing with eyes newly opened. Mr. Gaskell talks about the therapeutics of museums, that museum scholarship should be action in the world. He doesn't discuss the possibility of the development of a sense or experience of community

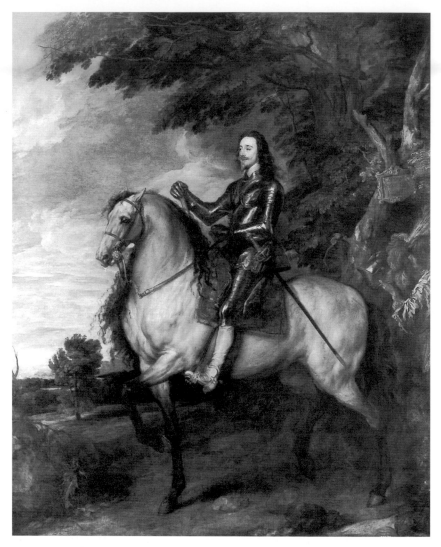

FIG. 5 Anthony Van Dyck (1599–1641), *Charles I on Horseback*, c. 1637–38. Oil on canvas, 144½ x 115 in. (367 x 292.1 cm). National Gallery, London

in a museum, and this is something that I am beginning to realize is not fanciful but a tangible aspect of the National Gallery. Maybe I should say that I'm not thinking of a single, narrow view of this concept, a Friends organization for example, which can often be unpleasantly exclusive, but of a variety of Gallery audiences whose experience of belonging in one way or another to the institution and to each other, staff and public together, overlaps, and is real and beneficial.... The National Gallery enables people to feel in one way or another that the collection is for them, and that they belong there. It's a place where ordinary people and rich patrons alike can touch base and feel they are part of a lively, learning community, a place where they can know that they are not alone.

That last phrase is extraordinary. That is one of the key obligations on museum directors. It is what pulls together the ambition of Eastlake— that people should be informed as to what the pictures are, and how, when, and why they were made. Above all, it confirms Peel's view that the purpose of the Gallery is to cement a union between the richer and the poorer orders of the state. They can know they are not alone.

When all the National Gallery's pictures came back to Trafalgar Square in 1945, Louis MacNeice wrote a celebratory poem. One of the first pictures to return was *Charles I on Horseback* by Van Dyck (fig. 5). The poem begins, "The kings are out of the caves and back in the Gallery." It finishes by saying that pictures like this can speak to so many people on so many levels—academic, personal, emotional—that what they can achieve and should achieve is a "Pentecost in Trafalgar Square." That is, I believe, precisely what those of us who hold collections like this owe the public trust: to enable the pictures to speak in as many tongues as possible, to as many people as possible, now and in the future.

NOTES

1. For an account of the Royal Collection, see Christopher Lloyd, *The Paintings in the Royal Collection* (London: The Royal Collection, 1999).

2. For a brief history of the National Gallery, as well as illustrations of paintings in the collection, including those referred to in this essay, see Christopher Baker and Tom Henry, *The National Gallery: Complete Illustrated Catalogue* (London: National Gallery Publications, 1995).

3. See Martin Davies, *The Earlier Italian Schools, National Gallery Catalogues* (London: National Gallery Publications, 1951, rev. 1961), 386–89.

4. On the Berlin National Gallery, see Françoise Forster-Hahn, "Shrine of Art or Signature of a New Nation?" in Gwendolyn Wright, *The Formation of National Collections of Art and Archaeology, Studies in the History of Art* 47 (Washington, D.C.: National Gallery of Art, 1996), 79–100, and Thomas W. Gaehtgens, "The Museum Island in Berlin," in ibid., 53–78.

5. See Cecil Gould, *The Sixteenth-Century Italian Schools, National Gallery Catalogues* (London: National Gallery Publications, 1975), 275–78.

6. Gabriele Finaldi, *The Image of Christ* (London: National Gallery Company, 2000), 168–75.

7. See Cecil Gould, *The Sixteenth-Century Italian Schools, National Gallery Catalogues* (London: National Gallery Publications, 1975), 324–26, and Nicholas Penny, Ashok Roy, and Marika Spring, "Veronese's Paintings in the National Gallery, Technique and Materials: Part II," *National Gallery Technical Bulletin* 17 (1996): 43–45.

8. See Davies, *The Earlier Italian Schools*, 173–76. The history of the reconstruction of the altarpiece appears in Martin Davies, *The Early Italian Schools before 1400*, rev. by Dillian Gordon (London: National Gallery Publications, 1988), 19–22.

9. See Davies, *The Earlier Italian Schools*, 414–49.

10. Ibid., 347–51.

11. *Parliamentary Report. Site Commission on the National Gallery,* 1857 (Annexes).

12. See David Saunders, "Pollution and the National Gallery," *National Gallery Technical Bulletin* 21 (2000): 77–94.

The Object of Art Museums

James Cuno

DIRECTOR, COURTAULD INSTITUTE OF ART, LONDON

FORMER DIRECTOR, HARVARD UNIVERSITY

ART MUSEUMS, CAMBRIDGE, MASSACHUSETTS

WE HAVE ALL heard stories of people going to museums in the days following September 11, just to be there, quietly, safe in the company of things that are beautiful and impossibly fragile, yet that have lasted for centuries through war and tumult to lay claim still on our imaginations. I was reminded of Neil MacGregor's story of London's National Gallery during the Blitz. As German fire bombs and rockets rained down upon the city, the people of London called for Old Master pictures to be put back on view (they had been kept in safe storage deep in Wales ever since the start of the war). And they were: one painting at a time, a different painting each month. It was as if the gallery's visitors were saying that as long as their artistic legacy was on view for them to enjoy (even if only one painting at a time) they could be assured that life would go on as before and that they still had the right to see—indeed still had the *capacity for,* however dark the days and long the nights were—beauty in the world, *their* world, a just and purposeful world.

In a recent book, Elaine Scarry writes of beauty as leading to justice by soliciting in us the desire to care for that beautiful object—and then through a lateral distribution of caring, to protect all such objects; and of

course not only objects, but all living things too—flowers, butterflies, people. The opposite of beauty in Scarry's terms is not ugliness, but injury, harm, endangerment.[1]

I like to think that by providing and preserving examples of beauty, museums foster a greater sense of caring in the world and urge their visitors to undergo a radical decentering before the work of art. That is, quoting the French mystical philosopher Simone Weil, at the moment we see something beautiful, we "give up our imaginary position as the center. . . . A transformation then takes place at the very roots of our sensibility, in our immediate reception of sense impressions and psychological impressions."[2] The English moral philosopher Iris Murdoch said something similar when she wrote that "anything which alters consciousness in the direction of unselfishness, objectivity and realism is to be connected with virtue."[3] To experience beauty is, therefore, to experience an "unselfing," and all the energy we formerly put into the service of protecting, guarding, and advancing the self is then free to be in the service of something else.

We have all had the experience before ancient objects—four-thousand-year-old Neolithic Chinese pots, for example—of a sudden jolt of recognition that people who lived so long ago and so far away, and in ways so utterly different than ours, cared equally as we about beautiful things, and looked upon these pots as we look upon them now: in wonder and with a desire to hold and preserve them forever. A stem cup, with its deep, burnished black surface, eggshell-thin wall, and hollow stem with openwork decoration is of the greatest rarity and most profound beauty; so is a white clay zoomorphic ewer with its pinched spout, twisted rope handle, and crimped band decoration. They are at once beautiful things and reminders that beauty was present long before us and that we are but stewards of that beauty, ushering the past into the future for others to experience as we experience it now.

The nineteenth-century poet and critic Matthew Arnold described criticism as the effort "to see the object as in itself it really is," to which the literary critic Lionel Trilling replied:

The object, whether it be a phenomenon of nature, or a work of art, or an idea or a system of ideas, or a social problem, or, indeed, a person, is not to be seen as it, or he or she, appears to our habitual thought, to our predilections and prejudices, to our casual or hasty inspection, but as it really is *in itself*, in its own terms, in these alone. Objectivity, we might say, is the respect we give to the object as object, as it exists apart from us.... Eventually we will probably, and properly, see the object in more terms than its own.... This way of seeing the object, as something we move toward or away from, even as something we wish to destroy, is not precluded by the ideal of objectivity, which requires only that, before the personal response is given, the effort to see the object as in itself it really is, be well and truly made.... In the face of the certainty that the effort of objectivity will fall short of what it aims at, those who undertake to make the effort do so out of something like a sense of intellectual honor and out of the faith that in the practical life, which includes the moral life, some good must follow from even the relative success of the endeavor.[4]

We in museums offer our visitors the opportunity to make this effort, to stop before works of art such as a Northern Song conical bowl of the eleventh century or exceptionally beautiful glazed Qingbai porcelain bowls of the twelfth century, and be absolutely arrested by them, to experience them as being outside ourselves, as they really are *in themselves*—an experience that holds promise of decentering us at a radical moment of unselfing, encouraging us to endeavor to respond objectively to these works of art, these centuries-old Chinese pots, and to experience them as beautiful and to experience beauty as leading to caring, even to justice.

I will focus my discussion on the "object of the art museum," a reference at once the things art museums collect, preserve, and present—art objects, works of art—and as the purpose of art museums. Philosophically speaking, an object is a thing external to the mind or perceiving subject. It

is also an obstacle, a hindrance, as in the verb *to object*, meaning to interrupt or propose changing direction. I want us to consider objects in museums—and the object of museums—as things that exist outside of us, in themselves, and resist the commonplace; that have us leaving, as the poet Peter Sacks says, "at a different angle" to that in which we came, changed somewhat from who we were, or thought we were, before we experienced them. Objects as resources, as the means by which we are re-*sourced*, re-oriented, and renewed.

I want to focus on the object because while museums do many things—like provide their visitors relative safety, a sense of place, distractions from everything else that is going on in their lives, a place to meet their friends and make new ones, to buy, eat, and drink things, hear concerts and lectures, and to feel empowered as they recognize that museums are here for them and work on their behalf without regard to their age, race, ethnic origin, religion, or sexual identity—nothing museums do is more important than adding to our nation's cultural legacy and providing visitors access to it, if only, as in the National Gallery during the Blitz, one object at a time.

Acquiring, preserving, and providing access to works of art is the basis for an art museum's contract with the public and the foundation of the trust that authorizes that contract. I do not mean simply physical access to the object, although that's very important; I also mean access to knowledge about and a deeper appreciation of the object. The museum is not just a treasure house, it is also a center of a very special kind of research and education. Its mode of research and teaching does not duplicate that which is conducted in schools, colleges, and universities, where the study consists of text- or image-based activities. In the art museum, research and teaching are object-based: prompted by the object, engaged with the object, and offered up by the particular way objects are experienced in space as physical things made of matter of a certain size and scale, worked in a certain way, and presented under certain circumstances, whether they be those of the gallery or the study room.

For these reasons, I want to reflect on the experience of engaging with works of art, especially in their most fundamental sense—as objects,

manufactured things making claims on our close and sustained attention. This is not always easy with museums, especially in this age of extraordinary attendance. We have all had the experience of crowds in special exhibitions, where we've had to sneak quick glances over people's shoulders at the objects put temporarily on view. But it is difficult to engage with art in our permanent collection galleries too, because of the combination of things that were never intended to be seen together or in the way we show them.

The French poet Paul Valéry reminds us of this in his 1925 essay "The Problem of Museums":

> I make my way into a room of sculpture where a cold confusion reigns. A dazzling bust appears between the legs of a bronze athlete. Between repose and vehemence, between silliness, smiles, constrictions, and the most precarious states of equilibrium, the total impression is something quite intolerable. I am lost in a turmoil of frozen beings, each of which demands, all in vain, the abolition of the others—not to speak of the chaos of sizes without a common scale of measurement, the inexplicable mixture of dwarfs and giants, nor even of the foreshortening of evolution presented to us by such an assemblage of the complete and the unfinished, the mutilated and the restored . . . the eye, within the angle of its sweep, and at an instantaneous glance, is compelled to take in a portrait and a seascape, a study of food, and a triumph, along with views of people in the most varying states and sizes; and it must also accept mutually incompatible color harmonies and styles of painting, all in the same look.[5]

Valéry is staggered and repelled by the accumulation of different things on view in a museum, and so might we be. The finer the works of art are, "the more exceptional as landmarks of human endeavor, the more distinct must they necessarily be. They are rarities whose creators wanted each one to be unique."[6]

How can we answer Valéry's charge that museums kill the very qualities of a work of art that makes it the extraordinary achievement that it is? We in museums live by juxtapositions, this object next to that one, the two richer for the comparison they offer. But how do we get our visitors to slow down and look closely, to consider the individual object on its own terms, independent of the others on view in the same gallery? Philip Fisher asks a similar question when he notes that what is on view in museums is not the work of art but the relations between works of art, what they have in common and what "in their sharpest way clashes in their juxtaposition."[7] We want to focus our visitors' attention, even to arrest it. But so much interferes with our best intentions: the museum as a tourist destination and an economic engine crowded with visitors, and the museum as a collection of multiple things acquired for the most part by chance. The museum as historian—and most of us who work in museums were trained as historians—wants to connect the dots, to make sense of the things it has as a collection and not as an accumulation of discrete things. The critic or connoisseur attends to the individual object; the historian seeks to explain a pattern of relationships between objects. At best, the museum wants to do both, simultaneously.

I don't have a very sophisticated response to this confused state of affairs, except to have us consider the different conditions of our temporary exhibitions and permanent collection installations. Temporary exhibitions emphasize the narrative experience of museums—this artist's career developed this way, this school of art looked like that, all of this was produced in one place at one time under the patronage of this or that king or pope, and so on and so forth—while permanent collection installations emphasize the experience of objects one at a time, first this then that, but not necessarily this in terms of that. Indeed, typically we enter permanent collection galleries with the general confidence that the objects on view have been grouped there for some obvious reason: perhaps they were all made by the same culture at about the same time, or perhaps they are all paintings. We don't have to test the curator's thesis for the particular installation; it is made by the individual works of art, one at a time.

Elsewhere I have addressed our art museums' reliance on tempo-
rary exhibitions and on the way they hype the museum experience and
emphasize the fleeting over the permanent and the experience of the
museum as a destination over the experience of works of art.[8] Thomas
Krens, the director of the Guggenheim Museum, has codified the success-
ful twenty-first century museum experience as "great collections, great
architecture, a great special exhibition, a great second exhibition, two shop-
ping opportunities, two eating opportunities, a high-tech interface via the
Internet, and economies of scale via a global network."[9] I offer an alterna
tive museum experience: the permanent collection and the opportunity it
affords for sustained and repeated engagements with individual works of
art, presented without the hyperbolic promotional apparatus of the tempo-
rary exhibition. In this case, the permanent collection one object at a time:
nine objects, in fact, considered objectively, for themselves, as objects in
themselves.

The first is a controlled mudslide, worked and modeled quickly with
tools and fingers pressing in and directing the apparent flow of clay into
enveloping folds suggesting cloth drapery (figs. 1 and 2). Behind the figure's
right shoulder, where the implied feathers meet cloth and skin, we see
fingernail impressions, evidence of the maker of the object, of its being
made by hand in time and place. We think we know the place (Rome) and
time (1673 or 1674) when the great Baroque sculptor, Gian Lorenzo Bernini
made this. We even think we know the source of the muddy clay itself: the
Monte Vaticano in Rome, an area just above the Tiber and east of the Vati-
can, famous at the time as the Valle dell'Inferno. The transformation of
this hell-sourced clay into a *bozzetto*, or sketch, for what would ultimately
become a bronze kneeling angel for the altar of the Blessed Sacrament in
Saint Peter's Basilica is part of the *magic* no less than the *history* of this
particular object.

Two years ago, staff of the Fogg Museum's Department of Painting,
Sculpture, and Decorative Art and the Straus Center for Conservation and
Technical Studies examined all of Bernini's *bozzetti* and *modelli* in the Fogg
(fig. 2).[10] Of concern, of course, was the question of who actually worked the
objects, whether it was the master, Bernini, or some now-forgotten member

FIG. 1 Gian Lorenzo Bernini (1598–1680), *Kneeling Angel*, c. 1674–75. Terra-cotta, height 13 in. (33.5 cm). Fogg Art Museum, Harvard University Art Museums, Cambridge, Massachusetts

FIG. 2 Gian Lorenzo Bernini, *Angel Holding the Superscription*, c. 1669. Terra-cotta, height 11⅝ in. (29.4 cm). Fogg Art Museum, Harvard University Art Museums, Cambridge, Massachusetts

of his workshop. Of greater concern, however, were the objects themselves as "traces of a purposeful activity" and "tools for use," as Ivan Gaskell, lead curator on the project, wrote in the publication. In the first instance, the objects were studied with all available means, from the human eye to a variety of scientific instruments. Objects conservator Tony Sigel observed that they were predominantly formed through additive modeling, their makers building their forms by adding clay to substructures, often shaping the clay with their fingers and sometimes the palms of their hands before further defining the shapes with oval-tipped and toothed tools.

These are not heavy objects. They can be held easily in our hands. Their size, scale, immediacy of effect, and familiar material invite our touch: we want to hold them, to press our fingers into their hollows, to match our fingerprints with those of their maker. Their haptic appeal calls upon

our early memories of our own hands working with clay, when we felt the slight resistance of the cool, wet matter as we pushed our hands through it, squeezed it, felt it slide through our fingers, making that familiar schlooping sound as pockets of air were released from the sucking backdraw of the clay.

Yet as we look at these objects, we imagine we feel the wind rippling through their hair and drapery, and we are reminded that despite their earthbound material, they are intended to represent heavenly beings with wings, figures that don't so much kneel as hover in the magical wind of Transubstantiation that emanates from the altar on which the Eucharistic elements of bread and wine are converted into the body and blood of Christ. These objects are not what they appear to be. They are but early stages in the development of larger sculptures and are fragments of a more complex ensemble of figures. In their clay forms, we read them as discrete works; we know they were but tools for use, yet we experience and value them as complete unto themselves. Their ultimate purpose may be suggested by their wings and rippling drapery, but that is made known to us only after further inquiries, external to the experience of them as discrete objects. They are objects first, commanding our attention as they are presented so matter-of-factly in a first-floor gallery of the Fogg Museum.

Now, consider another object made of clay: a fragment from the body of an Attic black-figure *dinos* or big, rotond, wide-mouthed bowl (fig. 3). It is attributed to the painter Sophilos, the first Athenian vase painter to have signed his work, and dated to the second quarter of the sixth century B.C. This fragment came from a bowl like the one now in the British Museum.[11] Although its particular decoration is more reminiscent of the stand on which the British Museum bowl rests, the fragment comes from the widest part of the bowl's body and shows parts of four registers of animals: the second from the top (the most visible one) includes the hind quarters of a boar, a panther, and a water bird, while the next one down includes a siren and probably a lion or another panther. We aren't sure of the meaning of such groupings of animals and mythological creatures. They sometimes accompanied narrative scenes, as in the top register of the British Museum *dinos*, but they were also left to themselves on Corinthian

FIG. 3 Sophilos, fragment from a *dinos*, c. 570 B.C. Terra-cotta, 7⅛ in. (18.2 cm).
Arthur M. Sackler Museum, Harvard University Art Museums, Cambridge,
Massachusetts

vases; a never-ending parade of animals and creatures circling the body of
the vase, tier upon tier, each group kept separate from the next.

A fragment from another vase, this one Etruscan (fig. 4), is from the
part of the vase that curves up onto the shoulder. Dating to the last quarter
of the sixth century B.C. it has been attributed to the Etruscan artist known
as the Micali Painter. The fragment shows an open-mouthed, teeth-bared,
ferociously roaring lion. We needn't see more of this animal to know just
how fierce he is, as he lunges, thrusting his neck out, perhaps in pursuit of
another beast. The hint of a raised foreleg along the bottom right edge of the
fragment and the razor-sharp etched lines of his mane suggests a mad, even
ravenous pursuit, round and round the vase, never tiring, never stopping.

Unlike the Bernini *bozzetti*, the clay of these vase fragments is fine—
especially fine in the case of the Attic vase. The finer Greek clays took on
a natural luster when rubbed (as can be seen by turning the fragment over
to inspect what would have been the unpainted inside of the pot), and then
were further enhanced in preparation for painting by the application of
a red ocher substance called *miltos*. By contrast, the Etruscan clays, coming
from Tuscany, were coarser but, prepared as they were for painting, still

FIG. 4 Micali Painter, fragment from an amphora, c. 530–520 B.C. Terra-cotta,
3⅞ in. (9.9 cm). Arthur M. Sackler Museum, Harvard University Art Museums,
Cambridge, Massachusetts

finer than the Roman clays of the *bozzetti*. The fact that these vase pieces
are fragments, no larger than a coin or the lid of a small jar, means that
we can easily hold them in our hand and feel the character of their sur-
faces, and then turn them over to compare the quality of the painted and
unpainted surfaces, and marvel at the thinness of their walls, in each case
no more than a few millimeters thick.

We can also compare the painting method and style of an Attic black-
figure cup from the sixth century B.C., perhaps by the Amasis Painter (fig. 5),
with that of an Attic red-figure cup of the fifth century B.C., perhaps by the
Brygos Painter (fig. 6). The Amasis Painter, in painting a figure who might
be Dionysus, used two different colored slips one red and one black, to make
his form, and then rather simply but surely etched out the details of eye,
eyebrow, hairline, petal profiles, ear, beard, neckline, shoulder, and drapery
folds. The Brygos Painter worked in the opposite direction, applying thin
lines of black slip on a red ground to mark the contours of his figure's drap-
ery folds. When you hold this fragment in your hand and turn it into a
raking light, you can see the black contours as ridges of slip in relief of the
red ground and the diluted lines that served the painter as his initial sketch.

FIG. 5 Amasis Painter, fragment from a cup, c. 540 B.C. Terra-cotta, height 2³⁄₁₆ in. (5.5 cm). Arthur M. Sackler Museum, Harvard University Art Museums, Cambridge, Massachusetts

Fragments offer a pleasure that can't typically be had from the whole vase or cup: you can hold them in your hands, feel their weight and surfaces, turn them over and over, and bring them to your eye for close examination. The British scholar of Greek vases, John Beazley, noted some seventy years ago that "a collection of fine fragments gives a good view of the development of the vase painter's art, and draws the eye to beauties of detail that might escape notice." And "work on fragments exercises this sense [of distinguishing between styles] and develops it."[12] Fragments are indeed aids to the development of connoisseurship in the study of Greek or Etruscan vase painting, just as they are aids in the study of the technology of vase making itself. But they are also a means of considering the relationship of the part to the whole.

Each of these fragments and the earlier two were once part of vases or cups. The figure on the Amasis fragment might have been part of a cup like the one by the Amasis Painter at the Metropolitan Museum, also datable to the middle of the sixth century B.C. The Metropolitan's cup is ringed by figures and animals representing the divine stables of Poseidon: large men groom and calm their horses as devilish imps play and taunt them.

FIG. 6 Brygos Painter, fragment from a cup, c. 480 B.C. Terra-cotta, height 1½ in. (3.9 cm). Arthur M. Sackler Museum, Harvard University Art Museums, Cambridge, Massachusetts

More typical on cups by Amasis were depictions of Dionysus supervising the vintage. Harvard's likely Dionysus was probably on such a cup, and we can imagine lifting it to our lips as we drink, bringing the broad figure band into view for our companions to see the amiable satyrs stomping the grapes to make the wine while mortals dance before and after them.

Similarly, the Brygos fragment was probably from a drinking cup. We can't know the original scene, but we are delighted by the beauty of the flowing drapery and intrigued by the hint of perhaps an eye in the upper right corner. Might it be from a scene following a battle, with a helmeted figure falling against the folds of his lover? We can't know, and we needn't. The beauty of a fragment, like the literary fragment of the German Romantics, is that it is at once part of something else, something larger, and is complete in itself, even in its partial form. In this respect, we might think of its being to the complete object as poetry is to prose. And we might describe the fragment, like poetry, as a condensed, intensified pattern, whose intensity is necessarily accompanied by the pleasure of release from the condensed to the expansive, as when reading a poem and suddenly seeing it—getting the point of it, grasping, if only for a moment, its larger meaning.

In "What Poetry Is About," Cynthia Ozick writes that "poetry is intelligibility heightened, strengthened, distilled to the point of astounding us." And whatever its subject, however small, whatever it is about—"a bat, a plum, a jar, a wind, a sigh, a thigh: whatever is thought or sought or caught or wrought . . . *poetry* is about what is eternal, and *therefore* about the fracture in time that is a single moment."[13]

Greek vase fragments are fractures in time, single moments of larger scenarios, whether of the complete decoration of a particular pot, or the development of red- and black-figure painting, or the role pots played in ancient domestic life, or the complex history of the making and economy of vases and cups that saw them manufactured in astounding numbers for import around the Mediterranean, but especially to the Tyrrehenian coast of Italy for the voracious consumers of the ancient Etruscan towns. But we can experience them as fractures only—until, that is, we are released from the hold of their condensed and intensified beauty.

In the same essay, Ozick compares poetry to pots. She describes pots as utilitarian, "intimate companions of humankind since humankind evolved." And yet they are almost never just utilitarian. "Utility did not contemplate imaginative departures and additions of form, it did not envision the fanciful shapes of animals or birds; and utility did not demand decorative design, coarser in one culture, more brilliantly complex in another. The drive to mark the most ordinary articles with the impress of art was and is humanly universal and appears to be humanly innate. Always and everywhere, art attaches itself to the utilitarian."[14] And when it does, such pots are much closer to poetry than to ordinary, functional, concave utilitarian objects.

We shouldn't be surprised to learn that when Greek vase or cup painters signed their pots, they often added the word *epoiesen* to mean "I made this." Nor should we be surprised to learn that the root of the word *poetry*, in the form of poesy, is the Greek word *poesis*, meaning "making." Poems, like pots, are made. Literary scholar Helen Vendler, citing Auden, often calls them "verbal contraptions," or "contraptions" made of words, by which she means not just "the semantic units we call 'words' but all the language games in which words can participate."[15] I hope, as we consider

the contributions museums make in our lives, we can focus our attention on works of visual art as *made* too, as visual contraptions made of lines, shapes, colors, and all of the visual games in which works of art can participate. By presenting works of art, museums give us regular access to the beautiful, made, compelling thing.

Let us continue with some more fragments, in this case painted studies by the early-nineteenth-century French painter Jean-Auguste-Dominique Ingres for his mural-sized painting, *The Martyrdom of Saint Symphorien*, commissioned from the artist for the cathedral at Autun in 1824 and completed in 1834 (figs. 7–9).[16] These studies date from 1833, when Ingres resumed work on the project after the Revolution of 1830, and represent a mature stage in the development of the painting; one was preceded by thirteen preparatory drawings.[17] The subject of the painting, Saint Symphorien, depicted in the study (as in the painting) is at lower right of center with his arms outstretched. He was a local saint, a second-century martyr who refused to sacrifice to a pagan god. His resigned, peaceful, upward glance meets his mother's cry as she thrusts herself over the ramparts and points with her left hand to the heavenly source of her son's steadfast faith.

Of special interest is the relation of the figure studies to the final composition. While we can match up most of the figures one to one, they are not aligned on the left as they will be in the final painting: the mounted figure, for example, is to the right of Saint Symphorien in the study and to the left in the painting. In the second study (fig. 8), he is repeated and placed just above two figures who in the final painting are separated by groups of other figures. Similarly, Ingres repeats figures such as the saint's haloed father in the lower right and upper left of the study in figure 7; and the lictor in figure 8, whose stance is taken by the mustached figure but whose face is displaced to the figure in the upper center.

Thus, while these are studies for a finished painting, they are not studies in the conventional sense of the term: individual figure studies or compositional variants. They could more accurately be described as an accumulation of fragments, a collection of parts of painted studies of individual figures or groups of figures, put together—and this is the most interesting part—as if to make of each canvas a finished painting in and of itself.

FIG. 7 Jean-Auguste-Dominique Ingres (1780–1867), *Studies for "The Martyrdom of Saint Symphorien,"* 1833. Oil paint over graphite on canvas, 23⅝ x 18¾ in. (60 x 47.6 cm). Fogg Art Museum, Harvard University Art Museums, Cambridge, Massachusetts

FIG. 8 Jean-Auguste-Dominique Ingres, *Studies for "The Martyrdom of Saint Symphorien,"* 1833. Oil paint over graphite on canvas, 23¾ x 19⁷⁄₁₆ in. (60.3 x 49.3 cm). Fogg Art Museum, Harvard University Art Museums, Cambridge, Massachusetts

That is, Ingres composed each of these studies in terms of the rectangular field of its own canvas and not in terms of the finished Saint Symphorien painting.

The composition of the first group of studies (fig. 7) is ordered along dramatic crossed diagonals: from upper left to lower right, from mother to son, and from grieved attendant to haloed father; and then from lower left to upper right, along the outer contour of the right thigh at the center, from muscular right lower leg to raised right lower arm, and from one bearded nude man to another. The composition is then centered by the rotation of arms and hands counter-clockwise from the mother's outstretched left hand, down along her right arm and her son's raised right arm, and back up his left arm to the outstretched hand of the mounted figure. Near the center of this rotation is the isolated right hand, like the spoke point of a wheel, which functions similarly in the upper left group in the finished painting. The second group of studies (fig. 8) is composed along converging diagonals: down the centurion's right arm and up the lictor's right leg

FIG. 9 Jean-Auguste-Dominique Ingres, *The Martyrdom of Saint Symphorien*,
1834. Oil on canvas. Cathedral of Autun, France

and back across the latter's right arm and alignment of heads, from right
to left. At the center of this composition is also a rotation of hands and
arms, with again a right hand at its spoke point.

Each composition is then further animated—as if to make the point
that it is a collection of fragments—by discrete isolated bits that echo across
their respective canvases: the small charcoal study of toes and the more

complete painted version just above it in the lower right of the second study echo the right foot of the leftmost figure; just as the charcoal study of the saint's left eye near the top edge of the first example echoes the painted version in the lower right of center. By drawing our attention to these fragments, Ingres is, of course, emphasizing composition—the order and balance of a painting, the act of drawing it together and making it whole by arranging its parts according to the alignment of the pictorial field. This was not missed by the critics of the finished painting when it was shown in Paris in the Salon of 1834. One critic wrote negatively of the full composition, he praised its parts: "here and there are fragments of which only [Ingres] is capable ... many figures would gain by being cut out and separately framed."[18] And when in the artist's memorial exhibition of 1867 these two studies were exhibited for the first time, Théophile Gautier wrote: "One stands stupified before these ... masterpieces ... we cannot [but recall our] impression [from the museum] in Athens ... of reunited fragments of broken statues found in the ruins."[19]

Paintings *are* made of parts. They *are* visual contraptions. But at their best they are always more—even when they are only a collection of fragments unintended for public display. They are resonant with meaning, as in the first group of studies the idea of peace through faith is set against the many gestures of terror, confusion, and despair; in the second, the searing glance of hatred, anonymous and futile, is seen on the face of the crouching stone thrower in the center of the composition. We have seen these images too many times, on the streets of Jerusalem, Islamabad, Kabul, and, recently, Lower Manhattan. They are as meaningful now as they were in the years following the Revolution of 1830 or in the riotous waning decades of the Roman Empire. Strange and compulsive as he was, Ingres was not able to put brush to canvas, or drawing implement to paper, without returning to his earlier compositions, over and over again. In a drawing of 1858 in the Fogg Museum, Ingres redrew his 1834 composition as if to answer his critics who judged the original commissioned painting lacking and who forced him "to endure the shafts of envy, intrigue, ignorance and bad faith."[20] Over the years Ingres often saw himself as a martyr to his cause. He might have envied Saint Symphorien, who was

FIG. 10 Paul Cézanne (1839–1906), *Plaster Cast of a Putto*, c. 1894–95. Oil on canvas, 17½ x 12⅛ in. (44.5 x 30.8 cm). Fogg Art Museum, Harvard University Art Museums, Cambridge, Massachusetts

prepared to leave life in peace and triumph, while Ingres reworked his life over and over, explaining in 1859, just seven years before his death: "Should . . . an artist hope to leave a name for posterity, then he could never do enough to render his works more beautiful or less imperfect."

Now let us turn to one last painting, which might be described as a fragment of a fragment, or even a fragment within a fragment (fig. 10). This picture by Cézanne appears at first to be an unfinished painting depicting a plaster cast of an armless *amour*, or *Putto*. On closer examination, we can read the unpainted right half of the canvas as a sun-washed wall. The unpainted bits on the left wall and on the statuette's belly, legs, and the tree-trunk support between its legs can also read as sun-washed. This leaves the picture's painted area to be read as the shadowed studio corner

FIG. 11 Paul Cézanne, *Still Life with Plaster Cast of Cupid*, c. 1894.
Oil on paper laid on board, mounted on wood, 27¾ x 22⁹⁄₁₆ in.
(70.6 x 57.3 cm). The Courtauld Institute, London; Courtauld bequest

from which, out of the glare of the sun, we see the statuette's form emerge. But the painting seems manifestly unfinished: the blue table edge in the lower right corner is only slightly sketched in, and there are errant brush marks in the unpainted area near the right edge of the canvas. What does it mean to say that a painting is unfinished? Does it mean simply that its surface is not fully painted in, that its painted image doesn't stretch from corner to corner, that the brush strokes on its surface are not resolved but remain highly visible as distinct marks?

The question of "finish" in painting had been much debated earlier in the nineteenth century. By the time Cézanne painted this picture, the seemingly unfinished new paintings of the Impressionists had for almost two decades been generally accepted as finished and truthful to the appear-

ance and condition of modern life and the natural landscape. By the time Georges Braque painted his breakthrough proto-Cubist landscape paintings of 1907–8 (like the one, inspired by Cézanne's Estaque landscapes and acquired by the Fogg in 2001), the question of what was and what was not a finished painting was not even an issue.

Of greater interest in Cézanne's painting of an *amour* is the paint on the canvas and the subject of the painting: the statuette itself. Cézanne painted and drew this statuette many times during the last years of his life, sometimes in fully developed still-life paintings like the one from c. 1894 in the collection of the Courtauld Institute, London, where it is shown on a table with other familiar still life items—apples and onions, plate, and table cloth—and against a painted canvas leaning against other canvases in a corner of the artist's studio (fig. 11).[21]

Writers have often pointed to the ambiguity of the figure's placement in that work: it seems to be at once in front of the canvas against which it is seen, and painted on it. Less often are noted the edges of the tabletop and canvases, which have troubling alignment with the necks of the onions and the Cupid's penis, which is in line with the lower edge of the painted canvas against which the statuette is seen.

In his study, "Cézanne's Apples: An Essay on the Meaning of Still-Life," Meyer Schapiro explored the erotic implications of Cézanne's still lifes, especially those with apples. He noted that *fructus*—"fruit" in Latin, a language Cézanne knew well—retained from its source the verb *fruor*, the root of "satisfaction," "enjoyment," "delight." "Through its attractive body, beautiful in color, texture, and form, by its appeal to all the senses and promise of physical pleasure, the fruit is a natural analogue of ripe human beauty," Schapiro wrote.[22] But what of the onion, a vegetable that when cut brings tears to one's eyes?

One wonders about Cézanne's fascination with this mutilated Cupid in the last years of his life. We know that he was struggling and despairing of his work. It all seemed partial to him, incomplete and unresolved. A month before he died in 1906 at the age of sixty-seven, after a career of some four decades, he could still write in a letter to the painter Emile Bernard:

I find myself in such a state of mental distress, so greatly troubled. . . . Will I ever reach what I have so diligently searched for and what I have so long pursued?—I hope so, but as long as I haven't reached it, a vague state of malaise haunts me, and it will only disappear the day I have reached port, that is, when I see things developing better than in the past. . . . But I am old, sick, and I have sworn to die painting rather than to sink into that degrading senility which menaces most old people, who fall prey to the mind-devouring passions that destroy their reason.[23]

What preoccupied Cézanne, and not just at the end, but throughout the final decades of his life, was his inability to get the intensity of color into his paintings that he saw in nature, even when that nature was a mutilated plaster cast bathed in shades of ocher, blue, gray, green, and violet shadow. In a letter to his son just six weeks before he died, he wrote, "With me the realization of my sensations is always painful. I cannot attain the intensity that unfolds itself before my senses. I do not have the magnificent richness of coloring that animates nature."[24] This was crucial, for it was by means of color ordered through logic and harmony that Cézanne sought the realization of his sensations. As the critic Lawrence Gowing put it: "Cézanne's patches do not represent materials or facets or variants of tint. In themselves they do not represent anything. It is the relationship between them—relations of affinity and contrast, the progressions from tone to tone in a color scale, and the modulations from scale to scale—that parallel the apprehension of the world."[25]

Over and over again Cézanne emphasized the importance of color in nature and painting. "There is only one route for rendering everything, for translating everything: color. Color is biological, if I can put it that way. Color is living, all alone it breathes life into things. . . . Color is the place where our brain meets the universe."[26] And even, "colors are the sparkling flesh of ideas and of God, the transparency of mystery, the iridescence of the laws. Their opaline smile reanimates the dead face of the vanished world."[27] What would it mean, then, if he didn't have "the magnificent

richness of coloring that animates nature"?[28] He would have no means of realizing his sensations. He would be impotent before the object, unable to respond, as good as an armless statuette, a fragment of his potential, a failure in the end. His agony only grew deeper: "my age and my health will never allow me to realize the dream of art that I have pursued all my life."[29]

Cézanne died in October 1906. A year later, a retrospective of his career was held in Paris. In attendance was a young German poet, Rainer Maria Rilke, who recorded his thoughts and observations in a celebrated series of letters to his wife, Clara. In one he wrote of his struggles trying to understand Cézanne's paintings. "I spent two hours in front of a few pictures today.... One can really see all of Cézanne's pictures in two or three well-chosen examples.... I find myself advancing now. But it all takes a long, long time. When I remember the puzzlement and insecurity of one's first confrontation with his work ... and then for a long time nothing, and suddenly one has the right eyes."[30] *Suddenly one has the right eyes.* Suddenly after hours of close looking, one begins to see that the paintings are all about color and "that no one before him ever demonstrated so clearly the extent to which painting is something that takes place among the colors, and how one has to leave them alone completely, so that they can settle the matter among themselves. Their intercourse: this is the whole of painting."[31]

For Rilke, Cézanne's colors come into their own, one in response to another. And here he draws a startling comparison:

> as in the mouth of a dog various secretions will gather in antici-
> pation at the approach of various things—consenting ones
> for drawing out nutrients, and correcting ones to neutralize
> poisons: in the same way, various intensifications and dilu-
> tions take place in the core of every color, helping it to survive
> contact with others. In addition to this glandular activity within
> the intensity of colors, reflections ... play the greatest role:
> weaker local colors abandon themselves completely, content-
> ing themselves with reflecting the dominant one. In this hither

and back of mutual and manifold influence, the interior of the picture vibrates, rises and falls back into itself, and does not have a single unmoving part.[32]

And then Rilke closed his letter, having exhausted his efforts to describe accurately what he saw in Cézanne's paintings: "You see how difficult it becomes when one tries to get very close to the facts." In our case, it is the difficult approach to the facts of a painting of a nineteenth-century plaster cast of a fragmentary seventeenth-century sculpture.

Rilke's letters were not just reports on his confrontations with Cézanne's art. They were his own exercises with language. He worries, "I wondered last night whether my attempt to give you an impression of the woman in the red armchair was at all successful. I'm not sure that I even managed to describe the balance of its tonal values; words seemed more inadequate than ever, indeed inappropriate."[33] And in another case: "For a moment it seemed easier to talk about the self-portrait . . . it doesn't reach all the way through the whole wide-open palette, it seems to keep to the middle range, between yellow-red, ocher, lacquer red, and violet purple; in the jacket and hair it goes all the way to the bottom of a moist-violet brown contending against a wall of gray and pale copper. But looking closer, you discover the inner presence of light greens and juicy blues chasing the reddish tones outward."[34] How hard it is to describe Cézanne's work. No easier, it would seem—but it must be—than making it in the first place. If only we were to take Cézanne's advice, which he gave to painters in general: "There is a logic of color, damn it! The painter owes obedience to nothing else. Never to the logic of the brain; if he gives himself over to that, he is lost. Always the logic of the eyes. If he senses correctly, he will think correctly. Painting is first of all in vision. The material of our art lies there, in what our eyes think."[35]

How are we to trust our eyes? And then how are we to marshal the resources, even if they are only words, to respond accurately? This is the challenge set us, of course, not just by Cézanne's work but by all works of art. And it is a challenge we in museums feel especially, for we are charged with presenting the art before our visitors' eyes, one object at a time. So how should we do it without interfering, without coming in between the visitor and the

art? How can we direct their attention to the art with just enough assistance to help them, but with not so much that we limit their responses? We should be ever mindful of Valéry's complaint: "I am not overfond of museums. Many of them are admirable, none are delightful . . . At the first step that I take toward things of beauty, a hand relieves me of my stick, and a notice forbids me to smoke. Chilled at once by this act of authority and by the sense of constraint, I make my way into a room of sculpture where cold confusion reigns."[36]

How are we to minimize the acts of authority and how are we to reduce the confusion? There are no easy answers. But I would suggest that we could begin by clearing away some of the clutter in our museums, the many distractions we have introduced into them—the commercial, the alimentary, the promotional, the entertaining, even—to the extent that it comes between the viewer and the work of art—the educational, and by weaning ourselves of our reliance on temporary exhibitions and all of their attendant hype. We need to be more modest in our efforts, to once again regard as our most important contributions the acquisition, preservation, and presentation of research of our permanent collections. For in the end, this is what our visitors most want from us: to have access to works of art in order to change them, to alter their experience of the world, to sharpen and heighten their sensitivities to it, to make it come alive anew for them, so they can walk away at a different angle to the world.

This, I propose, is the basis of the public's trust in art museums. The public has entrusted in us the authority and responsibility to select, preserve, and provide its access to works of art that can enhance, even change, people's lives. And in turn, we have agreed to dedicate all of our resources—financial, physical, and intellectual—to this purpose. Art museums are a public trust. In the wake of the events of September 11, that still darkening cloud in which it is hard to find a silver lining, let us be reminded that we can best earn that trust simply, by remaining open as places of refuge and spiritual and cultural nourishment. In museums people can experience a sense of place and be inspired, one object at a time, to pursue the ideal of objectivity and be led from beauty to justice by a lateral distribution of caring. This is the object of art museums; perhaps even the *poetics* of art museums. If only one object at a time.

NOTES

1. Elaine Scarry, *On Beauty and Being Just* (Princeton, N.J.: Princeton University Press, 1999).
2. Ibid., III.
3. Ibid., 112.
4. Lionel Trilling, "Mind in the Modern World," in *The Moral Obligation to Be Intelligent* (New York: Farrar Straus Giroux, 2000), 496.
5. Paul Valéry, "The Problem of Museums," in *The Collected Works of Paul Valéry*, ed. Jackson Mathews, trans. David Paul, vol. 12 (New York: Pantheon Books, 1960), 202.
6. Ibid., 204.
7. Philip Fisher, *Making and Effacing Art: Modern American Art in a Culture of Museums* (Oxford: Oxford University Press, 1991), 8
8. James Cuno, "Art Museums Should Get Back to Basics," *Boston Globe,* 26 Oct. 2000, sec. A, p. 23.
9. "Hip vs. Stately: The Tao of Two Museums," *New York Times,* 20 Feb. 2000, sec. 2, p. 50.
10. Ivan Gaskell and Henry Lie, eds. *Sketches in Clay for Projects by Gian Lorenzo Bernini,* exh. cat. (Cambridge, Mass.: Harvard University Art Museums, 1997).
11. John Boardman, *The History of Greek Vases* (London: Thames and Hudson, 2001), 51, pl. 61.
12. Aaron J. Paul, *Fragments of Antiquity: Drawing upon Greek Vases,* exh. cat. (Cambridge, Mass.: Harvard University Art Museums, 1997), 10.
13. Cynthia Ozick, "What Poetry Is About," in *Quarrel and Quandary* (New York: Alfred A. Knopf, 2000), 170.
14. Ibid., 167.
15. Helen Vendler, *The Art of Shakespeare's Sonnets* (Cambridge, Mass.: Harvard University Press, 1997), II.
16. Valérie Bajou, *Monsieur Ingres* (Paris: Adam Biro, 1999), 234–45, fig. 166.
17. Marjorie B. Cohn and Susan L. Siegfried, *Works by J.-A.-D. Ingres in the Collection of the Fogg Art Museum* (Cambridge, Mass.: Fogg Art Museum, 1980), cat. no. 36.
18. Ibid., cat. no. 37.
19. Ibid.
20. Ibid., cat. no. 58.
21. *Cézanne.* Galeries Nationales du Grand Palais, exh. cat. (Paris: Réunion des Musées Nationaux, 1995), cat. no. 162.

22. Meyer Schapiro, "Cézanne's Apples: An Essay on the Meaning of Still-Life," in *Selected Papers: Modern Art, 19th and 20th Centuries* (New York: George Braziller, 1978), 5–6.

23. Paul Cézanne, letter to Émile Bernard (21 Sept. 1906), in *Conversations with Cézanne*, ed. Michael Doran (Berkeley and Los Angeles: University of California Press, 2001), 49.

24. Paul Cézanne, letter to his son, Paul (8 Sept. 1906), in *Paul Cézanne Letters*, ed. John Rewald (New York: Da Capo Press, 1995), 327.

25. Lawrence Gowing, "The Logic of Organized Sensations," in *Cézanne: The Late Work* (New York: The Museum of Modern Art, 1977), 66.

26. Joachim Gasquet, "Cézanne," *Conversations with Cézanne*, 113.

27. Ibid., 126.

28. Paul Cézanne, letter to his son, Paul (8 Sept. 1906), in *Cézanne Letters*, 327.

29. Paul Cézanne, letter to Roger Marx (23 Jan. 1905), in *Cézanne Letters*, 313.

30. Rainer Maria Rilke, *Letters on Cézanne*, ed. Clara Rilke, trans. Joel Agee (New York: Fromm, 1985), 42–43.

31. Ibid., 35.

32. Ibid., 81–82.

33. Ibid., 83.

34. Ibid.

35. Gasquet, "Cézanne," in *Conversations with Cézanne*, 120.

36. Valéry, "The Problem of Museums," 202.

Pictures, Tears, Lights, and Seats

John Walsh

DIRECTOR EMERITUS,

J. PAUL GETTY MUSEUM, LOS ANGELES

JAMES CUNO SAYS something in his essay that I want to repeat:

> In the end, this is what our visitors most want from us: to have
> access to works of art in order to change them, to alter their
> experience of the world, to sharpen and heighten their sensi-
> bilities to it, to make it come alive anew for them, so they can
> walk away at a different angle to the world.

This is the basis of the art museum's public trust, he says. For an art
museum actually to do what he describes takes it beyond being an educa-
tional institution in the conventional sense. It acknowledges the museum's
duty to the artists who made the work and its obligation to further the
audience's spiritual and intellectual growth. I agree, and I want to explore
this particular aspect of our public trust.

 In order to take full opportunity to serve the public, art museums
have chosen to do many different things. They educate their visitors, adults
and children alike, in the history of art and in other subjects that art illu-
minates vividly. They entertain them with films and food and shopping
and family fun. They boost civic awareness and help create bonds among

people who wouldn't otherwise mingle. We learned after September 11
that art museums can provide a kind of refuge and reassurance to people
disoriented by brutal, incomprehensible events.

All these functions are healthy, economically beneficial, and certainly
growing. They are also of strictly secondary importance. Functions like
these, if we were at a concert instead of a museum, would include the pro-
gram notes; the drinks and pleasant milling around at intermission; Boston's
fine foursquare Symphony Hall on Huntington Avenue, or the elegant music
shed at Tanglewood. These things make us happy and build support for the
Boston Symphony Orchestra, but nobody would confuse them with the key
function of the orchestra—music—the way they do in a museum. In an
art museum the key function, the greatest and most valuable thing it can
do, is give individual visitors a profound experience of works of art.

That experience can be like listening to a great composition beauti-
fully played. It can generate sensations that bypass the rational brain and

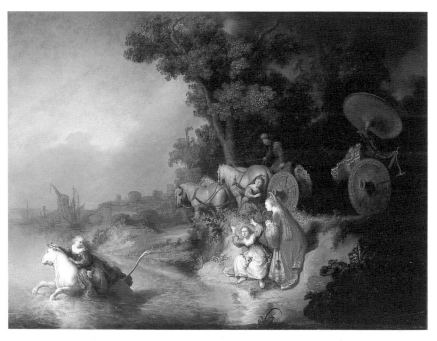

FIG. 1 Rembrandt (1606–1669), *Abduction of Europa*, 1632. Oil on panel,
24½ x 30⁵⁄₁₆ in. (62.2 x 77 cm). J. Paul Getty Museum, Los Angeles

go right to the scalp, the tear ducts, the lungs, the heart. It can penetrate our intellectual defenses. It can shake us, disorient us, and give us a stark sense of loss of what might have been for us. It can open up unexpected ways for us to think and feel, make new associations, stir new curiosities. That kind of deep experience gives people the keenest motive for learning more about works of art, but that's not its justification—if any justification were needed.

FIG. 2 Rembrandt, *Abduction of Europa*, detail

In an essay for the exhibition *Dislocations* at The Museum of Modern Art a few years ago, Robert Storr wrote, "To be moved by art is to be lifted out of one's usual circumstances and taken out of oneself, the better to look back upon the place one has departed and the limited identity one has left behind."[1] I want to address those deep experiences and how museums might make them easier to have, rather than more difficult. That is the greatest challenge for our museums beyond sheer survival, but it is the least acknowledged. The experiences I am talking about happen only in front of original works of art—no substitutes, however vivid or accurate.

Let me first demonstrate what I mean by qualities that can only be grasped by a lingering examination of the original and suggest some sensations that can only be felt doing so. I'll start on familiar territory, with an early painting by Rembrandt at the Getty Museum (fig. 1). It is small—about two and one-half feet across—and for many visitors who have a dark and brooding image of Rembrandt's work in mind, it comes as a surprise. It has the flavor of a fairy tale in miniature. A girl is riding on a white bull, and she is not pleased about it. The label tells you she is Europa, a princess who was abducted by the philandering Jupiter in disguise. Up close, she sits on a tiny sidesaddle and holds on with one hand while she digs into Jupiter's side with the other.

Closer still (fig.2), she is the picture of conflict, maybe more regret-ful than frightened as she looks back to the world she is leaving. Her pearls, gold chain, and satin dress are breathtakingly vivid. On shore, her hand-maidens—far more obviously upset but just as dazzling to look at—are reflected in the shimmering water. The astonishing gold coach is pulled by somnolent horses that don't notice what is going on. In the distance a river landscape that looks very fresh and Dutch brings the drama close to home. Though the myth was set in Palestine, it is as though it was re-enacted in Rembrandt's back yard by neighbors. It is a picture meant for close, lingering inspection, only up close can you savor the droll, lively treatment of the story, the utter wonder of the technique, and the very par-ticular characters playing the roles.

My second example is a familiar image, the *Raft of the Medusa* by Géricault of 1819 in the Louvre.[2] It is so well known, so immense, and has such competition from more accessible and less gloomy pictures in the same vast gallery, that many people just take note and move on. If you don't move on, what strikes you first is gloom. A color scheme of browns and yellows and coppery greens. A morose light, and nightfall on the way. Coming closer you may feel vertigo, because from the distance it takes to see the details, all you can see is the picture, right up to the edges of your vision. You can't quite make out all the shipwrecked men, dead and alive, but you see that the living ones are mostly turned to the back and are surging upward, waving. You just barely make out the tiny ship they see on the horizon, hopelessly far away. That rising line of surging bodies *is* hope—hope literally embodied. You sense that, and you also feel the con-trary force of the wind lifting the sail, pulling the raft away from rescue toward the huge wave and the darkness. One man is looking at you, hold-ing the pale corpse of what might be his son, staring vacantly, the only living person who isn't part of the hopeful surge. You can come to this picture with all your anti-rhetoric defenses on full alert and still be, to your surprise, moved by the body language and the atmosphere of the picture, which, you realize from the first, is a matter of life and death, and is beyond language. But you need to be there, in front of it.

Look at a sculpture in bronze by the seventeenth-century Florentine Gianfranco Susini, also at the Getty (figs. 3 and 4). Since it is small—only about eleven inches high—and about struggling animals, you may not be taken with it and you may move on, especially if you merely look at it head on, the way book illustrations condition us to do with sculpture.

FIGS. 3 AND 4 Gianfranco Susini (1585–c. 1653), *Lion Attacking a Horse*, c. 1610. Bronze, 9½ x 11 in. (24.1 x 27.9 cm). J. Paul Getty Museum, Los Angeles

You see the sheer concentrated grip of the lion and the convulsive pain and fear of the horse. If you take your time and move around slowly, however, the piece reveals itself like a new acquaintance in conversation. Further around, you see how efficiently the lion uses his back paws, gripping the horse with one and the ground with the other. Still further around, new compositions form. You see the lion's tail curling with a kind of electrical charge. You see the upward curve of the neck of the horse—an animal that can't help being graceful, even while being eaten. The end view reveals the neck as a pyramid of straining muscle. Without your movement around the piece, this amazing interplay of savagery and grace wouldn't unfold. Moving, you have plenty of time to consider that the work is entirely an invention by the artist—no animals were harmed in the making of this sculpture!—and you have the leisure to ponder why death struggles of animals have had such fascination as subject matter for so many centuries.

Finally, let me describe two works by a great artist who died young, five years ago, Felix Gonzalez-Torres. In one, the gallery floor sparkles, covered from wall to wall with gold nuggets. There is a familiar pleasant smell in the air, and up close you see that the nuggets are candies wrapped in gold cellophane, a single layer of hundreds of pounds of identical pieces. Another visitor picks one up and opens it. After a moment of shock and resentment at her behavior, it occurs to you that taking a piece is OK; that's the point, and you do. On the label you read that at the end of each day the candy is replenished—a kind of kid's fantasy with echoes of the Big Rock Candy Mountain.[3]

In the next room there is what at first sight might be a concrete block. It proves to be a neat pile of paper, a stack of identical prints picturing the wavy surface of the sea.[4] Again, somebody bends down, removes one, rolls it up and takes it away. So do you. At night, the stack grows back again. Meanwhile you have been sorting through your thoughts about the unfamiliar nature of what's going on in a commercial SoHo gallery: my God, they're giving it away! And—what's the "it"? If I buy the piece and install it in my museum or at home, do I permit my visitors to take it away and then replace it? You think about the transaction with visitors: it's a gift—a subversive switch on the notion of ownership. On spectatorship,

too—you're a participant. It's a reminder that works of art are at all times only partly visual. The experience of these pieces will be recalled by hundreds, eventually thousands, of people by the taste of the candy they took away, by the sight of their print. You only grasp the true character of Gonzalez-Torres's pieces—gifts offered and accepted unconditionally—and you are only moved by this if you are actually present, in no hurry, with your senses and mind switched on.

I wanted simply to demonstrate what can happen to any thoughtful person not armed with a lot of art history on prolonged looking. But I did not pick these works at random: they are works that caused me real excitement and disturbance when I first saw them. Typical of good gallery experiences, they prompted meandering thoughts, stabs at associations, and—some of the time—discoveries. When we visit museums and don't pause for long enough to let these thoughts rise, if instead we just move along taking mental notes, will the revelations come later, in the car or the shower? Will we be changed after the fact? Maybe; most likely not.

I had come to feel a bit isolated and against the grain in my preoccupation with strong experiences in museums. I was exhilarated a few years ago hearing Philip Fisher, a thoughtful writer on contemporary art, give a lecture about the problem of distraction in museums, which I'll come back to. Then, last year, came a book so passionate and so subtle that I lost whatever doubts I had been developing: *Pictures and Tears: A History of People Who Have Cried in Front of Paintings* by the Renaissance art historian and contemporary art critic James Elkins, which puts ballast into my arguments.[5] Elkins asks: "Why should I try to understand people who cry in front of paintings? Why bother searching through history for stories of people who have cried? For a simple reason: tears are the best visible evidence that a person has been deeply moved . . . I want to find instances of genuinely powerful responses to pictures, reactions so forceful and unexpected that they can't be hushed up."[6] The book is based on four hundred letters Elkins received in response to his requests for stories. Most stories are vivid, and many are as inexplicable to Elkins as to the person who shed the tears. He tries to classify the various circumstances into broad groups. There are some familiar ones, like the tourists experiencing the "Stendhal

Syndrome," a name invented in 1989 by the psychiatrist Graziella Magherini to describe the symptoms of tourists in Florence who reported being emotionally undone by seeing the works of art they had only imagined for years and were finally standing in front of. Stendhal had described his own nervous exhaustion in Florence in 1817 in terms of "ecstasy," "celestial sensations," and "heart palpitations," and ever since, there have been many such reports by literate tourists.[7]

Elkins describes people who are moved by paintings that remind them of passing time. Other people wrote to him about time standing still in front of a picture, about boundaries vanishing, about seeming to be at one with the work. One person evidently came to tears at the magnetism of a landscape painting by Caspar David Friedrich. (There were few reports, by the way, of tears shed in front of pictures with subjects like the Pietà that were meant to evoke tears.) One person described having a powerful sense of recognition, happiness, and what she called "grace."[8] Elkins can recall only one mention of grace in the entire critical literature, when Michael Fried described what he called "presentness," the "quality that some artworks have . . . of filling the field of experience, and absorbing the viewer's gaze and thoughts." Fried ends his article with the sentence, "Presentness is grace." In the objective, secular world of art criticism, that was a startling statement, and still is.[9]

Nobody understands crying, not even psychologists, Elkins says. That is partly because strong emotions "shut down our ability to reflect." The stories Elkins collected don't explain it either, but they form a literal, vivid record of personal experience. What gives the book some of its weight is Elkins's survey of the history of individual sensibility and intense personal experience in front of works of art from antiquity onward, especially since the Romantic period. He discusses the picture by Greuze of a girl mourning the death of her tame bird that Neil MacGregor discusses in his essay and he describes it as stirring visitors in Edinburgh to helpless tears from the time it was first exhibited and praised lavishly by the great philosopher and critic Denis Diderot.[10] To us it is maudlin and embarrassing beyond redemption. The Abbé du Bos, a contemporary tastemaker,

might have been speaking for the entire age of sensibility when he said "the primary object of poetry and painting is to play on the emotions; poems and pictures are only good if they move and involve us." To poetry and painting, he could have added the recent English invention, the novel.

Elkins touches on a now-famous essay by Michael Fried on "absorption" as a theme in eighteenth-century writing and art—the quality of rapt, sympathetic attention to words and images, and indeed to any activity— that was a kind of ideal moral state.[11] Fried illustrated one example, *Father Reading the Bible* of 1755 by Greuze.[12] Elkins does not call for a return to weeping at pictures by Greuze or any other manipulative artist. What he insists on is that evoking strong reactions was the purpose of most painting in the Middle Ages, some painting of the Renaissance, and much more painting in the eighteenth and nineteenth centuries. For a century, he says, we have been living in a dry-eyed era. He wants to explore why we have become so inhibited and whether we have an incurable condition.

The heart of Elkins's book is a description of his own evolution in the course of his youth and educational and professional life from being intuitive and passionate to being knowing and restrained. Of his art historical training he says, "Some of what I learned did enrich my experience and show new meanings. But its cumulative effect, historical knowledge undermines passion." He says knowledge deepens and enriches, but makes it more difficult to see in a feeling way. Elkins values the jolt and the rough edges of first-hand experience; at one point he says, "Each idea is like a little tranquillizer." He admits that he received letters from people who know a great deal about paintings and do still cry, but, he says, "virtually all academics are in the tearless camp."

Elkins lists some reasons that have been given for why we don't cry: "The twentieth century has gotten us out of the habit." "Museums and universities breed people with a cool demeanor." "Weeping doesn't fit the ironic tone of post-modernism." He likes one reason in particular: "It's comforting to think that paintings require only domesticated, predictable emotions." He makes eight suggestions for having strong encounters with works of art:

1. Go to museums alone. Seeing takes concentration and calm.
2. Don't try to see everything—pick a few rooms and choose one painting.
3. Minimize distractions—pick an un-crowded room and a work in good light.
4. Take your time—sit, relax, get up, come back, expect that it may take a long time for a painting to speak to you.
5. Pay full attention—give the work what Fried called "absorption."
6. Do your own thinking. Read, study, "but when it comes to looking, just look and make up your own mind."
7. Be on the lookout for people who are really looking, not simply browsing and checking labels. Observe them without disturbing them and, if you can talk to them without disturbing them, do.
8. Be faithful: return to paintings you've spent time with.[13]

Elkins adds some suggestions for academics. It's fine to study how pictures used to work and how people used to react. But don't be complacent about the explanations you give, and don't assume they are full accounts of the way pictures actually do work. Give yourself the chance to have "the most intimate, naïve encounter, and then dissect it into knowledge of historical value." And "let yourself be a little less consistently rational. . . . we think while we cry, and we feel while we think. . . . It's said that only sober thoughts are reliable. But if sobriety can bridge centuries, why not passion?" Elkins ends by asking himself and us: "What does it mean to say you love paintings, and yet never be *in love* with a painting? What does it mean . . . for people to spend their entire lives looking at objects clearly designed for expressive purposes and not be moved even once (in any circumstance, for any reason, no matter how indefensible) to the point of shedding tears? I am still not sure. But I know a loveless life is easy to live."[14]

I mentioned Philip Fisher earlier. I would like to extract some points from the lecture that impressed me so much a couple of years ago; it appeared in an issue of *Salmagundi* under the title "Museum Distraction in a Culture of Engulfment."[15]

Fisher acknowledges the huge popular success American art museums have had in seizing public attention, drawing a cosmopolitan audience, and providing a uniquely varied menu of the old and new. He observes that museum experiences are generally socialized: we go there with others and often talk to them while we are looking. The experience is un-solitary; it is bound to the museum's opening hours; and it is "visually noisy." The resulting distractions bring about a lower quality of attention, and a briefer time spent in the presence of complex works, than with any other art form. Fisher asks why we settle for this. Is it because we don't believe the works of art in museums are worth the attention we give to poems or music or fiction?

He contrasts the distracting public environment of museums with the privacy in which most other art forms are experienced today. We read and listen to music at home, in silence, alone, at any time we choose. Fisher calls this state of experience "engulfment"; Fried called it "absorption." Even at concert or opera or play, no matter how lively the crowd, when the lights go down we are effectively alone with the performance. Fisher traces engulfment to novel reading in the eighteenth century, and says that whereas recordings made it possible for music to be heard far from the distractions of a social sphere—in the private engulfment of the home—great works of art remain public, and are subject to the conditions of distraction that museums place on them. He suggests that museums and their visitors have actually come to favor works of art that are suited to brief encounters, such as Impressionist paintings, whose "overall harmonized surfaces" don't appear to require either long or intense looking. For much art before and after Impressionism, the intended emotional context was passion; what is popular today instead offers mood. There is a reduced emotional vocabulary and a correspondingly reduced response.

Fisher emphasizes that museums make their ideas felt most strongly in suites of rooms, where works are shown in carefully arranged sequences taking perhaps forty-five to ninety minutes of perambulation— the basic museum experience that he calls "walking past works of art." He asks how museums might help their works of art claim more prolonged

attention and makes some suggestions. Why not show certain works in a room alone, "with all the intellectual brilliance that now goes into the design of shows, with the goal of defining and then slowly increasing the idea of deepened curiosity and complex, prolonged attention?" Or reserve one wall for a single work in an otherwise unchanged gallery? He is hoping for smaller-scale but longer encounters that could have a particular excitement for visitors. These galleries with a single work could be part of the design of temporary exhibitions too. I think Fisher's plea for a higher quality of attention is compelling, and he reminds us very usefully of the historical forces that have "privatized," one could say, the formerly public experience of art forms—all except museums.

I would like to offer my own speculations about how art museums, if they chose to, might give more inducements to deep looking and might remove the obstacles to it. Like Fisher, I want to take a partly historical look at the obstacles. I have mentioned some of these, and so have Elkins and Fisher. I put them in four categories: distractions of sight and sound, including other people; visual overload; linearity and the promise of a story line; and discomfort.

Distracting sights and sounds are sometimes built into the architecture: for instance, rooms that serve as both galleries and corridors are seldom peaceful places to look, especially with hundreds of people trooping through. There are a lot of these, from the Grande Galerie at the Louvre (which was inherited from a palace and which we wouldn't want to change) to James Stirling's Clore Gallery at the Tate Britain in London, added in 1985 to house its vast collection of pictures by Turner, whose long hall is thronged with foot traffic that makes the paintings by Turner very hard to concentrate on.

In other museums there are attempts to provoke excitement by providing interesting ways for visitors to move around the building and get ever-changing views of other visitors moving around the building. This has a very distinguished fifty-year history that begins with the Guggenheim Museum and its celebrated ramp, whose tilt is an insistent reminder to keep moving. It opens a constantly shifting panorama of other people, not to mention a gut-wrenching view into the abyss (fig. 5). Drawings by Frank

FIG. 5 Solomon R. Guggenheim Museum, New York. View of balcony with crowd

Lloyd Wright show that he intended something different, that the bays of
the spiral would be used as a sequence of three-sided galleries with furni-
ture that would invite you to stop, turn your back on distraction, sit, and
look at the works in the collection. The Guggenheim's ideas reappeared in
very different kinds of museum buildings in the 1960s and 1970s, for
example the University Art Museum in Berkeley, a lobby with open-ended
galleries attached, and Richard Meier's High Museum in Atlanta, with a
soaring round lobby and curved ramps.

Some museums absorbed the influence of such French techno-
fantasies as the flying passenger tubes in Charles de Gaulle Airport: the
Pompidou Center escalators have been at least as popular as the collec-
tion, I imagine. There are also the unsettling indoor helicopter rides you
get in the transparent elevators of John Portman's Hyatt Hotels that inspired
museum elevators from San Antonio to Stuttgart to become entertaining,
like James Stirling's jokey constructivist contraption in the Staatsgalerie in

FIG. 6 The Museum of Modern Art, New York. Escalators (now demolished)

Stuttgart, virtually a sculpture itself. The East Wing of the National Gallery of Art by I. M. Pei has a lobby that is something of a people-moving fantasy; Cesar Pelli's addition to The Museum of Modern Art, now demolished, had all the efficiency of a department store, if not as much fantasy (fig. 6). Foot traffic, relentlessly on the move, becomes a constant presence in the visitors' experience, and even in the galleries some distance away it exerts subliminal effects on their attention span. There is also noise, mostly of people coming and going and talking, often amplified by the harsh acoustics of hard floors and plaster walls. There is a spectacularly uncomfortable example of this in the new Tate Modern, but you can find noisy galleries everywhere.

Am I being hypersensitive here? Elitist? After all, visual excitement, escalator rides, and dazzling buildings do attract people who might not otherwise come. And maybe our distraction threshold has risen in the past generation, a thought you can't escape in the deafening restaurants that are now the norm. In museum exhibitions, crowds, bustle, and a sense of event add up to word-of-mouth enthusiasm—"buzz," to use the Los Angeles buzzword of the 1990s, which in turn makes for more

crowds, more bustle. Applying the common standard in museums, that spells success. Applying that standard, what constitutes real, lasting success—I mean visitors engrossed in looking, in smaller numbers, moving slowly—may actually seem like failure. I'd like to report that there is a blazing debate going on in art museums about the present-day standard of success, but I don't think there is, and I am hoping these essays help provoke one.

Often there is the bizarre problem that the works of art in museums are poorly lighted: either by light of a color and character that was never intended for them, like focused yellowish floodlights, or light reflected from paintings with a glare that makes them hard to see. I say bizarre, because of the hundreds of millions of dollars expended by museums for new construction and upkeep each year, very little gets spent on improving the lighting—being certain that the light is sympathetic and as correct for the objects as it can possibly be. It's not that we are ignorant: we have a lot of pictures of artists in their studios that provide information about the light by which they worked—sculptors like Bertel Thorvaldsen, for instance (daylight from high up, and diffuse), and painters like Friedrich (window light from the north). There is a whole literature on museum lighting, mostly unread by curators and architects. And we have some examples of wonderful light in recent buildings: Louis Kahn's British Art Center at Yale and Renzo Piano's Menil Collection galleries, just to take two. What more important thing does a museum do than provide good light?

Museum installations are often simply too large and often too dense to encourage much more than browsing by anyone who is not trained to look selectively. To some extent this is probably a fixed property of museums, and it has been debated since the nineteenth century. Though it has gradually diminished, excess is our heritage, you could say. Public art exhibitions of paintings in the nineteenth century such as the Salons in Paris and shows of the Royal Academy and British Institution in London were not easy places to examine contemporary art, especially pictures hung high, and the sheer frame-to-frame density made it hard to concentrate on any one work. There was still no assumption that the purpose of

the show was to give you a leisurely look at each picture. And the halls were places for the fashionable to congregate and willingly be distracted.

In the national galleries in London and Edinburgh, the crowded and arbitrary display of paintings encountered strong objections in the 1860s and 1870s from people who had seen the more orderly and historically based installations on the Continent, especially Germany. Dramatic reforms were proposed, like a room for landscapes designed by E. M. Barry for the National Gallery in London that would have been well lighted, thematic, and simple. But it did not get built. Exhibition design was decisively changed in the nineteenth century, not by museums at first, but by artists and art dealers. Both had good practical reasons for controlling their clients' attention and focusing it on few works. Benjamin West's private gallery in London had dramatically blocked skylights so the pictures were the brightest things in the room. In Agnew's gallery on Bond Street—which is still open for business—there was a spare installation, comfortable seats, and a carefully controlled light to suit each kind of picture.

In museums in Europe and America, the German model gradually prevailed: fewer works, placed where you can see them, in sequences and juxtapositions that emphasize historical and stylistic relationships. The museum became what Philip Fisher calls "the first teaching machine." Nowadays you can find curators having fits of impatience with didactic principles—for example, the recent old-fashioned rehangings in Edinburgh and the Museum of Fine Arts, Boston, of paintings two and three high— but in general art history still prevails. The didactic installation has obvious value. It also has obvious dangers, among others being that curators who make the choices are tempted to put too much on view, to the detriment of individual works. But I'll return to this.

I have been describing distraction and visual overload, two kinds of obstacles to concentration. At this point, the opera fan in me is going to grab the wheel and we will swerve off the road for a minute, for I often think that if museums really want to deal with distraction, they need a Richard Wagner. Wagner believed fiercely that music drama deserved a better grade of attention from the audience than it was getting in opera houses. These were designed for spectacle in several senses, and it was

not just the performers who were on show, but also the customers. The better-off sat in boxes with anterooms and servants, and then came and went during the performance. At the Paris Opera they made a great scene coming and going on the *escalier d'honneur*, which Garnier designed for exactly that purpose. They went right on inspecting each other during the opera, too, much to the delight of Edgar Degas, who made two paintings of the ballet of the ghosts in act IV of *Robert le Diable* by Meyerbeer.[16]

It was easy to ogle one other, since the house lights were left on during the performance. It was not so easy to see the stage, though, especially if you sat downstairs, since the pit was so shallow that you had to look between the orchestra players.

Wagner did not want his audience walking in off the Munich streets with a headful of worldly thoughts. In 1871 he chose the town of Bayreuth in rural Franconia to build his own theater, grandly called Festspielhaus, to which the audience would have to make a kind of pilgrimage, as people do to the church at Vierzehnheiligen nearby. Architecturally, it was no showplace—inside and out, it was the opposite of the typical opera house. The exterior was clad in vernacular brick and half-timber. The interior is like a slice of a Roman theater, giving good and nearly equal views to everybody. No one looks down from a box. The orchestra is now out of sight, in an enormous pit, and the music—intentionally diffuse and remote sounding—emerges from a gap that Wagner called a *mysticher Abgrund*, a mystical abyss. No longer were the house lights left on during the performance to allow the audience to read the libretto and inspect one another. For the first time the lights were turned down. As a result the stage was much brighter than the auditorium and subtler stage lighting and scenic design were possible. Everything operated to eliminate distraction, heighten attention, and enhance both sight and sound.

Bayreuth took you away from your surroundings and from your own petty life and encouraged you to focus your whole being on a work of art. In Wagner's view you were elevating and purifying yourself in the process. His mystical intentions were not widely adopted, but his techniques were. They had a deep influence on theater and opera and symphonic performances, and they still do. No contemporary exhibition

designer rivaled Wagner in his insistence on total control, but the one who came closest was an artist who also wanted visitors' undivided attention for purely aesthetic reasons, the American émigré painter James Whistler. Like Benjamin West, Whistler manipulated the overhead light for dramatic effect. He chose everything in the room to harmonize with the pictures, and hung his work in relatively sparse combinations. His designs became known and imitated everywhere, and they were a major force in the great paring-down of installations from the 1880s into our own era.

Back to museums. In another class of obstacles to deep, thoughtful looking I put "linearity," the expectation by visitors that they will be presented with a coherent sequence of objects and ideas, even a story line. Special exhibitions have built those expectations, of course, reinforced by narratives that we dispense in wall texts, brochures, and recorded messages, recounting the life and struggle of the artist, the waxing and waning of a civilization, the shaping of an artistic movement by its contributors. We condition visitors to look for an interpretive framework. We reinforce the habit—the art historian's habit par excellence—of comparing, of accounting for works of art by relationships with other works. This is a path to one kind of understanding, but surely not to the only truth, and not necessarily to the deepest and most memorable experiences by visitors. Sequences have been part of the teaching methods built into installations since the Berlin museums. At the Victoria and Albert Museum at the turn of the century, visitors were given a map—the *Red Line Guide*—so they could follow the curatorial thread (fig. 7). Visitors nowadays, conditioned by the experience of special exhibitions, have become more accustomed than ever before to sequences and to being told how each work fits. When they encounter the permanent collection galleries, however, they are apt to be disoriented by the relatively unstructured, freer-flowing installation, and feel inadequately prepared and impatient.

Finally, discomfort. We will all have our own complaints here; my own is about seats. In most museum shows, seats are absent, or put in places from which I can't see, or are already sat on by the competition. What can we conclude from this? I have to believe that some museums are figuring that it's bad for "throughput" if visitors sit around in exhibitions.

FIG. 7 Ground floor of the Victoria and Albert Museum, from *The Red Line Guide to the Victoria and Albert Museum* (1904)

(At the Getty, I am delighted that Richard Meier designed not only good light but restful couches!) In permanent galleries there are rarely enough seats either, and if there are, they are seldom comfortable. Some curators are apt to complain that seats spoil the look of an installation, but what is the installation for, anyway? If we are serious about extending the attention span of our visitors, seats are the simplest, cheapest means to do it. That, and coffee. And toilets.

There is also the discomfort of trying to read labels with small type, low contrast, and stupid placement. A hero of mine is Benjamin Ives Gilman, the learned secretary of the Museum of Fine Arts, Boston, during the design of the new museum on Huntington Avenue, who was not only a crusader for good light in the galleries, but also an advocate of common-sense installations and comfort. He documented the opposite in the illustrations in his book of 1918, *Museum Ideals of Purpose and Method* (fig. 8).

I have been listing some of the obstacles that prevent people from seeing in a leisurely, undistracted way and lessen the chance that they will have the strong experience that the artists intended. If a major part of our

IV. Crouching

Fig. 16. *Object.* — Terra-cotta statu-
ette on lower shelf of case. *Q.* — What is
this goddess resting her elbow on? *A.* —
A smaller statuette bearing a drum-shaped
object on its head.

Fig. 17. *Object.* — English posset cup
in the base of a floor case. The observer
was asked to read the label.

Fig. 18. *Object.* — A Greek vase on lower
shelf of case. *Q.* — Describe the design
on this vase. *A.* — A rough vine pat-
tern.

260

FIG. 8 "Visitor half-crouching and crouching" from Benjamin Ives Gilman,
Museum Ideals of Purpose and Method (Boston: Museum of Fine Arts, 1918)

public trust is to foster those experiences, what might museums do about
it? You have heard suggestions from Elkins and Fisher; here are some
more from me.

1. Museums should start early, making a greater commitment to
 schoolchildren. In the process of exposing them to art and encour-
 aging the integration of art into their curriculum, draw the atten-
 tion of teachers and children to individual works, fewer of them,
 for longer periods. Explore them in all their aspects and reward all
 kinds of genuine responses. Resist turning them simply into illus-
 trations of history, or of ideas, or anything else. If, at home, people
 have been able to achieve a state of absorption with books and
 music, perhaps they can begin to do the same with works of art on
 the Web—if the works are presented so as to acknowledge their
 true complexity, rather than merely being part of a visual menu, or
 wallpaper. It may actually be that interactivity on the Web will not
 only inform the audience but also condition at least some of them
 to expect a more thoughtful encounter with the originals.

2. In the museum, we should review the basics of gallery installations, and do it with the help of observant, sympathetic laypeople who can help us see with the visitors' eyes. Look at the basics: lighting, installation, labeling, and comfort, then improve them. Then get more advice.

3. Find ways to promote visits to the permanent collection. Museums have actually been trying to do this—more or less wholeheartedly, with more or less success. Keep at it. Changing the featured single works from time to time, as Fisher suggests, does in fact work, as the National Gallery in London and many other museums have shown. Develop some qualitative measures for visitors' experience of the collection. Questionnaires and interviews with visitors can be tremendously revealing. Just how and why people have strong responses to works of art may be hard to know, but you can listen very profitably to their critiques of the galleries, the amenities, and the information you provide. Rethink the conventions of showing the permanent collection and consider showing even less. Consider removing lesser works and putting them on view in secondary spaces, a formula large museums have used for more than a century. Do as Philip Fisher suggests and experiment with single works in a gallery or on a single wall given just to it, perhaps with supplementary material. This has been done in many museums, seldom consistently, but often very successfully. Until a few years ago the Städelsches Kunstinstitut in Frankfurt used to show Rembrandt's *The Blinding of Samson* (fig. 9)—with life-size figures, explicitly and stunningly gory—in a room by itself, lighted beautifully by a window at the side, and with a bench. That's all. Nobody who saw it under those conditions will ever forget it. I offer here before and after pictures: the large and complex masterpiece by James Ensor, *Christ's Entry into Brussels in 1889*, as it hung when the new Getty Museum opened (fig. 10), and now, much more successfully, in a room with a few other Symbolist works (fig. 11).

4. Museums should do something about crowded exhibitions. Limit attendance. Stay open for more hours of the day. Put seats in the galleries. Respond more generously to the success your visitors have

FIG. 9 Rembrandt, *The Blinding of Samson*, 1636. Oil on canvas, 92⁷⁄₈ x 118⁷⁄₈ in. (236 x 302 cm). Städelsches Kunstinstitut, Frankfurt am Main

brought. Now let me try to read your minds for a moment. Limit attendance? How many museums can afford what he's suggesting, especially big ones in a financial squeeze? Isn't this the world as seen from a rich museum?

I have worked in museums that had to struggle and museums that didn't. All of them have needed to attract an audience—especially a newer, less traditional audience—whether to be solvent, or be socially responsible, or both. I've helped devise the attractions, willingly. The question is not whether we work to attract an audience, but what kind of experience we attract people to. What trade off will we make between attendance and quality of experience? That is what museum staffs and boards need to examine honestly. Where popular shows are concerned, it is perfectly possible to have a smash hit without subjecting museum guests to overcrowded, unpleasant, distracting galleries. In order to provide better conditions, museums

TOP: FIG. 10 J. Paul Getty Museum, Los Angeles. Gallery for late-nineteenth-century paintings, 1997

BOTTOM: FIG. 11 J. Paul Getty Museum, Los Angeles. Gallery with paintings by James Ensor and the Symbolists, 2001

must invest in better design, longer hours, and a timed admission system, and they probably need to give up some income from tickets and sales. This is a choice museums can make, but only if they believe that visitors deserve a better, deeper experience.

5. Finally, about information, and interpretation in general. It may sound as though I am disillusioned about my profession of art history. I'm not—but I think museums ought to take approaches to works of art that are less exclusively historical, less a matter of showing causation, influence, and sequences. Museums should suppress the instinct to compare the work in front of the visitor with another one she can't see. We should be modest in our claims of understanding works of art. Museums should consider giving more interpretive voice to artists, conservators, historians, writers, and other people whose responses are vivid and imaginative and heartfelt—and which might inspire visitors to have more courage themselves.

FIG. 12 Rembrandt, *The Young Rembrandt in His Studio*, 1629. Oil on panel, 9¾ x 12½ in. (24.8 x 31.7 cm). Museum of Fine Arts, Boston. Zoë Oliver Sherman Collection; given in memory of Lillie Oliver Poor

Art museums have set themselves many tasks. They play many roles in the fulfillment of their public trust. I believe that they will be meeting their most serious obligation when they are creating an audience that looks hard at works of art and has strong responses to them. We can hope that they learn to look with some of the undistracted intensity of the young Rembrandt (fig. 12), with open minds, at one work of art at a time. That will be an audience of happier, wiser, more complete people.

NOTES

This essay appeared in somewhat different form in *X-Tra* 5, no. 1 (2002): 2–11.

1. Robert Storr, *Dislocations*, exh. cat. (New York: Museum of Modern Art, 1991).
2. Sylvain Laveissière and Régis Michel, *Géricault*, exh. cat. (Paris: Galeries Nationals du Grand Palais, 1991), 153, fig. 242.
3. Dietmar Elger, *Felix Gonzalez-Torres: Catalogue Raisonné* (Ostfildern-Ruit, Germany: Cantz Verlag, 1997): cat. no. 251. The title of the 1993 work is *Untitled (Placebo—Landscape for Roni)*.
4. Ibid. *Untitled*, 1991, cat. no. 180.
5. James Elkins, *Pictures and Tears: A History of People Who Have Cried in Front of Paintings* (New York: Routledge, 2001)
6. Ibid., 38.
7. Ibid., 43–47.
8. Ibid., 178–80.
9. Michael Fried, "Art and Objecthood," in *Art and Objecthood: Essays and Reviews* (Chicago: University of Chicago Press, 1998), 148–72, especially 172.
10. Elkins, *Pictures and Tears*, 109–15.
11. Michael Fried, *Absorption and Theatricality: Painting and Beholder in the Age of Diderot* (Berkeley and Los Angeles: University of California Press, 1980).
12. Fried, *Absorption and Theatricality*, fig. 1.
13. Elkins, *Pictures and Tears*, 210–12.
14. Ibid., 217.
15. Philip Fisher, in a special issue of *Salmagundi*, no. 139 (summer 2003), called "Is This an Age of the Museum?" with contributions by Arthur Danto, Michael Fried, Susan Sontag, Philip Fisher, and others.
16. Jean Sutherland Boggs, et al., *Degas*, exh. cat. (New York: Metropolitan Museum of Art, 1989), cat. no. 103.

The Authorities of
the American Art Museum

James N. Wood

DIRECTOR, ART INSTITUTE OF CHICAGO

OUR SUBJECT IS "Art Museums and the Public Trust." I am turning my
attention to the American art museum and primarily those with a sub-
stantial permanent collection. The contents, strengths, and weaknesses of
these collections define the museums of each of my fellow contributors
just as they certainly provide the fundamental identity of the Art Institute
of Chicago. However, beyond the fact that we each have permanent collec-
tions that are loved and respected by our public, I think it is appropriate to
ask at the outset: the public trust in what? In attempting to answer this
fundamental question, I hope that along the way I can shed some light on
a second, no less relevant inquiry: what is American about the American
art museum?

Defining today's art museum can be a challenge for the profes-
sional, let alone the layman. Here are three statements, none definitive,
which share a common theme. The first is by Alfred H. Barr, Jr., writing
in 1944. "The museum collections as exhibited should be for the public
the authoritative indication of what the museum stands for in each of its
departments. They should constitute a permanent, visible demonstration
of the museum's essential program, its scope, its canons of judgment,

taste and value, its statements of principle, its declarations of faith."[1] The second is by David Carr, writing in *Museum News* in 2001. "The museum is an entity that emanates dense waves of power, value and authority. It is endowed with power by its treasures, and by its control of knowledge and information."[2] And third, Michael Kimmelman from an article in the *New York Times*, also from 2001: "Museums must re-assert their authority on what beauty really is, thereby reclaiming the idea of quality in art."[3]

Common to these statements is the issue of authority. The public trust allows us first and foremost to exercise authority, which in our democracy public institutions are granted in return for service. However, since the legitimacy of our museums is based first on trust and only indirectly on law, defining the nature of the museum's authority may help to answer the persistent question: what is it that can elicit this enabling trust on the part of the public? I should emphasize that I am using the term *trust* here to mean primarily the public's willingness to place confidence in the museum rather than the museum's role as trustee of works of art, important as that may be.

Authority is a notion that is rather out of fashion, but I believe it is essential to comprehending the concept of public trust.[4] Among its definitions, the "power to influence or command thought, opinion or behavior" makes clear both its importance and its potential abuse. The line between being authoritative and authoritarian is one that separates trust from coercion or intimidation. I would like to explore this essential relationship between the museum's authority and the public's trust and support by posing three questions: From where does our authority derive? What is its nature? And what are the challenges to it that we must anticipate and meet? If the museum fails to carefully define and conscientiously exercise this authority, it will fail the very public that has granted it and which ultimately has the power to revoke it.

In the article I referred to earlier, Michael Kimmelman makes an analogy used more and more frequently in attempts to define today's art museum. He writes, "the usual phrase today is secular cathedral" and further on he comments, "we put our faith in few traditional institutions these days, but the museum is still one of them." A cathedral is a church

that is the official seat of a bishop; as an adjective the word denotes "emanating from a chair of authority." I think we should think long and hard before accepting this definition, flattering as it might appear.

For the art museum to be a secular cathedral we must be prepared to present art that can speak ex cathedra with the voice of truth, but traditionally, in order to have that form of authority, the art was in the service of orthodoxy. We do not see art that way in our post-Enlightenment modern world. It is not divine word but human creativity, a post-Renaissance meditation on reality, beauty, and the human condition, but not an infallible sermon. I am sure some architects would like to be asked to build God's house, but no museum client today can provide that commission. One could say that Brunelleschi, with his dome for Florence's cathedral, solved the spiritual challenge so rationally that he replaced the client—and thereafter the greatest churches of Christendom would be known for their architects first, and their patron saints second.

To examine the question of what should be the basis for authority in today's museum, we should first look at our history. While the American art museum, as its counterpart in Great Britain, differs in many important ways from the Continental, particularly the French, model, the French Revolution and its aftermath was of central importance in defining a number of the sources of authority that are central to our museums today. I know of no better or more concise description of this history than Marc Fumaroli's 1992 essay "The Birth of the Modern Museum," published, appropriately, in the catalogue for the splendid exhibition *Masterworks from the Musée des Beaux-Arts, Lille.*5 The creation of the French Revolutionary State marks the clearest and most brutal transfer of authority to the art museum. In Fumaroli's words, "The Republic and then the French Empire considered themselves the Executors of the legacy of the Age of Enlightenment."6 Philosophers of the Enlightenment believed that the political and moral freedom of man could be effected through education: both through the arts, "the sons of genius" and the sciences, "the daughters of reason." The new public museum was the creation of the state and its aim was education. Its audience would be citizens, not believers or subjects. Similarly, ownership was no longer vested in the church or

the monarchy, but in the concept of a national heritage assembled and presented for the benefit of the public. These two powerful forces of public ownership and education led logically to an encyclopedic ideal wherein the finest works of art were to be removed from their religious and royal contexts to create the new public museum. Paris was to be the new Rome of the Enlightenment. As Napoleon's armies advanced across Europe, countless artistic treasures were uprooted and sent back in the opposite direction to the French capital.

In America, by contrast, the state was born separated from the church, not out of its destruction; we did not have to overcome an indigenous monarchy that claimed its legitimacy from that church, only throw out the representatives of colonial rule. Our Revolution was to reject the authority of the king, not to behead him. When we eventually determined the need for art museums, their contents were purchased, not confiscated. In this sense, the origins of the American museum are more English, but ultimately the model was European, for whether through revolution or act of parliament, the museum received its justification and much of its authority from serving the citizens of the state, in contrast to the believers of a church or the subjects of a king.

If the ultimate source of authority for the art museum is the state, what does that mean in America? The answer is not a simple one. As Randall Bourscheidt, president of the Alliance for the Arts, recently observed, "The arts are a strange part of American life. Almost everybody loves them on some level, but they have not been educated to think about it as part of government."[7] To the contrary, if anything, we have been educated to see them as expressions of individual talent and creativity protected by the Constitution from government control or manipulation. In contrast to European and virtually all other nation states, we have no Ministry of Culture—Sid Yates was not Jack Lang. It is not surprising and it is indeed appropriate that we have had such intense debates over what is the acceptable authority for our National Endowments to exercise in their support for the arts and artists. It would be hard to imagine the plaque at the entrance to the new installation of African, Oceanic, and Pre-Columbian art in the Louvre greeting us in an American museum today; it says these

galleries are "the expression of the will of France to grant its just place to Primitive art in the World of Museums."

If the authority of the Louvre flowed from the Revolution, which created it to receive the art liberated from the church and the king, the authority of the American art museum is derived ultimately from our Constitution, which assured the climate in which private individuals could create museums for the public good. Almost without exception, our great museums are the result of individual citizens determining the need; defining the mission; financing the building, often on publicly donated land; and assembling the collections through private purchase and gift. The institution's legitimacy was never decreed by the state, but bestowed by the public through their use, support, and trust. With the enactment of the income tax and the possibility of charitable deductions, government provided a greater incentive—and in some cases actual tax revenues—to help defray operating costs, but our museums have remained overwhelmingly private in both their financing and decision making. So we are not creatures of the state, but we are made possible by our political system. Therefore, for the American art museum to thrive and retain the public trust it must be, and be perceived as, consistent with and supportive of the Constitution and the democratic society that flows from it.

And here is a central challenge. The American art museum's authority ultimately derives from its being—and being perceived as—a vital and reinforcing element in our egalitarian democracy. At the same time, the public's confidence in museums depends equally on their being authoritative with regard to collecting, presenting, and explaining the artistic treasures that we hold in trust. Alexis de Tocqueville saw the problem clearly long before our museums came into existence. How in a young utilitarian and commercial society could the aesthetic luxuries of the upper classes of the Old World be enjoyed by those who worked as equal citizens in the New? Was it possible, in short, to democratize high culture? As an aristocrat who had lost everything in the French Revolution, he both understood and appreciated the old values while harboring a deep curiosity for new models for post-revolutionary society. He was skeptical about the fate of the arts in America and fearful of the potential for a "tyranny of the majority."

What would he have thought of and how would he have judged the American art museum, which has evolved to deal with many of the challenges that he so clearly articulated? I will return to de Tocqueville, who in his uncanny way predicted another challenge that I believe is one of the most serious facing us today.

One final observation on French and American museums. In France art museums are creatures of the state and therefore very difficult for the public to challenge, whereas in America they are predominantly private institutions with a commitment to public service, thus vulnerable to public criticism. However, by being far more financially and administratively independent of government we are correspondingly more insulated from political manipulation and state interference. At such moments the English Channel appears wider than the Atlantic. John Locke's observation, in his famous essay "A Letter Concerning Toleration," that religion is only valid if chosen freely by the individual and not imposed by an outside authority, finds great sympathy in American attitudes toward the arts and their relation to the state.

Have we arrived at an apparent contradiction, that the American art museum was made possible by our democratic political system, but that the public's trust is based on our ability to preserve elite values and precious works of art that we make available to all? To answer this, I believe it would be helpful to examine my second question: What is the nature of our authority? I will quickly review eight types of authority—I admit that the number is somewhat arbitrary, but I believe these are essential to gaining and justifying the public's trust. They are: nourishment, expertise, hierarchy, memory, conservation, architecture, mission, and leadership.

The first and indispensable type of authority that legitimizes the art museum is what I call the authority of nourishment. First and foremost we are our collections, and it is assumed that these original works of art, selected for their aesthetic quality and historical significance, provide something essential to society. Through these collections we make many things possible—inspiration, instruction, awe, pleasure, and entertainment, but I believe the single most appropriate word is *nourishment*, for it empha-

sizes the essential life-sustaining contribution that art has made through-out human history. A belief that this power could play a positive social role appears regularly in the founding ambitions of the modern Western art museum. As Neil MacGregor notes in his essay, a stated purpose of the National Gallery in London was "to cement the bonds of union between the richer and the poorer orders of the state" by encouraging them to "discover their common humanity." Before instruction came nourishment and the belief, even if unproven, that by striving to provide equal access, the museum could help bind together a diverse society.

Recently, as noted by John Walsh in his essay, James Elkins has stressed the liberation and meaning that comes from looking. Seeing, par-ticularly in a public art museum, is not possessing; it can provide nourish-ment without ownership, and therefore encourages the spiritual. Elkins speaks passionately about a very American respect for "naked, ignorant experience" (noting its sources in John Dewey and R. G. Collingwood). As a professor he is certainly in favor of the enriching effect of learning on our ability to see and appreciate works of art, but he also stresses the impor-tance and validity of the untrained experience, that more fundamental form of nourishment that the museum offers to everyone.

> Each fact is a shield against firsthand experience. Anyone who has ever glanced at a museum label or opened an art book is incrementally less able to be really affected by seeing the artworks. I don't deny that historical knowledge paves new roads to the work, deepens and enriches the work, and helps make sense of unfamiliar paintings. But it also alters the rela-tionship between the person and the painting, turning see-ing into a struggle. ... Once your head is filled with all kinds of fascinating bits of information, it gets harder to see any-thing beyond the labels, the audio tours, and the exhibition catalogs.[8]

This is an extreme position to be sure, and open to debate, but relevant to making the essential point subscribed to by most of our founders: that the

free and unaided access to great works of art, while perhaps only a begin-
ning, was the first justification for the museum's creation.

My second authority is expertise. If the foundation of the museum
is the permanent collection, a vital and dynamic institution must be about
ideas as well as objects. The professional staff of experts, through a con-
tinuous chain of decisions determining acquisition, presentation, publi-
cation, conservation, and programming, are constantly redefining the
museum. But they are creatures of the humanities, not the sciences, so
they cannot make the same immutable claims concerning truth. Muse-
ums feel a greater pressure than universities to stress applied rather than
pure research. It is no coincidence that the special exhibition catalogue has
become an important vehicle for projecting the authority of the museum's
expertise in a form that can be productively used by the general public.

In the same vein, if the museum's expertise is to inspire trust, it
must be exercised with responsibility, objectivity, and humility. It must be
welcoming, not condescending, and seen as the product of distinct authors'
voices, not an anonymous institutional proclamation. In short, it must be
a shared expertise dedicated to teaching others how to exercise their criti-
cal faculties, make informed choices, and enjoy the pride and pleasure
that comes from developing one's own personal taste. The collections of
our great museums provide a unique opportunity to demonstrate that curios-
ity about others is the greatest form of knowledge. The fact that art history
is hardly a science and that the concept of progress is particularly ill-suited
to understanding and appreciating the museum's collections only empha-
sizes the need for its experts to define many different kinds of truth with
regard to chronology, attribution, iconography, context, and condition
without succumbing to a relativism that reduces the collection to an arbi-
trary accumulation of material culture. To be authoritative in a democracy
the museum must maintain a creative tension between demonstrating its
expertise and questioning its assumptions.

A note of caution would be appropriate here. The more society
recognizes the museum as a source of authority, the more individuals
and groups within that society will try to usurp or corrupt it to become a
means to their own ends. From its ability to affect the monetary value of

works of art, to giving recognition and social power to particular individuals or communities, the museum is susceptible to the charge of abuse of authority.

Finally, I would like to emphasize a particular aspect of this expertise that I feel is of ever-growing importance. This is the expert distinction between the original and the reproduction. It has long been a central concern of the history of art and the exercise of connoisseurship, but in today's digital world it is increasingly important to maintaining the public's trust. I am confident that all reproductions of works from the collections, authorized or not, ultimately stimulate a desire to experience the original. However, my confidence is based on the assumption that the public comprehends that there is such a thing as an original that one is encouraged to visit in the museum. Here we can often be at odds with powerful forces within our culture, namely the advertising and entertainment industries' temptation to make definitions of truth and originality merely means to their own economic ends.

My third authority is hierarchy. The distinction between high art and craftsmanship goes back to the Renaissance, but it was given new importance in the years before the French Revolution, when eighteenth-century philosophers undermined the sacred foundations of art and focused on the concept of quality and the reverence for beautiful things, putting emphasis on considerations of taste, which resulted in the new and independent discipline of aesthetics. The cult of genius and the pursuit of the masterpiece were central to the efforts to build the first museum collections.

In the intervening two hundred years, the unifying concept of art has been continually expanded to the point where today it embraces the diversity of the entire world, both past and present. As the hierarchy built around the Western tradition has been replaced by a far more inclusive definition of aesthetic quality, the art museum has become infinitely richer while the need for qualitative distinctions within and among a vast array of cultures has become ever greater. The museum's claim and the public's expectation that they will exhibit the highest quality of work by a given artist or civilization is a compelling source of authority, but one that is not easily fulfilled. The painter Gerhardt Richter has stated the challenge more than

once in words to this effect: "The most important thing, in life and for humanity, is to decide what is good and what is bad. And it's the most difficult."

I would argue that the concept of quality is particularly important in an egalitarian society. The ideal reiterated throughout the history of the American art museum was that the best should be accessible to the most, and that the erosion of standards of quality to the lowest common denominator was to be avoided at all costs. All citizens were to have the equal opportunity to experience artistic excellence, just as the goal of public education was to provide everyone with the basic tools of knowledge to compete for employment and personal happiness.

However, an elementary education was mandatory, while the visit to the museum, unless incorporated into the school curriculum, was merely an opportunity. There is a clear tension here between a visitor's free choice and the tendency to justify the museum in terms of the numbers using it. The American museum is under increasing pressure to both compete in popularity with the entertainment industry and preserve the distinguishing values of excellence and spirituality that are central to our definition of what it should provide. This is exacerbated by a particularly American anxiety about the distinction between entertainment and high culture that is in contrast to the situation in Europe, where there is still a remarkable continuum between popular and more elite art forms. The French may be incensed about an invasion of American popular culture, but they have little concern about their own local product.

The fourth type of authority is memory. The idea of the universal art museum as the Temple of Memory is, in Fumaroli's words, "the consummate definition of the modern museum, as it was invented during the French Revolution: the church and school of the new civic religion." Not only did the American separation of church and state make us more reluctant to involve the government in the arts, but also there is the fact that a commercial society such as ours is suspicious of memory, if not outrightly hostile to it. Ironically, this has only enhanced the American museum's importance as the essential institution for expressing, preserv-

ing, and authenticating memory. In the words of Harvard's Reverend Peter Gomes, "Ours is a society in which religion does not serve as a public glue."9 Increasingly our culture is defined by the mass media with the result that we are "starved for a usable past" and left with a craving for "something where we are both more than ourselves and less than ourselves." This longing for meaning and value is hardly unique to contemporary American culture, but in our society more than many others, people are turning to the museum for "a center that holds," a place that will provide continuity from the past to the present, and a structure with which to confront the future.

In this situation the art museum's importance, and ultimately its authority, comes from the fact that it is the institution, through the works of art with which it has been entrusted, that is best suited to deal with the question of time and, ultimately, our mortality. The art museum materializes time in a very unique and essential way, recording the history of human creativity as it is made tangible through the history of art. But unlike most chronological sequences of material culture, it does not claim to document progress. Rather, it defeats time, for unlike scientific truth, artistic quality is not a linear march forward, but a meditation on the complexity, diversity, and resilience of human creativity and expression By demonstrating the immortality of human aesthetic achievement, it provides both a source of hope and a reminder of continuity in the face of historical change. In this sense the art museum could be said to have become a secular church, the repository of a transcendent truth about the human condition. And of particular importance for this country, it is not a local, tribal memory, but a capacious, cosmopolitan one that, thanks in part to the predominantly international nature of the collections in our major museums, encourages the visitor to be an aesthetic citizen of the world rather than of a mere place.

Not only do the collections range over time, but almost every work of art with any age expresses signs of the authorship of time through aging pigments, fragmentary losses, and the countless other frailties that conservators call "inherent vice." But rather than diminishing their aura, these

changes often only add to a work's humanity and enhance its power as a vessel for memory. Monochrome, incomplete, and scrubbed as the Elgin marbles may be, would we choose to will them back to their pristine state?

The authority of memory is not dependent on its completeness or its scholarly depth, and indeed healing can often require a partial escape from consciousness. Joyce Carol Oates, writing on our response to the September 11 terrorist attacks expressed this poignantly: "Amnesia seeps into the crevices of our brains, and amnesia heals. The present tense is a needle's eye through which we thread ourselves—or are threaded—and what's past is irremediably past, to be recollected only in fragments."[10] Clearly there are times that we enter the Temple of Memory to help us forget.

The American museum has been criticized as overly pragmatic and puritanical in its claims for the educational and therapeutic contributions it makes to society. But the public looks to the museum for help in negotiating memory just as they count on us to preserve and present beauty. I think it would be fair to say that in today's frenetic, modern society there is a craving for both beauty and time—and, of course, with no time for contemplation, beauty is at best fleeting. In this context Elaine Scarry's observations on beauty, noted in James Cuno's essay, are very relevant to the museum experience and the relationship between beauty, time, and the sense of our own mortality that is always a contributor to a profound artistic experience. Scarry stresses, quoting Simone Weil, "seeing something beautiful de-centers you—it makes you give up your position as the imaginative center of the world."[11] This harks back to Reverend Gomes's state of being both more than ourselves and less than ourselves. And if one agrees with Scarry that such experiences encourage tolerance and a sense of justice, then the museum experience can be seen as both personally rewarding and socially positive.

A fifth type of authority exercised by the art museum is conservation. Our modern concept of art conservation was another by-product of the French Revolution. Both a heightened concern and the development of new and innovative conservation techniques paralleled the transformation of the Louvre in 1803 into the renamed Musée Napoléon under the

leadership of its first director, Vivant Denon, who was an artist and con-
noisseur as well as an inspired administrator. As works of art poured into
the museum—first those liberated at home and shortly thereafter those
looted from abroad—each took its place in the new context of chronology
and national schools. No longer parts of larger programs and architectural
ensembles that had aged harmoniously over generations, each object was to
be preserved from the ravages of time and restored to the original inten-
tions of its creator as scientifically as the techniques of the day allowed.

Marc Fumaroli cites the example of Raphael's *Madonna di Foligno*
taken from the altar of the Umbrian church of Sant'Anna delle Contesse
in Foligno, which on arrival in Paris was much in need of the skillful
restoration that was undertaken. However, following Napoleon's defeat,
on its return to Italy it bypassed Foligno at the request of the pontifical
authorities, who expressed concern for its future preservation; it became a
centerpiece of the Vatican Museums, where it remains today. Fumaroli
observes that "the argument in favor of the physical survival and conserva-
tion of works of art, more than the educational purpose assigned to them
by the revolution, proved decisive for the museum."[12] While the *Madonna
di Foligno* did not go home, its provenance was never in doubt. But the
question of provenance, particularly of archaeological material, and more
recently of works that may have changed hands illegally during the Holo-
caust, promises to continue to be a central issue in the years ahead. The
debate over the relative importance of a work as an aesthetic object or a
cultural artifact, and the demand of modern-day states that cultural patri-
mony claims take precedence over the museum's responsibility to collect
and preserve in the public domain, puts us at the center of an increasingly
heated struggle between competing claims of authority and, ultimately,
ownership.

The American art museum must define and exercise its authority
with particular care. In one sense it holds and conserves its collections in
trust for future generations, but in many of our museums the trustees
have ultimate ownership of these collections, while the buildings and the
land on which they rest are owned by municipal authorities. While this
situation, in clear distinction to the state ownership of almost all European

collections, has given the American museum flexibility and independence, particularly in such areas as hiring, acquisition, and deaccessioning, it ultimately puts an added pressure and responsibility on the institution to assure that in exercising this independence it does not undermine the public trust. We are fundamentally a self-regulated—although publicly subsidized through the tax code—sphere of our society. It is an enviable situation that must constantly be justified through the integrity of our actions and the quality of the experience we provide.

My sixth category, architecture, might at first glance appear to be one of the most obvious sources of the museum's authority, yet the extraordinary range of museum buildings produced in the United States over the past 150 years does not suggest a simple answer. In some respects architecture is destiny; as Winston Churchill observed, "We build and then our buildings shape us." Many of the first generation of American art museums, constructed in the later nineteenth century, were indeed built with great confidence and ambition, but the distinguished collections of originals that now justify their existence only displaced the plaster casts and reproductions over some time. In the case of the Art Institute of Chicago, one could almost say that the original building preceded the modern city. It was constructed as the only permanent project for the 1893 Columbian Exposition, and early photographs show a pristine Renaissance palace surrounded by rubble that was the residue of the Great Chicago Fire of two decades earlier (fig. 1). When in 1909 Daniel Burnham presented his ambitious Chicago Plan, it was clear that he had put his compass point at the heart of the museum and drawn an inclusive arc to the west, complemented by a necklace of public park land spreading to the north and south that would forever guarantee public access eastward to the lake shore. The Art Institute's founders, not unlike their parliamentary counterparts in London, had insisted that the building be at the heart of the future city, accessible to public transportation and the working-class population. This decision with regard to location certainly helped earn the public trust, but what of the building itself?

Susanna Sirefman wrote recently, "The ideal museum building cultivates both anticipation and memory while relating to its location and

FIG. 1 The Art Institute of Chicago, rear view of the Allerton Building, c. 1910

its community."[13] I would argue that the original Art Institute building on Michigan Avenue achieves this admirably. Its success depends on a humanity of scale rather than an authority of size. This result is quite miraculous when you consider that it feels perfectly proportioned to a city and surrounding park that at the time of its creation did not exist (fig. 2). At first this might appear to confirm the headline for a recent *New York Times Magazine* article, "Forget the Art—It's All About the Building."[14] To the contrary, this building made the very visible public statement—the trustees were committed to acquiring a permanent collection that only over time would justify the structure.

The authority of such buildings today flows from the fact that they symbolize a promise to the public that was made good many times over, rather than a mere architectural statement in their own right. The size and style of the individual building is ultimately far less important than its

FIG. 2 The Art Institute of Chicago and the School of the Art Institute, aerial view, 1991

relationship to the art that it contains. Structures as different as Philip Johnson's miniscule Pre-Columbian Pavilion for Dumbarton Oaks in Washington, D.C.; Louis Kahn's Kimball Art Museum in Fort Worth; Renzo Piano's Menil Collection in Houston; and, I am confident to add even without having seen it, Frank Gehry's new museum in Biloxi, Mississippi, designed to display the brilliantly eccentric ceramics of George Ohr; achieve their lasting architectural distinction from their ability to serve and enhance the collection. This is not to deny the brilliance of many recent signature structures, nor their impressive economic impact on depressed urban environments, but alone they do not assure the authority of the building as an art museum, and in some cases they may actually undermine it.

However, there is no doubt that there are some who even today feel that the museum's original purpose remains its fatal flaw, regardless of

the sensitivity of the architecture or the quality of the collection. One of the many contributions of Fumaroli's essay was to draw attention to the little-known essay "The Problem of Museums," written by Paul Valéry in 1925. In it he condemned the very concept of the modern museum as a mere assemblage of masterpieces torn from the contexts for which they were intended and through which they derived their meaning. Valéry described the visit to a museum:

> This stroll I am taking, weirdly beset with beauties, distracted at every moment by masterpieces to the right or left compelling me to walk like a drunk man between counters.... The ear could not tolerate the sound of ten orchestras at once. The mind can neither follow nor perform several distinct operations at once; simultaneous lines of reasoning are impossible to it. But the eye, within the angle of its sweep, and at one instantaneous glance, is compelled to take in a *portrait* and a *seascape*, a study of *food*, and a *triumph*, along with views of people in the most varying states and sizes; and it must also accept mutually incompatible color harmonics and styles of painting, all in the same look. Just as a collection of pictures constitutes an abuse of space that does violence to the eyesight, so a close juxtaposition of outstanding works offends the intelligence.[15]

Valéry concludes his lament by describing these collections as abandoned children: "Painting and Sculpture, says my Demon of Analysis, are both foundlings. Their mother, Architecture, is dead. So long as she lived, she gave them their place, their function and discipline. They had no freedom to stray."[16]

Brilliant and provocative as Valéry's essay is—and it should be read by every museum director and curator—I do not think he invalidates the modern museum, but rather makes us aware of its limitations. For while concentration and narrow focus have their profound rewards, an alternative and totally valid experience of works of art can also be achieved

by wandering through the world's great museums. This alternative experience, closer in spirit to that lauded by Baudelaire as an essential and rewarding aspect of modern life, analyzed by Walter Benjamin in his voluminous notes on the Parisian arcades, and paralleled by the modern techniques of cinematic montage and Cubist collage is not without its very unique pleasures. It may be derided as aesthetic shopping deprived of the fulfillment of acquisition, but to my mind that is part of its validity, and the building and installation that can successfully accommodate this experience while simultaneously encouraging the opportunity for pause and reflection, creating a counterpoint, one might even say, between the profane and the sacred, will be well suited to meeting the needs and desires of today's audience.

Put another way, today's museum must be secular, but not valueless. We need a contemporary belief system through which to experience art, but this is rarely the system in which it was originally created. Over time the appreciation and meaning of art is constantly changing. In each new cultural situation a context must be created in which increasingly diverse works of art are given value and encouraged to speak. For the past two hundred years Western civilization has realized that context through the art museum, where the myths of mankind, as they are articulated through works of art, can be experienced without the precondition of belief.

Let me briefly touch on two more vehicles for the art museum's authority and then examine what I feel are the primary challenges facing us today. The authority of mission is so central that it could be easily overlooked. What the appropriate mission should be in detail is specific to each museum; what the missions share is that to be authoritative they must be clear and understood by the board, the staff, and the public. To assure this over time, there needs to be a process by which it is periodically reassessed, taking into account past and current experience and the changing aspirations of each of these groups. The familiar litany of "to collect, preserve, and present" is common to the mission of most art museums, but it is the variations on these themes that give the American art museum community its vitality and much of its public value. Be it the

priority of a universal collection or the focus on a single period or artist, the ambition to produce definitive scholarship, or to enhance grade-school education, the mission can be seen as a form of contract with the public. There is no signed document, and most communities that make up our publics would be hard put to agree on a single spokesperson. The result is intentionally a relationship determined by trust, rather than law.

My final category, authority, is the leadership through which the mission is implemented. Capable management is essential for stability and success, but alone it is an inadequate claim to authority, for lacking leadership, management rarely anticipates and adapts to change. The authority of leadership is realized only by exercising it. The leader must have vision, conviction, and power adequate to overcome inertia or opposition. This power takes many forms, and the obvious advantages of financial means, social stature, and the sheer weight of tradition should not be underestimated, but to be sustained it must flow out of the achievement of a mission that over time is seen by society as valuable. However, these long-term advantages of prestige and respect cannot be achieved without surviving the increasingly intense competition in the present for financial resources, collections, exhibitions, the most qualified staff, and the most outstanding trustees. Furthermore, this competition is taking place in an arena where there have come to be dangerously eroded distinctions between art and entertainment, and philanthropy and commerce. This is also a moment when many trustees increasingly see their role as providing entrepreneurial expertise in managing the institution's assets, in contrast to the successful businessmen of the past, who believed the museum to be something very distinct from the commercial world, a higher realm in which to give back some of the fruits of their success to society.

Today the leader must determine where and how to compete and, most importantly, how to properly measure success to assure that it validates and reinforces the mission. Victory must be defined in terms of excellence that makes each museum distinctive, a unique destination in the eyes of the community and the world. Size is not the distinguishing factor. However, as the exercise of leadership becomes more and more overtly competitive, particularly in terms of fundraising and earned income,

this in turn exerts an increasing pressure to achieve short-term advantage at the expense of long-term goals, and the authority of the market can easily undermine and replace the authority of the mission. The most obvious example today is the professional limbo in which now exist decisions with regard to special exhibitions and the loans of important works of art—torn between the competing forces of scholarship and education on the one hand and profit and entertainment on the other. That a number of important loan exhibitions dealing with popular material have managed to successfully combine these often competing factors has not eliminated the tension that this has caused in the profession; in many ways those successes have only intensified the usually unspoken pressure on museum professionals to replicate this mix.

A comparable challenge to leadership is that of anticipating and realizing change without sacrificing the mission. As Ronald Heifitz has stressed, today's leader must increasingly exercise authority through respecting multiple interpretations. In other words, the voice of authority must often become an umbrella that invites a wide range of interpretations and often concedes that there is more than one authoritative point of view of a given aspect of reality. The leader has authority over an arena, in our case the art museum, where multiple viewpoints are debated by experts. The challenge is for the institution, and particularly its leader, to be seen as exercising the authority of freedom of discussion, but not endorsing relativism. Heifitz asserts that today's leader must try to "build an architecture for diversity" that can incorporate a more plural view of the truth in response to our own changing society and its increasingly global context.[17] In his mind, the art museum can provide a welcome and non-denominational sanctuary that embodies the plurality of truth. But to return to our earlier analogy, this sanctuary has no bishop's throne. Rather, the museum director must mediate between the authority of excellence and elite values on one hand, and the egalitarian authority confirmed by a democratic society on the other, while simultaneously avoiding that "tyranny of the majority" that de Tocqueville had predicted would preclude America from supporting anything other than popular culture.

In conclusion, let me turn to my final question: what are the current challenges to the museum's authority that we must anticipate and meet? Clearly there are many, but I would like to focus on two dangers that I feel most threaten a museum's ability to remain true to its mission. These are, first, the danger of allowing theory to determine mission, which narrows one's actions to the ideologically correct; second, allowing the market to determine mission, which leads to commercialization.

First let me emphasize what the challenge is not. It is not, in my opinion, the heightened atmosphere of competition. This has been with us to varying degrees since Charles Willson Peale unveiled his original museum in 1786 with the intention of "amusing and instructing" his visitors. Competition is a basic source of legitimacy in our society and a natural and healthy outgrowth of the same soil that determined that our museums would be primarily private rather than organs of the state. And it has been pointed out repeatedly that our very lack of social cohesion, with its competing claims and expanding diversity, has been essential to the nation's success and the creation of our most important artistic contributions. Similarly, the mounting of large popular exhibitions is not a problem per se. They have a long history, the Armory Show having been presented in Chicago in the galleries of the Art Institute, and as long as they are held to the same high qualitative standards as those demanded of the permanent collection, they have proven to be an excellent vehicle for scholarship, publication, and the introduction of new audiences to both a specific topic and the museum as a whole.

Returning to the two areas I feel pose the greatest threat: What is the danger of theory? In many ways the very idea of the modern museum was an intellectual response to the rational theorizing of the Enlightenment. In Fumaroli's words, "From the very beginning there was an element of abstraction in the idea of the museum, an impersonal side, like a bureaucratic and scientific reserve, which could produce a chilling, intimidating, and ultimately sterilizing effect."[18] But at the museum's core was the commitment to promote beauty and qualitative distinction, which placed priority on the original aesthetic object and the viewer's ability to experience it under optimum conditions. Scholarship could provide an important

means, but only a means, to enhance an experience that was ultimately inexplicable.

Postmodernist theory has challenged these assumptions as well as the very possibility of a hierarchy of talent, objective judgment, and aesthetic autonomy. As Neil Harris has noted in his recent essay, "The Divided House of the American Art Museum," the absorption with self-improvement and social responsibility that has characterized American museums over the last three decades has been paralleled by increasingly strident "critiques of Post-Enlightenment History, supplemented by contemporary investigations into audience composition that have essentially eviscerated a whole range of reformist institutions that have long laid claim to progressive admiration: hospitals, reformatories, public school systems, universities, libraries, and museums. These institutions, and others like them, turned out (in the eyes of these critics) not to be trophies of benevolence, but disciplinary devices in an extended class war."[19] These writers, many of them French, found particularly fertile ground in the United States, where the ideals of democracy are more freely applied to the artistic realm and aesthetic elitism grates against egalitarian convictions. As Harris notes, today "only the university rivals the museum among contemporary institutions in its simultaneous position of prestige and vulnerability to criticism."

I would argue that the American art museum is true to both our democracy and Constitution in that it provides access to works of art assembled according to qualitative criteria and defends their elite nature rather than diminishing the claims of beauty and excellence in the name of theoretical justice. Alfred Barr's imperative that the museum exercise "the conscientious, continuous, resolute distinction of quality from mediocrity" should remain our ambition. And particular emphasis should be given to the word *continuous,* for this assures a process that embraces change rather than a timeless canon. I am suspicious of the condescension of theorists who assume the unindoctrinated public is defenseless against the manipulation of art and museums, and would be better off unexposed. Kirk Varnedoe has said it succinctly: "The notion that ulti-

mately it is the theory which is the viable and worthy part of art history—
this seems to me an entirely rank prejudice."[20]

And finally, while many of these theorists question the legitimacy
of the museum's authority there is a simultaneous and often only slightly
veiled desire to usurp that authority for their own social agendas. The
claim that museums should be a catalyst for social change is heard contin-
uously, both from the right, where the need is often seen to be one for
censure, and from the left, where the museum is frequently held up as an
ideal vehicle for progressive reform. The challenge for the museum is to
be socially engaged, but not partisan, to pick the path that transcends nar-
row ideologies while knowing full well that controversy should not be
avoided for its own sake.

The often anxious relationship between the mission of a not-for-
profit institution and the opportunities and seductive dynamism of the
marketplace is not a new one. The ideal of economic independence secured
by an adequate endowment and reliable sources of annual support from
trustees and members was a model that bore a substantial relationship to
reality until the late 1960s, which saw the beginning of the relentless and
intertwined pressures to expand physically and cover an increasing pro-
portion of the mushrooming operating budget through earned income,
traits that now characterize the majority of America's art museums. There
has been and will continue to be a welcome role for the entrepreneur
within the not-for-profit sector as long as the measurements of success
are not allowed to be reduced to mere numerical and financial calculations.
But we must be constantly vigilant that the market does not usurp the
authority of the mission. Even at Harvard a widely respected new initiative
in the business school to help improve the skills of those managing not-
for-profits prefers the designation "social enterprise."

Over the last decade the often creative synergy between market and
mission has shown dangerous signs of losing a proper sense of balance.
Much as the French Revolution had done two centuries earlier, the sudden
but unexpectedly peaceful end of the Cold War in 1989 marked a histori-
cal turning point that we are still struggling to digest. For the American

art museum two effects have become increasingly clear. At home and in much of the rest of the world, the free-market system was seen as the ultimate, unchallenged source of legitimacy, and by extension, authority. Abroad, the acceleration of globalization increasingly equated American art with the most commercial aspects of our popular culture. This is in vivid contrast to the perception, cultivated by our government's support and promotion in the 1950s and 1960s of the ideal of individual freedom of expression and the then avant-garde artists who personified it. The history of our National Endowment for the Arts has mirrored this evolution.

I would like to think that this "market fundamentalism," to use George Soros's term, has peaked in light of the economic and political events of 2001–2, but the real test for the American art museum will be the specific types of authority that we choose to exercise in the years ahead. For if we were to accept the authority of the market as our ultimate source of legitimacy through choice or default, experience can guarantee two results. First, that we cannot win playing by the rules of the commercial world no matter how much we debase our mission, and second, that unless the role of the market is restricted in accordance with the mission, it will demand preeminence over all other forms of authority, resulting in a shift from nourishment to gratification, from teaching and expertise to entertainment and celebrity, from memory to manipulation, from conservation to consumption, from hierarchy to promotion and from architecture to spectacle. It turns out that de Tocqueville, once again, said it early and succinctly, asking, "What kind of despotism do democratic nations have to fear?" His answer, as summarized by Adam Gopnik, was "a paternal, invisible despotism of entertainments."[21]

In conclusion, have the events of September 11 shed any light on the question of the authority of the American art museum? Clearly they have been a searing experience that has forced people to look into themselves—and this is the domain of art, not theory or commerce. Since then we have been able to clarify what the American museum stands for through stark contrast to the values of fundamentalist belief. As Ian Buruma wrote recently in the *New York Review of Books*, the creed of those determined to overcome modern, and primarily Western, civilization is the antithesis of "the Post-

Enlightenment, Anglo, Franco, Judeo, American West that sees itself as governed by secular, political institutions and the behavior of all citizens as bound by secular laws. [For us] Religious belief and other matters of the spirit are private.... Our laws do not come from divine revelation but are drawn up by jurists."[22] Ultimately the American art museum's authority must flow from its ability to be one of the most tangible and accessible forums for the experience of excellence, the affirmation of tolerance, the appreciation of personal expression, and the pursuit of individual happiness embodied in our Constitution. Guaranteeing the integrity of this forum has never been more important, and to the degree that we succeed, our museums will indeed be worthy of the public trust.

NOTES

1. Alfred H. Barr, Jr., quoted in Calvin Tomkins, "The Modernist: Kirk Varnedoe, The Museum of Modern Art, and the Tradition of the New," *New Yorker*, 5 Nov. 2001, 72.

2. David Carr, "Balancing Act: Ethics, Mission, and the Public Trust," *Museum News*, Sept./Oct. 2001, 30.

3. Michael Kimmelman, "Museums in a Quandary: Where Are the Ideals?" *New York Times*, 26 Aug. 2001, sec. 2, p. 1.

4. While contemporary views of authority often link it derogatively to masculinity, we should not lose sight of the "female" side of the museum inherent in the word itself and the idea of the muse as a feminine force of creation and inspiration.

5. Marc Fumaroli, "The Birth of the Modern Museum" and "What Does the Future Hold for Museums?" in *Masterworks from the Musée des Beaux-Arts, Lille*, exh. cat. (New York: Metropolitan Museum of Art, 1992), 1–30, 284–91. I am indebted throughout this article to this essay and to conversations with its author.

6. Ibid.

7. Quoted in Robin Pogrebin, "Inheriting Uneasy Truce between Arts and Politics," *New York Times*, 24 Dec. 2001, sec. E, p. 1.

8. James Elkins, "The Ivory Tower of Tearlessness," *Chronicle of Higher Education*, 9 Nov. 2001, sec. B, p. 7.

9. Peter Gomes, in conversation with the author, 2001. All other quotations in this paragraph from Peter Gomes are from this same conversation.

10. Joyce Carol Oates, "Words Fail, Memory Blurs, Life Wins," *New York Times*, 31 Dec. 2001, sec. A, p. 11.

11. Simone Weil quoted in Elaine Scarry, *On Beauty and Being Just*, (Princeton, N.J.: Princeton University Press, 1999), 111.

12. Fumaroli, *Masterworks*.

13. Susanna Sirefman, "Formed and Forming: Contemporary Museum Architecture," *Daedalus* (summer 1999): 298.

14. Deborah Solomon, "Forget the Art—It's All about the Building," *New York Times Magazine*, 9 Dec. 2001.

15. Paul Valéry, "The Problem of Museums," in *The Collected Works of Paul Valéry*, vol. 12, ed. Jackson Mathews, trans. David Paul (New York: Pantheon, 1960), 203–4.

16. Ibid., 206.

17. Ronald Heifitz, in conversation with the author. All other quotations from Ronald Heifitz are from the same conversation.

18. Fumaroli, *Masterworks*.

19. Neil Harris, "The Divided House of the American Art Museum," *Daedalus* (summer 1999): 49.

20. Kirk Varnedoe, quoted in Tomkins, "The Modernist," 72.

21. Alexis de Tocqueville, quoted in Adam Gopnik, "The Habit of Democracy," *New Yorker*, 15 Oct. 2001, 216.

22. Ian Buruma and Avishai Margalit, "Occidentalism," *New York Review of Books*, 17 Jan. 2002, 6.

A Deontological Approach to Art Museums and the Public Trust

Glenn D. Lowry

DIRECTOR, THE MUSEUM OF MODERN ART, NEW YORK

THERE ARE MANY ways to explore the question of art museums and public trust. I take as my point of departure the American art museum, though my comments may, in a general sense, apply to European art museums as well. But it is important to remember that American art museums are primarily private entities that are accorded public status, whereas European museums are, for the most part, civic and state institutions. For European museums the question of public trust may be different, as they are by statute public entities and as such are no different from many other types of governmental agencies. The complex relationship that exists between most American art museums and the public does not necessarily apply to European art museums, or at least apply to them in the same way as it does to our art museums.

I have decided to approach this question of public trust from a personal angle, one that reflects my own understanding of art museums and why the issue of public trust has become so important now. In doing so I hope to underscore the point that public trust is first and foremost an issue of responsibility, which the *Oxford English Dictionary* defines as being morally accountable for one's actions. I hope, as well, that I might provide

some insights, if not answers, to a number of questions posed by several recent articles about art museums. I refer specifically to Roberta Smith's "Memo to Art Museums: Don't Give Up on Art," and Michael Kimmelman's "Museums in a Quandary; Where Are the Ideals?"[1] two extremely provocative essays that explore, in their own way, the issues of public trust that museums must contend with as we begin a new century.

Public trust has emerged as a central question for art museums in large part because while museums appear to be pushing the boundaries of acceptable practice in terms of their marketing, fundraising, programming, and ambition, there are as yet no clear rules as to what is appropriate behavior. Shifts in museum practice are being driven by the fact that art museums have changed from quiet sanctuaries of discovery and learning to intensely visited sites, often frequented by thousands of people a day. How similar to a for-profit corporation can an art museum be, for instance, before it is no longer a not-for-profit institution? At what point do good business practices come into conflict with the core values of mission-driven institutions? Can art museums compete against other forms of leisure activity without giving up their educational mandate or affecting adversely the unique experience they provide for the general public to look at art? It is within this context that Smith asks the question, "What do art museums want?" since, as she says, "it increasingly seems that they want to be anything but art museums," while Kimmelman argues that "museums are at a crossroads and need to decide which way they are going. They don't know whether they are more like universities or Disneyland, and lurch from one to the other."

The immediate cause for Smith's query were two exhibitions she found deeply flawed: *Giorgio Armani*, presented at the Guggenheim Museum (fall 2000) and *Made in California: Art, Image and Identity, 1900–2000*, presented at the Los Angeles County Museum of Art also in 2000. The former, Smith suggests, turned the Guggenheim into a department store; the latter converted LACMA into a historical society. In doing so both consciously avoided dealing with the objects on display as works of art.

Kimmelman, responding to what he sees as the inexorable democratization and commercialization of art museums, argues that this has

resulted in a crisis of confidence on the part of museums that can only be solved, as he puts it, by "less equivocation, less democracy, less blurring of the line between commerce and content, and a reassertion of authority on the part of museums."

Smith and Kimmelman have a lot more to say about art museums. But underlying each of their essays—as is evident in their titles, which suggest that museums are confused and afraid of art, that many have ceased to be venues of artistic inquiry and discovery—is a sense that the public trust art museums enjoy has recently frayed. Smith makes this point emphatically when she concludes: "We needn't worry about museums lending their vaunted imprimaturs to dubious art forms of visual and material culture or inferior artworks. Any museum that does so often enough will lose that imprimatur. A few more shows like *Armani* and it won't matter how many architectural masterpieces the Guggenheim can afford to build; they will just be rentable exhibition halls."

None of this, of course, is to take away from the fact that art museums have also become highly successful enterprises that are now universally acknowledged as the preeminent civic institutions of our time. In the United States alone there are currently some 3,500 art museums and according to the most recent statistics they are visited by over 68 million adults a year, an astonishing number that works out to roughly one out of every three men and women in the population.[2] Every major city either wants an art museum or wants a bigger or better one. Supported by a booming economy, intense civic pride, and the local and state governments' growing awareness of the economic benefits of cultural tourism, museums across America have become the defining public institutions of their communities, often housed in spectacular new buildings or additions designed by internationally celebrated architects. This is as true for large urban museums like The Museum of Modern Art as it is for smaller ones like the Pierpont Morgan Library or rural ones like the Sterling and Francine Clark Art Institute.[3] Fueling this growth is an unprecedented level of philanthropy. At last count over $3 billion had been committed since the late 1990s to various museum projects across the United States, and despite the recent slowing of the economy, new projects continue to be developed.

Given the success and popularity of art museums there is a certain irony that their credibility is now being questioned. But it is precisely the institution's popularity that has, in many ways, brought it under closer scrutiny. As art museums dramatically increased their audiences, adopted marketing strategies from the business world, and began demonstrating that they could generate substantial economic returns for their communities, the public and the media started to take a much closer look at their operations. And with this attention came an awareness that art museums, like other institutions, are not perfect, that they occasionally engage in questionable practices, whether allowing a sponsor to effectively buy an exhibition, or ceding curatorial control to a donor or collector, or programming exhibitions solely to generate income, or entering into arrangements that involve real or perceived conflicts of interest. The most notorious recent example of this occurred at the Brooklyn Museum of Art, when it presented *Sensation*, an exhibition of young British artists from Charles Saatchi's collection, and found itself initially under attack by the mayor of New York for displaying what he perceived to be blasphemous art, and then by the press for being less than forthright about a number of facts, including whether Saatchi was also a major financial donor to the exhibition. This is not the place to go into great detail about this exhibition (too much has already been written about it), but I do want to underscore one point. And that is that despite the Brooklyn Museum's attempt to portray what happened to it as a battle for artistic freedom of expression against a mean-spirited mayor and an unsympathetic press led by the *New York Times*, this is not what really transpired.

To be sure, the crisis was provoked by the mayor's rash actions, and the museum had to fight to keep its doors open. But the museum's protection under the First Amendment was never in doubt, as was clear from extensive pre-existing case law, and like every other major paper the *New York Times* defended Brooklyn's right to present the exhibition. What the *Times* and other papers criticized repeatedly was Brooklyn's apparently intentional misleading of the public over the way in which the exhibition was financed. Having promoted *Sensation* with a highly inflammatory advertising campaign that centered on the slogan, "Health Warning: the

contents of this exhibition may cause shock and vomiting," and deployed the marketing tactics of a major movie studio, the museum discovered that it was now the subject of the very attention it had generated; and the media, not to mention the public, did not like what it saw. The museum's programs and practices were scrutinized and its ethics were questioned, and even its most ardent supporters wearied of defending the institution against the constant barrage of accusations that came from the press and the public at large. Indeed, this scrutiny was so intense, and its implications for other museums so potentially damaging, that the American Association of Museums took the unusual step in the aftermath of *Sensation* of adopting new guidelines concerning the financing of exhibitions and the avoidance of conflicts of interest in order to bolster public confidence in museums and demonstrate to lawmakers that museums are capable of policing themselves.[4] Whatever gains the museum may have had in attendance and profile were more than offset by the fact that this came at the cost of public trust in the institution.

But what is public trust? How is this trust created, and what does it mean to lose it? Is the concept of public trust an ethical or legal one? And to what extent is it pertinent to discussions about art museums? Why, we might ask, should we care about this term at all? By public do we mean a community at large, or more specifically, the subsection of a larger community that museums actually serve? Are the interests and concerns of the public that any one museum serves the same as another one? These are questions, of course, that can never be fully answered but they make clear, I think, that the concept of public carries with it both the possibility of a very broad definition and a much more particular one, but in both cases must be understood as denoting a group of actual or potential beneficiaries of the museum's activities and programs.

Let us turn then to the notion of trust to see how it modifies the term *public* to create the concept of public trust. *Trust* can be defined either as property held by one party for the benefit of another party or, more abstractly, as the confidence, faith, integrity, or justice we place in ourselves or others. Charitable trusts in the United States, such as museums, hold their property or assets for the public at large even if they are

privately financed and owned. And in return for engaging in activities that benefit the public interest, they are granted special privileges, such as tax exemptions.[5] If they want to retain those benefits they must act in a way that ensures the public retains faith or confidence—that is, trust—in their activities. To do so they must act with integrity and justice.

Public trust is thus a multivalent term that implies both a set of responsibilities—to preserve, protect, and enhance property held on behalf of the public—and a code of conduct to ensure that this responsibility is discharged with the highest degree of skill and diligence.[6] As public institutions, museums are expected to act and behave in a way that is in keeping with the perceived values they embody. This is true regardless of whether or not they are privately or publicly funded, civic or state institutions. We want our art museums to be places of repose and contemplation; venues of discovery and learning, awe and wonder, where we can become absorbed in the power and beauty of art. We do not expect them to have to deal with labor disputes and the harsh realities of the work place, and when and if they do, we expect them to act in a way that is consistent with the values espoused by the art they display, no matter how practical or appropriate this may be.

But museums, especially large metropolitan ones, long ago ceased to be simply quiet abodes of the muses, if they ever were. They have become highly complicated institutions with extensive collections, staffs, and publics that include annual visitors, members, individual and corporate supporters, artists, tourists, and scholars, as well as those who may never actually visit a museum but who believe in their mission. These institutions compete fiercely with each other, as well as with other cultural venues and forms of entertainment, for funding, attention, and prestige. Like universities and hospitals, they operate in a highly charged environment where they have to constantly balance the pursuit of their core mission with the practicalities of managing large budgets and multiple responsibilities, from exhibition programs to libraries and restaurants.

And yet, except for guidelines concerning fiduciary responsibility and conflicts of interest that are monitored in each state by its attorney general, there is very little that defines what constitutes acting within the

public trust. In many ways it is up to individual art museums to establish a relationship with the public—or at least those segments of the public interested in their activities—and then to act in a way that is consistent with their understanding of the museum. In this sense, the concept of public trust must be seen as negotiable and responsive to evolving expectations and conditions. We may never be able to define precisely what is meant by public trust but we know when it is present in the relationship of an art museum to its public, and by implication when it is absent. The onus is on the institution to carry out its mission with skill and intelligence, and with an understanding of the parameters of what it can and cannot do, before it finds that it is impairing the public trust. *Sensation* and the Brooklyn Museum illustrates the museum's dilemma: no one decision of the Brooklyn Museum amounted to much more, perhaps, than an instance of poor judgment, but taken together these decisions precipitated a crisis and resulted in a breach of public trust.

There are, of course, some areas to which recognized rules of proper behavior apply. The most obvious example is the practice of deaccessioning works of art, where there is a general consensus that this is acceptable only when the proceeds are used for acquiring more works of art, though even this rule is not absolute.[7] The difficulty in defining appropriate or acceptable standards for art museums is exacerbated by the media, which play an important role in determining the nature of the public trust by providing a forum for debate, discussion, and the formation of opinion but are deeply conflicted about this issue. Kimmelman, for instance, who is a keen observer of art museums, argues that art museums need to assert their authority by emphasizing their commitment to art and avoiding blurring the line between commerce and content. But at the same time, he can write admiringly about exhibitions like the Guggenheim Museum's *Brazil: Body and Soul*, despite the fact that the show is, as he put it, "part 1970s nightclub, part trade fair, part boutique, part construction site," in which the installation "vies with the art it ostensibly caters to."[8] Similarly he can affirm the need to respond to the ethical import of aesthetics, a point he makes in "Museums in a Quandary," yet ignore the ethical issues raised by the fact that *Brazil: Body and Soul* is as much a development and marketing exercise

to facilitate the Guggenheim's efforts to launch a museum in Brazil as it is anything else. I do not mean to belabor Kimmelman's inconsistencies, but they serve to underscore the fact that art museums are currently operating in an ambiguous climate, where the rules and expectations are neither clear nor easily ascertainable and even the most astute of critics is capable of holding contradictory, if not mutually exclusive, opinions about them.

This may all seem straightforward but it begs the larger question: what is an art museum? That is, what specifically is there about art museums that distinguishes them from other similar kinds of institutions, and what precisely is the trust that the public has in them? There are, of course, fairly obvious answers to the question "what is an art museum?" that have to do with their role in the acquisition, preservation, study, and interpretation of objects.[9] It is this aspect of the art museum that James Cuno, among others, has so ardently and eloquently spoken about on many occasions. I would like to suggest, however, that what gives art museums their particular importance is not the specific set of responsibilities they take as their mandate nor even the authority they derive from the objects in their collections but that they are ontologically distinct institutions, whose significance lies in the fact they are based on, and devoted to, the exploration and experience of ideas through unique works of art.

Every art museum began with the ideas of its founder or founders. But unlike other educational institutions, except to some degree libraries, museums are devoted to transforming and translating their founders' ideas into concrete reality through the presentation of tangible and authentic objects set in a particular place. Even museums that emerge on the internet, if they do, will have to be grounded by ideas that are articulated by discrete works of art located at a specific site, though that site may only exist as an address in cyberspace. It follows from this that no two art museums are alike since no two can, by definition, share the same idea and the same set of objects, not to mention the same building and community. Architecturally and programmatically this means that there can never be a single typology for the art museum, since each museum is unique.

This may help explain why art museums have become such platforms for architectural statements: for the combination of typological freedom and the desire of the trustees and donors of these institutions to create internationally recognized buildings to bring prestige and recognition to their community allows architects an almost free hand in their design. This may also explain why the Guggenheim's strategy of franchised or satellite art museums, while potentially lucrative, is, from an intellectual perspective, inherently flawed. Or, put differently, the Guggenheim has moved from being a mission-driven educational institution devoted to the display and interpretation of its collection—that is to the realization of the ideas of its founders embedded in the art it holds in trust for the public—to an entertainment complex, a point that it is quite open about. Here, for instance, is Ben Hartley, former director of communications and sponsorship at the Guggenheim: "We are in the entertainment business and competing against other forms of entertainment out there. We have a Guggenheim brand that has certain equities and properties. By doing these cross fertilizations [with the fashion industry] we get a crowd that perhaps doesn't typically come to Guggenheim openings, but if they are here for a party and happen to look at the art and come back again, that's valuable to us."[10] This is not to criticize the Guggenheim alone. Indeed, as early as the 1950s, Dwight MacDonald, writing in the *New Yorker* about The Museum of Modern Art, recognized that art museums were not simply or only about art. They were, he said, like nine-ring circuses, and the traditional function of preserving and displaying art takes up only one of their rings.[11] A decade later Albert Ten Eyck Gardner, a curator at the Metropolitan Museum of Art, made this point even more strongly when he noted:

> [The museum] is in fact a modern hybrid with the mingled characteristics of the cathedral, the royal palace, the theater, the school, the library, and according to some critics, the department store. As the emphasis or activity shifts, the character of the organization changes. Thus when the Museum serves as a place of entertainment it takes on the dramatic quality of the theater, when it is used for scholarly purposes it can become

an ivory tower, when its educational activities are stressed it
becomes a school. In the family of social institutions invented
by man, the place of the museum is not fixed. It is pliant and
develops in many directions, or sometimes moves simultane-
ously in several directions.[12]

What distinguishes the Guggenheim from other art museums is that
rather than keeping a fine balance between the museum as school and
theater, a place of learning and a place of enjoyment, it has focused its ener-
gies on becoming an entertainment center and appears to be no longer
interested in or committed to the ideas and the art that gave birth to the
museum at its founding. While some critics like Christopher Knight of
the *Los Angeles Times* have argued that art museums need to understand
that they are, in fact, just a new form of mass entertainment,[13] or as Kim-
melman more elegantly phrases it, that they are in the business of rational
entertainment, or entertainment grounded in a sense of quality,[14] I think
they miss the point that there is a difference between being entertaining
and entertainment, or more precisely, that museums can be places of
pleasure without having to be places of entertainment.

The distinction between pleasure and entertainment is important.
It is all too easy to fall into the trap set by Susan Sontag's essay "Notes on
Camp," where she argues for the importance of camp—or kitsch—as an
aesthetic experience of exaggeration, extravagance, artifice, glamour, and
style that can provide the answer for how to be, as she phrases it, "a dandy
in an age of mass culture."[15] But Sontag's witty advocacy of camp ignores
the difference between standardized, commercial forms of entertainment
and culture; that is, between the exploitative and the sincere, the ephemeral
and the enduring, hype and history, and easily leads to equating art with
entertainment.[16] Art museums should be venues of pleasurable experi-
ences, they should be amusing and delightful places where the act of dis-
covery and learning is enjoyable and engaging, part of a matrix of institutions
that operate in what the German philosopher Jürgen Habermas calls the
"public sphere" within which ideas and images, instruction and pleasure
are transmitted to the public.[17]

Since at least the seventeenth century in the writing, for instance, of Dryden and Boileau, this linkage between learning and pleasure has been closely associated with education. This is what Charles Willson Peale, the founder of the first public art museum in America, meant when he used the term "rational amusement,"[18] as opposed to Kimmelman's "rational entertainment"—to describe his museum as a place of edifying diversion rather than raucous partying or idle entertainment.[19] The word *entertainment* generally carries with it a negative connotation or value. It is derived from the French *entretenir*, meaning "to engage the attention of someone" or "to amuse." There is no sense of self-discovery or understanding associated with entertainment as there is with the notion of pleasure, which is also derived from the French, but in its original sense is self-reflexive. Entertainment uses pleasure and amusement to manipulate someone by drawing his or her attention away from one thing toward another. Its goal is to distract and provide an antidote to boredom, often by creating spectacles or events that divert one's attention from the realities of life.[20]

Art museums derive their validity from their unique ability to articulate and shape our understanding of why works of art are singularly important, why they deserve our attention and respect. Although the art museum has evolved enormously over the last two hundred years, it is worth remembering that the origins of the term *museum* lay in the ancient Greek word for the abode of the muses, or the nine sisters who were the offspring of Zeus and Mnemosyne (memory). As the children of Memory, the muses are closely associated with the act of thinking and remembering, essential aspects in the process of learning and creativity. It is from this aspect of the muses that we derive the contemporary meaning of the verb *to muse*, "to be absorbed in thought, meditation or contemplation," experiences fundamental to the act of making and looking at art.

The idea of the museum derives from Plato's academy and the Alexandria of the Ptolemies in particular, but the institution as we know it today is primarily a creation of the Enlightenment. Like other institutions of the Enlightenment, the museum was construed to be fundamentally educational, a venue for the systematic organization and presentation of artistic, natural, and scientific phenomena. Inherent in this is the idea of

the museum as a public space, dedicated to the diffusion of knowledge. The great museums of the Enlightenment—the British Museum or the Musée du Louvre, for instance—epitomize this effort to create a taxonomy of both the natural and artistic worlds in order to make them intelligible and accessible to a broad public.

This notion of the museum stands in stark contrast to the medieval *Schatzkammer*, or treasury, and the *Kunstkammer*, or cabinet of curiosities of the Renaissance, where odd rarities were brought together for private contemplation and pleasure. But the Enlightenment ideal of the museum as an instrument of broad public education has always been tempered by the reality, evident in the *Kunstkammer*, that looking at art is as much a sensory experience as it is a pedagogical one, a point understood by Charles Willson Peale as well as by artists of our time, for example Claes Oldenburg, whose Mouse Museum is a highly personal collection of made and found objects that celebrate the pleasures of consumption.[21]

Not surprisingly in our secularized and fractured world, art museums have also become, for many, places of religious or quasi-religious experience, the cathedrals or temples of our times, an idea that has its origins in German Romanticism, where museums were seen as shrines to the cult of art and places to contemplate sacred objects.[22] For an ever-increasing public today, the ability to spend a quiet moment contemplating art in the midst of a hectic day, often in an architecturally notable space, makes possible the kind of spiritual repose and intellectual regeneration so essential to our emotional and psychic well-being.

The great museums of the United States founded in the late nineteenth and early twentieth centuries, such as the Metropolitan Museum of Art, the Museum of Fine Arts, Boston, or the Philadelphia Museum of Art, were founded on the Enlightenment model but unlike the British Museum or the Louvre, they were privately owned and financed institutions. They depended for support not only on the relatively few wealthy individuals who founded and subsequently supported them, but also on their ability to establish and nurture a relationship with the communities in which they exist. These museums freely borrowed from classical architecture the language of the temple to infuse their buildings with an

imposing sense of dignity that set them apart from other civic institutions and linked them in a very visible way to the origins of democratic thought, making manifest their role in a constitutional and egalitarian America. At the same time art museums took as their mission the populist ideal, first articulated in post-revolutionary France, of sharing the imperial and aristocratic treasures of the past with a broad public. To do this required developing not only extraordinary collections but also far-reaching educational programs that could make these works of art resonate with meaning and come alive for a new public.

The advent of museums devoted to the art of the present, a movement that began in the United States in the 1920s and that gave rise to The Museum of Modern Art, among other institutions, further broadened the educational mission of museums to include developing a public appreciation and understanding of modern art. And with this new mandate came new relationships, often heated and contentious, with artists, the general public, and the media as the distance between contemporary practices and the space of the museum collapsed.

What makes all of this pertinent is that by giving a context to the ideas that gave rise to their founding, and the objects that make manifest those ideas, art museums became centers of intellectual, cultural, and social activity. By intellectual, I mean that art museums create a heightened awareness of one's environment by engaging the mind in an act of thinking and communication. This is what compelled Reger, in Thomas Bernhard's satiric novella *Old Masters*, to return over and over again to the Kunsthistoriches Museum in Vienna to sit and stare at Tintoretto's *White-Bearded Man*. He had to go there, he said, in order "to be able to exist," to think and to feel—in short to be alive.[23]

By cultural, I mean that art museums are about a discrete activity that involves the communication of ideas and values through looking at and thinking about art. They are fundamental, in this sense, to the preservation of the artistic legacy of the past and the making of that legacy meaningful to the present.[24] This is what Philip Fisher wants us to understand when he says that the subject of the museum is not the individual work of art but relations between works of art, both what they have in common and

what in the sharpest way clashes in their juxtaposition.[25] As such, museums respond to and help shape our understanding of ourselves and can either reflect and validate existing social values or underscore their absence.

By social, I mean that they are places of public activity where one goes not only to see works of art but to be with, and frequently to meet, other people. Kimmelman in "Museums in a Quandary" relates this aspect of the art museum to the tradition of *flânerie* and the notion that art museums are intriguing gathering spots in an increasingly diffuse urban culture. Or, as Christopher Newman in Henry James's great novel, *The American*, remarks to his long-lost friend who claims never to have been to the Louvre before, "It seems to me that in your place I should have come here once a week." For Newman had just encountered the charming Mlle Noemie there while discovering the power of Raphael, Titian, and Rubens, whose paintings presented him with what James called a "new kind of arithmetic" that left him slightly unsure of himself but curious to learn more. Herbert Muschamp, another critic at the *New York Times*, once said in conversation—and he was being serious—that the sculpture garden at The Museum of Modern Art was the best place in New York to pick up a date. And more than one couple has tried to have their marriage at the museum in front of the work of art where they first met. This is also why, after the tragic events of September 11, 2001, there was such an expectation on the part of the public that museums would play a role in New York City's healing process by providing safe and secure sanctuaries where people could go to think and meditate in the presence of art and in the company of other like-minded individuals seeking solace and inspiration.

Seen in this way, the space of the art museum is an inherently public or civic space. By this I do not mean simply the physical space of the museum, but also its psychological space. Art museums in this context need to be understood as quintessentially urban institutions that play a critical role in defining the intellectual and physical fabric of cities and towns. By public space I also mean that museums need to be seen as part of what Hannah Arendt called the "common world." The institutions that make up this world, like art museums, are premised on the notion of transcending time and creating the possibility of making a permanent home

of the earth for man. They constitute a world constructed of durable things, artistic achievements, cultural practices, and actions commemorated in history, preserved and passed down through time, linking generations of the past to the present and the present to the future.[26] Art museums, in particular, are a vital part of this world as their collections encode a complex curatorial narrative formed over generations tracing what Proust called "le fil des heures, l'ordre des années et des mondes," the continuous thread through which the institution's identity is constructed.[27] As such, art museums serve as a vital link between what Herbert Muschamp has called the "history of place" and the history of ideas. What makes all of this possible is that museums provide a critical public forum where works of art become engaged in a complex dialogue with the public. Every installation or display of a collection argues for a certain reading of that collection, for a certain understanding of the history of art, and above all, for the role of the museum as a center of intellectual and artistic activity. This is true no matter how simplistic or complicated, obvious or nuanced the approach. For the narratives articulated by an installation only become meaningful when they are part of a public discourse; otherwise they exist simply as abstract hypotheses

The point I want to make here is that this idea of the museum as a fundamentally public space intersects with the notion of it as a locus of public trust. For insofar as public trust means retaining the confidence of the public, museums must be perceived to be acting both responsibly and for the common good. This requires that art museums—*at a minimum*—inspire confidence in the public that they have made considered judgments about what works of art to collect or to borrow, about how those objects should be displayed and for what purpose, and about what exhibitions and programs to present. John Walsh commented about this earlier, in part, when he discussed the impact of lighting, installation design, and crowding on how museums fulfill their obligation to the public trust. Underscoring this activity is the presumption that all of the objects displayed or collected by art museums have been legally acquired and are genuine. It is this aspect of the museum that has led the philosopher Andreas Huyssen to argue that art museums are one of the few places left in our hyper-mediated

world that still offer authentic experiences based on real objects. In the same way, it is assumed that the exhibitions and programs made available to the public by museums are the result of a fundamental commitment to the artists and ideas these exhibitions and programs represent.

As civic institutions, art museums form one of the few common spaces that can accommodate the interests and needs of the most elite and privileged members of society with those of its more marginalized and disadvantaged, in the same way that they also allow for both shared experiences between groups of users and highly personal or intimate experiences between individuals and discrete works of art. In doing so museums constantly mediate between the very real expectation and concerns of the individuals who constitute their public and the more idealized and lofty expectations of society at large. When the difference between these two conceptions of the art museum becomes sufficiently distinct, the situation puts at risk the public trust in the institution as its practice does not fulfill the public's expectation of it.

Take, for example, what recently happened at the Smithsonian Institution. Under tremendous pressure by Congress to increase private philanthropy at the Institution, the Smithsonian has accepted a number of major gifts that came with considerable conditions. Among the most contentious of these was a $38 million grant from the Catherine Reynolds Foundation to the Museum of American History to create an "American Achievers" program. The grant was subsequently rescinded by the donor due to the Smithsonian's inability to fulfill its original commitment to her. Under the terms of the arrangement the Smithsonian agreed to allow the donor a voice in selecting individuals to be honored through her gift and in naming the members of the commission that would actually pick individuals to be honored. Shortly thereafter General Motors agreed to sponsor a GM Hall of Transportation with a $10 million gift, also at the Museum of American History.

The near simultaneous announcement of these gifts provoked a series of attacks by the press, public interest groups, and the Smithsonian's own staff for having compromised the Smithsonian's integrity as a public institution by appearing to have allowed, on the one hand, an individual to

exert undue control in the use of her gift, and, on the other, a corporation with a specific interest in an installation to name a space meant to reflect an entire industry. The Smithsonian's own Congress of Scholars criticized the Institution's secretary for having "obligated the Museum to relationships with private individuals that breach established standards of museum practice and professional ethics," and concluded that "of all the acquisitions made by the Smithsonian in over 150 years, the most significant by far is the trust of the American people."[28]

While the Smithsonian has worked hard to correct the perception that it violated any standards in accepting these gifts, the intense media scrutiny it received combined with both internal and external critiques of its actions has left it vulnerable to the charge that it "sold" the very commodity that makes it a valued and trusted institution. Or put differently, the public expects museums, and especially art museums, to act in a manner that is always above self-interest. We may want our museums, even our national museums, to be more self-sufficient, more able to raise funds from the private sector, but not if that comes at the loss, real or perceived, of intellectual independence or institutional integrity.

The issue of public trust for art museums, then, can be seen as a question of responsibility, of balancing public expectation with institutional needs. The degree to which art museums are judged to be acting responsibly is determined in large part by their ability to articulate their role and function in society in a way that the public and media can appreciate and approve of. Within this context it is assumed that art museums will behave in a way that is consistent with the responsibility and trust invested in them by society and codified by the privileges they receive as not-for-profit institutions. This has never been an easy task but it has become increasingly complicated as museums have had to respond to the challenges of increased competition, changing social values, and diminished financial resources, all of which have compelled them to stretch the boundaries of accepted museological practice.

The tension between art museums and the public trust they enjoy is likely to increase as museums grapple with how to operate responsibly in a global environment while responding to the pervasive force of highly

sophisticated commercial enterprises that freely borrow their look and approach from the art world. Globalization, of course, is not a problem unique to art museums, but with the extension of their programming through the internet, the idea that an art museum serves a definable or even recognizable public needs to be reconsidered. And with this reconsideration must come an understanding that the trustworthy performance such a public expects from museums may need to evolve as art museums seek to position themselves as part of a global network of artistic and educational possibilities whose guidelines concerning public trust will inevitably be different from those at a local level.

Of more immediate concern for art museums is the impact of what John Seabrook has called "nobrow" culture, an awkward though apt term that describes what happens when the line between art and commerce becomes so blurred by combining culture and marketing that one is indistinguishable from the other.[29] This is a world where, as Seabrook puts it, "One walks out of shoe shops, jewelry stores, and art galleries, and the shoes, the jewelry, and the art don't seem any different from one another as objects."[30]

It is also a world where paintings by van Gogh and Monet can be star attractions at casinos in Las Vegas, while art museums devote exhibitions to motorcycles, fashion designers, and popular movies like *Star Wars*. The challenge for art museums in this new world, according to Seabrook, is to find out how "to bring commercial culture into the fold—how to keep their repertoire vibrant and solvent and relevant without undermining their moral authority, which used to be based, in part, on keeping the commercial culture out."[31]

The key term here is moral authority, which, I would argue, brings us back to the issue of responsibility and where we began. If art museums are to continue thriving they must recognize that their moral authority derives from the trust the public invests in them because the public believes they are acting responsibly and for the common good. Any diminution of that trust is ultimately a diminution in that museum's authority and credibility, and once lost, that trust is very difficult to regain. The question, however, is not whether art museums can find a way to embrace commer-

cial culture but whether they can demonstrate that there is a clear and discernible difference between art and commerce that is worth preserving. I recognize that this is not an easy task in a world where art and commerce can, and often do, merge seamlessly into each other, where museums can become part of vast entertainment complexes, and where museums are compelled to act more and more like commercial enterprises. The responsibility, however, belongs to art museums to deal with this problem by giving sharper definition to the distinctions between their activities and those of the commercial world. This means a willingness to distinguish between art and fashion, between the circulation of ideas and their commercial exploitation. It also means understanding that museums are only the nominal owners of the objects in their collection. They do not have the same freedoms as a normal consumer would in terms of how they display, preserve, interpret, and dispose of their collections. That is why the manner in which works of art are displayed in art museums matters in a very real way, and why deaccessioning is such a highly fraught activity.

Art museums will either be able to continue to define themselves as unique and necessary institutions whose values and practices merit the special position conferred on them by their non-consumerist status, that is public trust, with all of its concomitant responsibilities and benefits, or they will, in fact, be absorbed by an all-pervasive commercial culture, where the latest Prada store can be called by the *New York Times*, "A museum show on indefinite display," where Antonioni can be "recast as a shopping experience," and, where "Consumption takes the place of production in the post-industrial landscape."[32]

Art museums, in short, will be able to survive as mission-driven educational institutions only if they can continue to convince the public that they discharge their responsibilities with integrity and diligence; that there is a discernible difference between the discomforting challenge of genuinely new art and ideas, whether created a thousand years ago or just last week, and the immediate pleasure of shopping at a designer store or going to a theme park; and that they merit the public's trust in them, and that because of this it is worth according them a special status in order to fulfill their public mission.

NOTES

I would like to thank Louis Begley, Mary Lea Bandy, and John Elderfield for their thoughtful comments and much appreciated advice concerning this essay.

1. Roberta Smith, "Memo to Art Museums: Don't Give Up on Art," *New York Times*, 3 Dec. 2000, sec. 2, p. 1, and Michael Kimmelman, "Museums in a Quandary: Where Are the Ideals?" *New York Times*, 26 Aug. 2001, sec. 2, p. 1.

2. *Creative America: A Report to the President, President's Commission on the Arts and Humanities* (Washington, D.C.: National Endowment for the Arts, 1997, 6, and Christopher Knight, "Your Ticket to Eternity," *Los Angeles Times*, 5 Sept. 1999, 8.

3. For a recent discussion of the current museum building boom, see Suzanne Muchnic "Exercises in Thinking Really Big," *Los Angeles Times*, 5 Sept. 1999, 9.

4. David Barstow, "After *Sensation* Furor, Museum Group Adopts Guidelines on Sponsors," *New York Times*, 3 Dec. 2000, sec. E, p. 1. The guidelines themselves can be found on AAM's Web site, www.aam.org.

5. Joel L. Fleishman, "To Merit and Preserve the Public Trust in Non-Profit Organizations: The Urgent Need for New Strategies," in *Philanthropy and the Non-Profit Sector in a Changing America* (Bloomington: Indiana University Press, 1998), 3.

6. Mario C. Malaro, *A Legal Primer on Managing Museum Collections* (Washington, D.C.: Smithsonian Institution Press, 1995), 5.

7. The accepted constraints on deaccessioning can be found in Association of Art Museum Directors, *Professional Practices*, revised 2001. For an alternative view on deaccessioning, see Glenn D. Lowry, "Taking the Lid off the Cookie Jar," *ArtNews* 97, no. 3 (Mar. 1998): 90.

8. Michael Kimmelman, "Brazil in All Its Extravagant Glory," *New York Times*, 26 Oct. 2001, weekend sec., p. 29.

9. See, for instance, the definitions by the American Association of Museums and the Association of Art Museum Directors.

10. Ben Hartley, as quoted in Susan M. Kirschbaum, "Dinner, Dancing, and Oh, Yes, Art," *New York Times*, 14 Mar. 1999, sec. 9, p. 1.

11. Dwight MacDonald, "Profiles: Action on West Fifty-third Street, Part I," *New Yorker*, 12 Dec. 1953.

12. Albert Ten Eyck Gardner, as quoted in William T. Alderson, in "Introduction" to Edward P. Alexander, *Museums in Motion: An Introduction to the History and Functions of Museums* (Nashville, Tenn.: American Association for State and Local History, 1979), 14.

13. Knight, "Your Ticket to Eternity," 8.

14. Kimmelman, "Museums in a Quandary," 26.

15. Susan Sontag, "Notes on Camp," in *Camp: Queer Aesthetics and the Performing Subject: A Reader* (Ann Arbor: University of Michigan Press, 1999), 53–65.

16. Rochelle Gurstein, *The Repeal of Reticence: A History of America's Cultural and Legal Struggles over Free Speech, Obscenity, Sexual Liberation, and Modern Art* (New York: Hill and Wang, 1996), 275. This is an issue that Jerry Saltz picks up at length in his article "Downward Spiral," *Village Voice*, 12 Feb. 2002, 65.

17. Jürgen Habermas, *Strukturwandel der Öffentlichkeit* (Frankfurt: Suhrkamp, 1990). See also James Sheehan, *Museums in the German Art World from the End of the Old Regime to the Rise of Modernism* (New York: Oxford University Press, 2000), 15; Sheehan uses the word *entertainment* as opposed to pleasure.

18. Lillian B. Miller, *The Selected Papers of Charles Willson Peale and His Family: Volume 3. The Belfield Farm Years* (New Haven, Conn.: Yale University Press, 1991), 422.

19. I am grateful to Neil G. Kotler for his insights concerning Peale and his use of the term *rational amusement*.

20. I am grateful to Nora Burnett for her research into the meaning of entertainment.

21. See Kynaston McShine, *The Museum as Muse: Artists Reflect* (New York: Museum of Modern Art, 1999), 70.

22. Sheehan, *Museums in the German Art World*, 47.

23. Quoted in ibid., 104.

24. Quoted in ibid., 85.

25. Philip Fisher, *Making and Effacing Art: Modern American Art in a Culture of Museums* (New York: Oxford University Press, 1991), 8.

26. Gurstein, *Repeal of Reticence*, 9.

27. Roger Cardinal, "Collecting and Collage-Making: The Case of Kurt Schwitters," in *The Cultures of Collecting*, eds. John Elsner and Roger Cardinal (London: Reaktion, 1994), 68.

28. Bob Thompson, *Washington Post Magazine*, 20 Jan. 2002, 14; and Delia M. Rios, "Smithsonian Struggle Closely Watched by Museums Nationwide," *Newhouse News Service*, 27 June 2001.

29. John Seabrook, "Nobrow Culture," *New Yorker*, 20 Sept. 2000, 104.

30. Ibid., 104. In a similar manner Joseph Giovannini talks about loft culture in "Medium Kool," *New York Magazine*, 7 Jan. 2002, 105, as a place where art, fashion, performance are brought together in "a brew that dissolves high-low distinctions among galleries, museums, and shopping."

31. Seabrook, "Nobrow Culture," 106.

32. Herbert Muschamp, "Forget the Shoes, Prada's New Store Stocks Ideas," *New York Times*, 16 Dec. 2001, sec. 9, p. 1.

Art Museums, Inspiring Public Trust

Philippe de Montebello

DIRECTOR, METROPOLITAN MUSEUM OF ART, NEW YORK

I HAVE STRUCTURED my discussion on the issue before us—on the art museum and the public trust—in two parts. First, there is an introduction in which I give my own interpretation of the term *public trust* in order to make sense of the second part, in which I propose to examine the state of art museums today and consider how current trends may be affecting that trust.

It is interesting to note that about the theme of art museums and the public trust there is no dissent among the participants here. On the contrary, each, in his or her own way, underscores the centrality of public trust and expands on this theme. They do not show material differences in their points of view so much as variations in inflection and emphasis. Glenn Lowry, for example, emphasizes morality and ethics. On the other hand, like my view, Jim Wood's is rather less rooted in deontology. He interprets public trust as the "public's willingness to place confidence in the museum" and proposes the idea of authority as that which leads to that confidence. I fully agree, and in addition to authority, I will discuss also such notions as authenticity being central to public trust.

Important as well is the close correlation between public trust and a museum's reputation, a nick on either one constitutes a serious breach of both. In essence, a museum should have zero tolerance for even a single

derisory comment from a credible source occasioned by even a single wayward step away from its mission, and to that end, every effort should be made to assure the absolute integrity of all we do. This is why, as Glenn Lowry points out in his analysis of the *Sensation* exhibition at the Brooklyn Museum, the quest for what was no more than local notoriety did serious injury to the reputation of that institution—and who knows how much, by association, to the field as a whole. *Integrity* is thus another word that goes hand in hand with notions of public trust, and its meaning for our purposes should be taken broadly; namely, integrity in the sense of probity, and also integrity in the sense of independence—as of judgment.

It goes without saying that probity should be expected of the museum, as well it should in all human endeavors, certainly where conduct is concerned. But probity should be found deeper still, embedded in our mission, in our thoughts, and in our intellectual approach. Authenticity, too, remains at the core of public trust. For starters, and quite simply because, since what we promise is authenticity, that is what our public expects to find within our walls. So there must never be any question of a reproduction, a simulacrum, taking the place of an original work of art. Nor should information about works of art be distorted for political or other ends, including, as is increasingly prevalent, for marketing reasons. To give an example of the level of tolerance that exists widely for simulacra today—and here I'll give you an instance outside the museum field per se—let me simply draw your attention to a project, which you might have read about, that has the support of many at Unesco and elsewhere, to rebuild from new materials the monumental Bamiyan Buddhas destroyed last year by the Taliban (as you know, tragically there are no pieces left that are large enough to be of any use).[1]

I am convinced that such an ill-conceived project would constitute further desecration of a ruined site. It would be no more authentic than displays at theme parks and thus, an egregious betrayal of authenticity. Besides which, it would almost certainly fail as a public attraction as well. In this case, of course, it is the empty space—the niche within the carved rock—that remains authentic, and such a poignant reminder of the folly of the deliberate act of iconoclasm that created it. The reconstruction would

fail to attract many visitors because the loss of authenticity will have betrayed public trust and because, as I've indicated, authenticity is what the public expects to find at art museums and at archaeological sites, more so certainly than art historical information about which the public may have little inkling.

But it remains vital that the objects that visitors come to see be original. This is why I continue to believe, for example, that the electronic outreach engaged by most museums on their Web sites should not ignite concern among us that the public, so glutted with images from our collections, will no longer come to museums to see original works of art. Reproductions, no matter how good, cannot and will not ever replace originals.

Even assuming that an identical, clonelike reproduction of a work of art could be achieved, it would never supplant the original on which it was based, for it would lack that one crucial element, namely authenticity. Let me give an illustration. In standing before Velázquez's *Las Meninas* at the Prado, leaving aside all the historical and art historical data that accompanies one's appreciation of this consummate masterpiece, the visitor derives much of his thrill, in addition to his apprehension of the sheer beauty of the work, from his firm belief, his total and utter confidence, his absolute trust, that the canvas before him is the one that Diego Velazquez painted, the very one before which the explosive force of his creative genius transformed pigment into a miracle of painterly verisimilitude. The thrill comes as well from his complete trust in the fact that this object, and not another, not its clone, either on the museum wall or in a cyber-museum, not anything else, is the object before which Philip IV himself stood in admiration some 350 years ago. That magic, the magic of the original, the authentic, is what the museum can never lose, for the public will always demand it.

One further word on reproductions: it has been predicted that future generations will find the computer screen so thoroughly seductive that if ever technology permits the creation of perfect replicas, people will no longer make the distinction between original and reproduction; or even care. I think they will, which is why I gave the *Las Meninas* scenario.

But here we can do better than simply be theoretical. Bill Gates, the

founder and CEO of Microsoft, has given us tangible proof of how the distinction between original and replica can be clear for even the most technologically oriented person. For a few dollars Bill Gates could have made an excellent facsimile of the Leicester Codex by Leonardo da Vinci. Instead, at the very time he was trying to put together Corbis, a vast digital archive of works of art around the world, he paid millions of dollars to have the original for himself. That, I feel, is very telling.[2]

This is why the museum must never fear competition from any quarter for its public's attention, why, as I'll show later, it must not create meretricious programs in an effort to compete directly with what is strictly an illusory threat, the entertainment industry. Such wrong thinking crops up with increasing frequency, and is occasionally even articulated; a recent example was offered by the Guggenheim Museum's director of corporate communications in what amounts to an astonishing lack of trust in the institution's very reason for being, the work of art, the *raison justificative* of the museum. He said: "We are in the entertainment business, and competing against other forms of entertainment out there."[3] I will return to the issue of marketing a little later.

Finally, authority—that is the quality, in my view above all others, that causes the public to have trust in the museum. James Wood explained authority very well in this context, and I see no need to spend time essentially paraphrasing him. Let me simply state that authority is the quality projected by the institution as a result of its acknowledged seriousness of purpose, scholarship, respect for the works of art, and integrity as spokesman for their place, time, and creator. Authority is distinct, of course, from authoritarianism; it is neither prescription nor proscription; it is not the autocratic dictation, ex cathedra, of greater truths to lesser mortals. Indeed, authority carries within it the humility that is the mark of true scholarship: that is, it knows what it doesn't know and it calls for constant reassessment as new facts alter older beliefs. Rather, I mean authority as the search for and obeisance to truth. In a recent conversation I had with Tom Messer, former director of the Guggenheim, he put it this way, which I thought quite apt and elegant: "Authority affirms its credibility by the purity of its intentions." Indeed, authority does not give free rein to control and to dic-

tate, but rather to serve, and when I say serve I mean not only the public for whom we hold the artistic heritage of mankind in trust, but that heritage itself.

As I have just indicated, I believe firmly that authority inspires confidence and trust in the visitor, who feels secure in the knowledge that the finest scholarship informs the museum's programs and presentations. If I may, I would like to extend this cause and effect phenomenon to another, more strictly emotive level. I also believe that the sense of security and comfort that the institution's authority provides for our visitor, and his resulting confidence in the critical framework curators use in the selection of the art on view, allows that visitor, in viewing the art, to abandon himself totally, freely, to pure enjoyment. I say freely, because thanks to his confidence in the museum's authority, the visitor can allow himself the luxury of surrendering totally to the work of art, unconcerned that political, commercial, or other such considerations will have inflected the curators' judgments. Thus it may be said that it is the judicious exercise of the museum's authority that makes possible that state of pure reverie that an unencumbered aesthetic experience can inspire. That experience, the result of the free abandonment I've described—too lyrically perhaps—does not mean that the visitor must check his critical faculties at the door along with his coat; it merely illustrates one level of appreciation that museums, deserving of the public's trust, make possible.

I should also note that I do not view the museum's authority as a moral authority, although that is how the founding fathers of the Museum of Fine Arts, Boston, and of the Metropolitan Museum expressed it in 1870: "My friends, it is important that we should encounter the temptations to vice in this great and too rapidly growing capital by attractive entertainments of an innocent and improving character. . . . The influence of works of art is wholesome, ennobling, instructive."[4] Nearly a century and a quarter later the notion of moral authority was brought up to date, if you will, albeit in a different guise, by the American Association of Museums in its 1992 publication *Excellence and Equity*, which James Cuno, incidentally, cited in another context some years ago in speaking of the misplaced emphasis of museums on social activism. The publication opens with:

"Museums perform their most fruitful public service by providing an educational experience in the broadest sense: by fostering the ability to live productively in a pluralistic society and to contribute to the resolution of the challenges we face as global citizens; museums must help nurture a humane citizenry equipped to make informed choices in a democracy and to address the challenges and opportunities of an increasingly global society."[5]

Such rhetoric cannot serve to strengthen public trust in museums, which surely must take into account an institution's ability to meet the expectations it sets for itself. I don't think I need to dwell on how fanciful the AAM message I just quoted is. Were such pronouncements to be widely and popularly disseminated, which fortunately they are not (they are meant only for the happy few, for our small group of insiders), we should not be surprised if our publics were to wonder what in heaven we were trying to put over on them.

Let me now proceed to the second part of my discussion and offer a candid look at the state of museums today. I propose to examine some of the trends I see, looking to the future, and how public trust might be affected if these trends persist.

Reluctantly, I begin with the Lamentations of Jeremiah and thereby tip my hand: "The adversary hath spread out his hand upon all her pleasant things: for she hath seen that the heathen entered into her sanctuary, whom thou didst command that they should not enter into Thy congregation." Don't think I have become a biblical scholar; I am merely quoting Sherman Lee, the former director of the Cleveland Museum of Art, who began a talk with that quote in the late 1960s; he was reacting to Thomas Hoving's exhibition *Harlem on My Mind*, held at the Metropolitan in 1968, an exhibition of social history and photo journalism that contained scarcely any art.[6] And he was reacting also to public clamor for greater social engagement and "relevance" on the part of museums through the dispersal of their collections to local communities, all at the expense of their traditional role as repositories for works of art.

First off, though, let me be fair and acknowledge that art museums

have weathered the storm of the 1960s rather well, and to their credit they have responded to the strident and misguided arch-democratic voices of that era with a responsible and salutary opening up to the public, a wider public than ever, without compromising their core mission. Let me stress further that the degree of professionalism that informs all levels of museum work is as high today as I have ever known it. It is therefore a real shame that the conscientious, scholarly, and imaginative work that curators are producing today is so ill-served by their museums' policies in so many areas—policies that have let the merchants into the "temple," though perhaps not quite yet into the "sanctuary." But there are indications that further invasion may not be far off and that erosion of public trust may well have started.

So what is the condition of art museums today, and what are some of the danger signs about tomorrow? In the first place, I should note that museums today are much larger physically as well as in size of staff and budgets. By extension, they are far more complex and much harder to manage. Size in itself is not a problem, of course, but larger buildings do need to be maintained and larger budgets, fueled by money. The resulting pressures tend to lead to policies that are driven not by mission forces but by market forces. One sign of this is that with growth, and to an extent as a result of growth, museums have shifted from being repositories, primarily, to being activity centers—we are very far indeed from the application of Bernard Berenson's well-known aphorism, "The work of art is the event."

Quite the contrary, today's museums exhibit a high and often feverish level of activity, a plethora of programs and exhibitions that are born of a new focus that Harry Parker, director of the Fine Arts Museums of San Francisco, has characterized as "a shift of emphasis from collections to visitors."[7] Indeed, the work of art, once sovereign, has ceded primacy of place in many an administration's attention to the public. That there should be any apposition between the two is, in itself, regrettable. Recalling that, of course, what we are and what we do is for the benefit of the public, nevertheless the increased focus on visitors carries with it an interesting paradox, namely, that when the visitor, as opposed to the work of art, occupies center stage, he is likely to be less well served, not better

served. As the museum strives to attract him and please him, he will, inevitably, be catered to. That is, to ensure that he is counted at the gate, he will not be challenged. Instead, most likely he will be greeted, through the programs that are offered, at his present level of artistic sophistication. By definition that is not a broadening or enhancing experience of the kind that we are obligated by mission to provide.

I have indicated that the growth of activity in all sectors of art museums has coincided with their growth in size and operating budgets. Each, in a way, has fueled the other in a vicious circle that will now be hard to break, or at least that few would be so foolhardy as to attempt to break. The fact is that over the years, museums have added professional staff to mount more and more programs, and they have added even more administrative staff to support the effort across the board. The resulting increased costs, which are huge, can only be met by increased revenues and these, in art museums, are closely tied to attendance and admissions, and the ancillary income they generate in museum shops, restaurants, and parking garages. Thus, the continuing pressure to keep the public coming in ever greater numbers translates in pressure to mount yet more exhibitions (they are the greatest attraction for visitors), and success at the gate, it would logically seem, calls for subjects of a popular nature. Over and beyond this temptation to choose exhibition subjects primarily for their popular appeal, the trap in which museums are now caught, is that in order to maintain financial equilibrium, the dizzying momentum in the activity level must be sustained. Deceleration, on the other hand, would result in substantial deficits. At this point, therefore, any effort to try to reduce the overall activity level, as one would wish, would have to be matched by painful structural changes. Museums have become so hyperactive that banners furled and unfurled on museum facades do not indicate, I'm afraid, the glow of health but rather the flush of fever. The cure, whatever it is and whenever it is administered, may prove to be, as I've just warned, a bitter pill.

It should be pointed out that art museums' increased dependence on popular exhibitions and high attendance has had additional, unforeseen, and unfortunate consequences that have changed in a profound way

the interaction among museums themselves. This is a rather new and disturbing—not to mention hugely expensive—consequence of this hyperactivity, and it has to do with a new spirit of competition that has taken hold of the field and about whose consequences I shall speak in a moment.

What I propose first is to focus on the principal source of this competition, which is that museums in ever greater numbers are vying for exhibitions, blockbusters preferably, that perforce mostly explore the same limited number of subjects. After all, these shows are meant to appeal to a public whose range of interests in art, on the whole, is relatively narrow. And who but museums are to blame if that is so? If museums continue to spoon-feed the same subjects to its public, albeit in slightly different permutations, themes endlessly revisited because of their predictable popular appeal—most people, after all, favor what they already know—then the public will not learn to demand more of museums or of art, their horizons having not been sufficiently expanded. And that is a direct consequence of a clear breach of public trust—of yet another aspect of public trust—which is the obligation of the museum to return the favor, so to speak, and that is, to trust its public. It goes both ways.

Trust in one's public acknowledges what we all know to be true, what I have observed personally time and again, which is that the public is eager to learn, avid even for a chance to experience and discover new chapters in the history of art. If presented with the same degree of seriousness, clarity, and flair that we apply to all we do, then even the most recondite subject will find favor. A priori, for example, the art of Byzantium, or tapestries of the Renaissance, to use examples from the Metropolitan Museum, are not what you would expect to be popular subjects.[8] Yet these and innumerable other exhibitions of a somewhat arcane nature have proved enormously popular. The public knows full well the difference between pabulum served up to entice it into the museum—which it will ultimately resent, knowing it has been shortchanged in the process—and programs born of seriousness of purpose and true educational motivation. What is in question here is not an art museum's need to be responsive to its public—for it goes without saying that it should—but public approval based on trust, on the visitor's sense that he is not being

pandered to. In the end no one appreciates being indulged or patronized and it is by treating our visitors with respect that we will gain theirs, and—to reassure those who would focus on the bottom line—also their long-term loyalty and support.

To that point, it would be well to remember that Oscar Wilde may have been right in asserting, in the "Ballad of Reading Gaol," that "each man kills the thing he loves," for the public may well become sated over time with the themes it has, up to now, so willingly flocked to see. The trouble is that if, in the meanwhile, the public has not been challenged and taught to want more by museums, in fulfillment of their mission, then where will museums be?

The real dilemma of art museums, and one I struggle with daily, as do my colleagues—I concede this is likely to remain one of their greatest challenges in the future, and one for which I have no ready answer—is the need to reconcile a number of inherently irreconcilable factors. To wit: first, there is the desire to induct as many people as possible, across the gamut of humankind, into the wonders of art; second, and concurrently, is the need to show art in relatively uncrowded galleries in order to provide the serenity and quiet that the appreciation of art demands; third, the recognition that art is inherently difficult to access. To be fully appreciated and understood art requires a degree of attentiveness, concentration, and time that many people will not be willing to give it, thereby placing limits on just how many more people we can hope to attract. This last point, however, is such a melancholy prospect that I am bound to wonder if I have not posed the problem in the wrong way.

Should our basic quandary not be approached by asking instead what is it that we could or should do differently, and will it have to be radically different, to try to achieve our most democratic aims?

Whatever we do, it will not change the fact that works of art require on our part more than just a cursory glance. They do not blare out their message at the blink of an eye nor offer the quick fix provided by most amusements; that is the currency of the entertainment industry, of places whose business it is to provide easy gratification, such as theme parks, amusement parks, gambling casinos, shopping malls, and the like, and to

which, unfortunately, museums are increasingly being compared, and with which some museums, shortsightedly, attempt to compete—even to ally themselves—to gain audiences, as I indicated earlier. While for most of the public, visiting an art museum is a leisure time activity, and therefore a choice among attending say, a sports event, a rock concert, a theme park, a matinee, or the art museum, I don't believe the public equates these activities. At the moment, I am happy to say, the vast majority of art museum visitors, as a multitude of surveys confirm, go to art museums as a deliberate choice to raise their sights, to seek self-enhancement; perhaps it is linked with the phenomenon of declining leisure time that our public tells us it is seeking to offer broader horizons for their children.

A recent *New York Times* article described the equation of museums with malls thus: "Museums are the best entertainment bargain for everyone . . . museums are drawing people who yearn simply for social contact, for a safe place to trade ideas and discoveries with strangers. . . . Big museums are evolving into a blend of playground, café, and fair, making the experience easy and comfortable. For the foot-weary or the art-overloaded, there are places to rest, to eat, and even to hear music. In many respects, a well-run museum is eerily like a upscale suburban shopping mall."[9] The author of this piece did not mean to be disparaging, which I find almost as dispiriting as the fact that a number of people who should have known better reacted to the article with a wry smile of amusement: at the least, it should have been greeted with a shudder of unease.

After all, it is by clearly differentiating ourselves from all manner of entertainment that we maintain our integrity. Rather than competing with the entertainment industry for audiences—which is wrong-headed and bound to fail, incidentally—we must emphasize what makes us different and special, indeed unique, and capitalize on these differences: notably, authenticity and the wonder of art. Only then can museums hope to retain and capture a public that will be loyal, not fickle like those who would flock to some razzle-dazzle event, but a public that will return time and again, confident—indeed trusting in the institution's determination to fulfill its promise of an enriching and uplifting experience, one that is not watered down by misplaced popularization. The increasingly frequent

flirting of some art museums with spectacles of popular culture, such as *Star Wars* at the Brooklyn Museum, brings to mind Hamlet's chiding the actors, that their histrionics on stage "though it make the unskillful laugh, cannot but make the judicious grieve."[10]

When art museums rush to be commercial or seek to titillate their visitors we see a lamentable failure of nerve. Our institutions—even though often founded by businessmen in league with civic officials—were not created to make money and vaunt civic identity. They were based on deeper values, values that affirm human creativity on the part of individuals and civilizations—as my earlier recollection of the founders of the Metropolitan and the Museum of Fine Arts, Boston, makes manifest.

Let me pursue a bit more at this juncture the issue to which I alluded a moment ago, that of the art museum and the theme park and the blurring of the demarcation lines between the two. In the process I shall pay a brief tribute to Harvard's noted paleontologist, the late Stephen Jay Gould. Gould, as you know, was a master of high popularization, and a fan of theme parks, and he wrote so pertinently on this issue that I'd like to quote him at some length here. Gould, writing about the exhibition *Dinomania* at the American Museum of Natural History at the time of the showing of the film *Jurassic Park*, condemns the inclusion of plastic dinosaurs and articulated robots in the galleries as a lure for the public:

> All institutions have central purposes that define their integrity and being. Museums exist to display authentic objects of nature and culture—yes, they must teach; and yes, they may certainly include all manner of computer graphics to aid in this worthy effort; but they must remain wed to authenticity. Theme parks are gala places of entertainment, committed to using the best displays and devices from the arsenals of virtual reality to titillate, to scare, to thrill, even to teach. . . . I happen to love theme parks, so I do not speak from a rarefied academic post in a dusty museum office. But theme parks are, in many ways the antithesis of museums. Theme parks belong to the realm of commerce, museums to the world of education.[11]

Gould then concludes by saying museums don't need to compromise to attract visitors, for, as he says: "We have an absolutely wonderful product to flog, real objects; we may never attract as many people as *Jurassic Park*, but we can still attract many: because, luckily, and I do not pretend to understand why, authenticity stirs the human soul."[12]

Gould's wonderful words apply just as well, naturally, to art museums. So, permit me now to return to the issue of special exhibitions, and the new spirit of competition to which I alluded earlier, for it bears on our theme. It seems to me that if the public is to have total confidence in the integrity of a museum's programs, it must be reassured that they come about as the result of a process of scholarly detachment predicated on collegiality and civility. Unfortunately, these precious qualities have suffered of late in the near frantic quest for the next blockbuster. The works of art that constitute exhibitions are mostly borrowed, but there was a time, one I still remember, when loans were obtained after provision of a serious rationale, an intellectual argument that justified the movement of the work of art in question. Today, I'm afraid, for many loans, simply an ability and willingness to pay or trade will secure the work of art. Reciprocity, swapping picture for picture, is frequently demanded in exchange, often without an adequate scholarly imperative for the return loan. With some institutions, we have come to expect return loans as a new modus operandi, as the cost of doing business—you see the language one now uses?—and reciprocal loans are discussed routinely as part of the dialogue between borrower and lender. The practice is so pervasive that some institutions, mostly in Europe, have now practically institutionalized the reciprocal loan, and I quote from a recent exchange of letters with a major museum, which had granted the Met the loan of an important painting for a forthcoming show and to which we subsequently refused a loan for unassailable conservation reasons.

Upon receiving the declination letter, my European counterpart's reply consisted of a single sentence which reads: "It is with great regret that I am compelled to refuse you the loan of *x* which we had previously granted, in vain as it turns out, since you now deny us the loan of picture *y*, thereby breaking established principles of reciprocity." Clearly this is

outrageous. But what is deeply troubling here is that the European museum granted the painting x with no reference to an exchange, though it clearly anticipated one, a specific one as it turned out; in other words, when their request was formulated, it was taken for granted that we would be morally obligated to lend whatever they asked for in return. Unfortunately, what they requested was a very delicate early picture on panel, of the sort that is never lent, and decidedly never lent by the European museum that now demanded ours. In short, to guarantee the success of its exhibition, of which the Metropolitan's picture would have admittedly been one of the stars, they were willing to put an irreplaceable masterpiece at risk. This is not the way to maintain public trust.

Museum directors have all, in recent years, come to expect the granting of reciprocal loans as a fact of life, but responsible institutions must view that principle as a broad one based on a spirit of collegiality rather than on individual transactions, that is, object for object exchanges. Over time, institutions with favorable—and responsible—lending practices toward one another will find that loans balance out and equity is achieved.

Where potential lenders do not seek exchanges of works of art, then more and more, in a textbook exploitation of current market forces, large loan fees, well above reasonable handling and administrative costs, are also being extracted. Some museums have been known to offer substantial sums to secure major works on loan that their institution or scholarship would not otherwise justify, and entire exhibitions are circulating routinely in exchange for vast sums of money, as much as the market will bear. And if there weren't enough museums competing for works of art (often the same highly desirable works of art), a number of outside organizations have now joined the fray and are circulating loan shows for a fee. Even for-profit entities, such as corporations, are entering the arena: according to the *Wall Street Journal*, Clear Channel, a large media conglomerate, is now planning to organize exhibitions. The *Journal*'s article begins: "In an effort to move into the high-profile world of blockbuster shows, Clear Channel Communications Inc.'s museum unit will create an exhibit with the Vatican that includes rare art and artifacts."[13] Then we are told that

the company expects to be paid back from ticket sales and after it has recouped its costs, it will split further ticket income with the participating museums.

In yet another market-driven maneuver, some museums, in order to further assure themselves of the availability of major works of art for their exhibitions, are entering into formal but, it seems to me, artificial alliances, notably the Hermitage and the Kunsthistorisches with the Guggenheim. One not-so-obvious casualty of such alliances will be loans to serious exhibitions where the argument made for the work of art is highly specific and does not allow for a substitute. Already we have seen important loans preempted by exhibitions of the "treasures from" variety that have been organized for a fee.

Loans by necessity entail the physical movement of works of art and the concomitant risks in handling and shipping, and for those reasons alone we have the duty—the absolute duty—to consider most carefully the nature of the requests that we receive. We must ensure that the exhibitions to which we lend have a seriousness of purpose that truly warrants taking the calculated risk inherent in the loan of a work of art. In turn, we must make certain that the exhibitions for which we seek loans offer a similar unassailable, scholarly rationale. This speaks directly to art museum's obligation not simply to the public of the moment, but to the public of the future. This is a dual obligation: to provide proper stewardship for art through its care in conservation, display, loans, and the like, and to train and develop museum professionals, and—indeed—the public that will sustain humanistic stewardship for the art of the past.

Here I am led to underscore another critical aspect of public trust, the other side of the coin, if you will. Namely, our sacred obligation, often forgotten amid museums' new focus on visitors, not only to the public, but also to the works of art in our care and of which we are the trustees for posterity. I've already spoken of our responsibility not to put works of art unduly at risk; that is in the nature of caring for their physical well being. But on another plane, not so easily defined, we also owe works of art this: that they be treated with dignity and propriety. Over and beyond the traditional art historical and museological attention we pay to works of art, we

owe them respect and we must be mindful of the context in which they are shown and of the place where we propose to show them. It must be appropriate, and it must become them, which is why I was always uneasy about exhibitions in Japan presented on the top floors of department stores and wonder now about Las Vegas hotels as venues. In the end, it is a matter of decorum.

I know it has become popular to suggest that museums should not be removed from everyday experience, indeed that they should blend in as much as possible; that point has been made frequently, and most forcefully recently by Robert Venturi, in his apologia for the Seattle Art Museum, of which he is the architect. Some have suggested that it is public-spirited to advocate that in order to reach the communities we serve, we should seek to demystify the museum-going experience. I must say, I view our role quite differently; in fact, as the very opposite. In our largely prosaic and materialistic world, where the factitious holds sway, it is the mystery, the wonder of art, that is our singular distinction and that our visitor seeks. So, it is precisely by distancing the visitor from what Sartre called "the monotonous disorder of daily life" that we best serve that visitor.

Admittedly, the climate I have sketched out relative to exhibitions is not a reassuring one, and both the integrity and the authority of museums have been weakened in the process. Inherent as well in the public trust are issues of credibility and expectations, which I raised earlier in citing the inflated rhetoric of an AAM document that promised far more than what museums could or should deliver. This leads me, finally, to return to the issue of marketing and promotion as an area where the public trust, our public's confidence, can so easily be shaken. How we market our museums tells much about how we view ourselves, and we should not expect our public to be unaffected by such attitudes.

So what are we telling our public in our relentless use of superlatives that makes us sound like town criers or ringmasters? Are we certain the public is convinced by our repeated claims that what we present is always the first, the biggest, the best, or the only of something? Credibility is not achieved by stretching credulity. Public trust is not served by false or exaggerated claims, and I'll concede we're all a bit guilty on that score and

we must be more watchful of what we take credit for. What is the public to think, for example, when a museum, in this case the Museum of Fine Arts, Houston, declares, upon the completion of two new buildings, that it is now "the sixth largest museum in America"? The claim may be true quantitatively when it comes to square footage, but the institution's standing as far as its collections are concerned—surely the more important gauge—has not changed that markedly. In being thus careless—it's really nothing more than that—museums risk sowing the seeds of doubt about all else they may declare or claim.

Also, what message are museums sending when they broadcast their own lack of faith and confidence in their primary purpose? The Victoria and Albert Museum's ill-conceived advertising campaign of a few years ago is infamous, but worth recalling in this context. You will remember that the museum, in a bid to shore up declining attendance, advertised itself as a café with "art on the side." You surely recall the controversy it ignited. It may seem petty to dwell upon semantics here, except that I believe in words and their ultimate betrayal of the user's real thoughts, or at least inclinations. So it is that we find in some museum Web site promotions, for example, the medium confused with the message, as we are entreated with fervor to "visit the museum on the Web." We still need to get to the front door to visit a museum—it's something else we get on the Web, such as information about the museum. Even the Louvre oversteps the bounds as it announces "le musée c'est chez vous, venez voir"! I'm sure no one at the Louvre is suggesting that people stay home and get on line in order to visit the museum; but that's what the message says, as phrased.

Please understand, I don't take these types of promotions literally, and they are not serious transgressions, but they do represent a certain slackness, or sloppiness, of approach about which we should be careful; people do pay attention to what we say. In the same vein, if we are to argue for the premium that our public places on expertise, and not diminish the role of the curator, then we should not loosely proclaim, as does one museum Web site, as it invites you to click on to images at will, so that "now you can be your own curator."[14]

Likewise, the phrasing of a recent promotion by the Museum of Fine Arts, Boston, although stressing its many programs, strikes me as unfortunate, its slogan being: "Much more than a museum," the *just* being implied. This is hardly a cardinal sin on the part of this great institution; it's a little thing. But it points to something that is not quite so little.

If, in their promotions, museums convey that they are uncomfortable with the notion of being "no more" than what they are, then what can they expect the public to think? And if in their promotions intended to entice visitors, museums feel that they must skirt the issues of art and excellence and speak of their primary role only obliquely, then what they themselves indicate is a lack of regard, indeed a lack of trust, in their public. This is why I have stressed that one aspect, and not the least, of the art museum and the public trust, with which I conclude, is the need for reciprocity, for matching faith in one's own mission with faith in the public's ability and willingness to share in it. For the public is key to the precious colloquy engaged in by the principal players on the museum stage: the art, the curator, and the visitor. It's very simple, really: To earn and keep the public's trust, we must not sell the public short. If we keep this covenant, the mission will always retain primacy of place—to the benefit of both the institution and the public.

NOTES

1. Martin Bailey, "Bamiyan Buddhas May Be Rebuilt," *Art Newspaper,* 1 Mar. 2002.

2. An exhibition to just this point was mounted at the Seattle Art Museum. See Trevor Fairbrother and Chiyo Ishikawa, *Leonardo Lives: The Codex Leicester and Leonardo da Vinci's Legacy of Art and Science,* exh. cat. (Seattle: Seattle Art Museum, 1997).

3. Ben Hartley, as quoted in *New York Times,* 14 Mar. 1999, sec. 9, p. 1.

4. W. C. Bryant et al., *A Metropolitan Art-Museum in the City of New York: Proceedings of a Meeting . . .* (New York, 1869), 1.

5. *Excellence and Equity: Education and the Public Dimension of Museums* (Washington, D.C.: American Association of Museums, 1992).

6. Allon Schoener, ed. *Harlem on My Mind: Capital of Black America, 1900–1968,* exh. cat. (New York: Random House, 1968).

7. Harry Parker, as quoted in Marjorie Schwarzer, "Turnover at the Top: Are Directors Burning Out?" *Museum News* 81 (May/June 2002): 42.

8. *The Glory of Byzantium* (11 Mar.–6 July 1997) and *Tapestry in the Renaissance: Art and Magnificence* (12 Mar.–19 June 2002).

9. Ann Cronin, "Museums: The Sluggers of the Cultural Lineup," *New York Times,* 9 Aug. 1995, sec. A, p. 1.

10. *Star Wars: The Magic of the Myth* (April 2002). See Michael Kimmelman, "The 'Star Wars' Effect, And the Part That's Art," *New York Times,* 5 Apr. 2002.

11. Stephen Jay Gould, "Dinomania," *New York Review of Books,* 12 Aug. 1993.

12. Ibid.

13. Anna Wilde Mathews, "Clear Channel Plans to Exhibit Rare Art from the Vatican," *Wall Street Journal,* 2 May 2002, sec. B, p. 2.

14. After I gave this talk, it was pointed out to me that the Metropolitan's own Web site invites visitors to "curate" their private exhibition on line. *Mea culpa,* and needless to say, this unfortunate wording has since been changed.

Round Table Discussion

James Cunö, *Courtauld Institute of Art*
Philippe de Montebello, *The Metropolitan Museum of Art*
Anne d'Harnoncourt, *Philadelphia Museum of Art*
Glenn D. Lowry, *Museum of Modern Art*
John Walsh, *J. Paul Getty Museum*
James N. Wood, *Art Institute of Chicago*

JC: We thought from the beginning that each of the talks would be interesting, but that it would be equally helpful if we all gathered at the end, having read each other's essays, having lived with this project for nine months, to amplify and refine our formal remarks and address certain things we didn't take up in our own individual talks or that were suggested by others.

Everything I heard over the course of the lecture series leads me to believe that our subject, Art Museums and the Public Trust, struck a chord with both the museum visitor and the museum professional. I heard over and over again that our lectures needed to be published because the question of the public's trust in art museums is a central one at the moment. For more than a decade, people noted, we have enjoyed uncritical popular support and enthusiasm. (There was criticism, of course; but mainly from academics or politicians, not members of the general public.) But now that's changing. Too often museums have been linked to scandal or questionable practices. And people are beginning to wonder about museums, about what and whom we stand for. We are on the verge of joining the

other distrusted professions—lawyers, politicians, the clergy, and corporate executives.

I was reminded of this the other day by an editorial cartoon that showed two men in front of a newspaper stand, the surface of which was covered with newspapers with problematic headlines about Arthur Andersen, Enron, Tyco, sex scandals in the Catholic church, baseball players on steroids, and so on. And one man said to the other, "Oh, for the old days when it was only the government that you couldn't trust." Now, evidently, we can't trust anyone; perhaps, sadly, even museums.

JNW: How much did we contradict each other? I felt an almost suspicious consensus. There was plenty of variety in our remarks, but other voices could have offered more contradictory viewpoints, perhaps.

JC: I didn't intend our series to be representative of our field of museum practice today. I thought other voices had already been heard, in newspapers and magazines, and in the almost hagiographic elevation of a couple of our colleagues. So I thought this is a chance to offer another point of view. I selected you all because I thought we would agree on many things but not on everything and that our disagreements would be just as interesting as our agreements. After all, however much we might agree on the basic purpose of art museums, we are responsible for very different kinds of museums—from the larger, encyclopedic, and international museum to the smaller, more highly focused, and regional, even the university-based museum.

ADH: I felt one of the most compelling remarks was made by Philippe toward the end of his talk, which was that museums need to have trust in their public in order to have their public's trust.

JC: "Don't sell the public short," I think is what you said.

PDM: We certainly have found and observed it in other institutions, and it really goes back to the adage that you can fool some of the people some of

the time, but not all of the people all of the time. And I think that remains a truism.

ADH: I think what's also very interesting is that we have found, oddly enough, that it is sometimes easier to raise funds with greater success for less obvious projects than for what we think of as the easier ones. We raised every cent that we needed for Barnett Newman, but we haven't yet raised enough for an exhibition about Degas and his passion for the dance. In other words, I find that one can in fact raise money more easily for exhibitions of lesser-known subjects than for better-known ones.

PDM: We have had exactly the same experience with a couple of very strong Impressionist shows that attracted no funders. And I wonder if in fact it isn't due to something that many of us put forward in our essays, that is, we might think that in order to draw the public to our museums we have to provide them with what is known and popular. But the public, and with them the donors, may be tiring of yet again being asked to support another Impressionist show. There is something rather exciting about being asked to support a Barnett Newman exhibition, something that's very different from what we normally do. Could it be that I am being just a little too optimistic?

ADH: I'm not sure that you are. Anyway, we do have to distinguish between corporate and individual supporters. I think the whole world of fundraising for exhibitions, fundraising for museums, has changed. We're counting less on corporations now and more on individuals. We've always counted on individuals, but I think a higher proportion of exhibition support, certainly in Philadelphia's case, and I would guess in MoMA's too, comes from individuals than it used to? No?

GDL: No, it's turned around in the last five years. When I arrived, and this I think is just coincidental, we couldn't get a corporation to fund an exhibition. Philip Morris, for example, which had funded a lot of major shows, was pulling back. That is, maybe every once in a rare while we'd get a

corporate sponsor. Now, in the last couple of years, corporations have started to flood us with questions about what shows we might have for them; and these were corporations that we've never worked with before. But I think that's episodic. What strikes me as more interesting and more closely related to the question of public trust is the fact that corporate support is being spread over a much broader range of possible exhibitions. And I think the reality is that if we do what we do well, if we put together a program that is strong, clear, and articulate, it galvanizes support, whether it's from the public at large, an individual donor, or a corporation. And I think the reality is that the museums that are really committed to outstanding programs are getting support for those programs.

JNW: So identification with the institution is as important or even more important than with the individual exhibition, you would say?

GDL: I think so.

JNW: I agree. I wish corporations were lining up to support the Art Institute of Chicago's exhibitions, but they're not. But when they do, I think it's as much because they want to be identified with the institution as with the individual exhibitions we are discussing.

JC: And do you think that has as much to do with the quality and integrity of the institution as it does with its "brand name," so to speak?

JNW: Those two things are intertwined.

ADH: I think the overall liveliness and quality of what the institution does is the hardest thing to quantify, because it's all about reactions to quality over a long time, over a period of years. I don't think the word *brand* is particularly helpful. But certainly what the Art Institute in Chicago stands for and acts for is what counts. I mean, it's perceived as a tremendously active public institution.

JC: But there is some talk among some members of our profession about "brand," about manufacturing "brand" and sustaining "brand," using the terminology of the marketplace or the corporate world. And my sense is that a "brand" is something you impose on something, like "branding" a steer. It's not something "of" the museum, something that emerges after years of doing good work in the eyes of the public. It's more like something you decide to market after discussions in back rooms and after observing focus groups. It's about an image you want people to have about you; not what you've earned, not what they've taken away after experiencing you over many years. "Brand" is about fashion. It's disposable: in this year, out the next. I think we've seen some museums try to emphasize their "brand" or manage their "brand" and seek connections or relationships with funders that might want to trade on that "brand." In the end, such a strategy only reveals the hollowness of the institution that employs it.

JW: It's a short-term strategy, by definition.

JNW: It's a self-destructive strategy.

ADH: Brand and reputation are just totally different.

JC: In our understanding, they are. But business people tell me that that's not true for business, that "brand" is built on reputation. But you and I see reputation as something different, something developed over a longer period of time.

GDL: But I also think it cuts to the heart of the difference between the for-profit and the not-for-profit world. The for-profit world has a language and a set of expectations, a code of behavior and a structure that operates differently from those of the not-for-profit world. And there has been an invidious migration of business strategy into the not-for-profit world. This isn't to say not-for-profit institutions can't be run better or managed better,

but I think that the notion that the same methodology that applies to the for-profit business world can also be applied to the not-for-profit world is profoundly wrong.

JNW: Do we feel that that climate is changing maybe a little more in our favor, maybe that there's a little less blind knee-jerk market fundamentalism?

JC: Where did the pressure come from in the first place? It didn't come from the public. Did it come from the trustees who in their professional lives speak the language and think the thoughts of the for-profit world?

JNW: It came from different funding sources, from both trustees and government.

ADH: I think government pressure was calling for something very different.

JNW: I don't mean the endowments [NEA and NEH]. I mean governments saying, "we want you to justify yourself in terms of your economic impact on the community." You know, more bottom-line business strategies than pure philanthropy, or tax money going for just a long-term accepted educational purpose.

ADH: I think the pendulum is certainly swinging back. Our mix of board members—and there certainly are business people on the board—are much more muted in their sense that a museum is in fact like a profit-making corporation. Those voices were more voluble and more naive ten years ago than they are today.

PDM: So you think the distinction between wanting the museum to be run in a businesslike manner as opposed to its being run like a business is well understood among our trustees and funders?

JNW: Increasingly understood.

GDL: In fact, I think you can make the argument that the for-profit world has an awful lot to learn from the not-for-profit world about how to manage the public's trust. So far, by and large, museums have managed to retain the public's trust, while corporations have not. We all are suffering, but not the way corporate America is suffering. Museums have not squandered the public's trust; we are conscious of the need to preserve it. And I think this series of essays will help to sharpen the focus on this subject. Not that the public's trust in museums hasn't been in jeopardy in certain recent cases— but it is still something vital. Just look at the speed at which the not-for-profit world, especially in the New York area but perhaps across the country, was able to manage through post–September 11 traumas and the economic downturn; a major reason is that there is a loyal public.

JNW: And these aren't customers, they're not shareholders, they are citizens public

ADH: There are people who need what we have to offer and what we want to share. I think it's fascinating that we're all still as idealistic as we are. I am thrilled, because I know I've been a hopeless optimist forever.

JNW: We have a consistent optimism about what the museum's core mission is and what its public value is. But still, I feel we're struggling in different ways. Speaking for myself, I feel we're trying to ward off a kind of pessimism about how certain intractable contradictions are going to be dealt with, because I don't have the answer yet. For example, this whole exhibition question. How is it going to work out? We are not going to ban exhibitions. We've got to work our way through this whole relentless exhibition schedule and at the end of the day come up with a responsible way of dealing with our sense that we need to keep coming up with newer and better ideas for temporary exhibitions.

ADH: But that's where we need to take a historical perspective. Because we all probably remember quite clearly twenty-five years ago, or twenty years

ago, when the NEA basically got people together, and we all said that the age of the great exhibition is over, we're not going to be able to afford it any longer; we're not going to be able to insure the loans. In a sense we are saying the same thing again. And yet, it's fair to say that some of the most expensive exhibitions are also the ones from which people can learn the most—*Byzantium*, for example, which I'm sure was not among the Met's least expensive exhibitions. That show was a sort of museum in itself for three months.

JNW: I don't think we want to say that major exhibitions are passé and that they shouldn't be done. They have to be done the right way, of course, or they put the public's trust in a museum at risk. Wouldn't you agree? I'm trying to walk a very fine line. I certainly don't want to come across as saying that the worst thing museums are doing is organizing and presenting big exhibitions. You were all very articulate in your comments about the dangers of relying on temporary exhibitions. But I don't think we mean to stop them altogether.

PDM: No, but at the same time I will have to concede that it is absurd that we should have right now on view at the Met *Eakins, Gauguin,* and *Impressionist and Danish Pictures from Ordrupgaard*. All three at the same time? Craziness.

JC: And having just presented *Ancient Szechuan* and *Renaissance Tapestries*.

PDM: So for me it's the pace, it's that relentless frenzy.

GDL: But you don't have to do it; there is an alternative.

PDM: You don't have to do it, that's true. This is an instance where the conflation of certain schedules conspired against us. But as one of you quite correctly indicated, the exhibition activity is really curator-driven. In fact, curators at the Metropolitan have enormous power in the sense that there is a large number of them, a huge number of constituencies of people

who want Islamic art, people who want drawings, this, that, or the other thing. And over a period of time, and not too long a period of time, you have got to satisfy those constituencies, the scholars as well as the public and the people who are passionate about photographs and want to see photographic exhibitions.

GDL: You do about how many exhibitions in a year?

PDM: About forty.

GDL: And you have a curatorial staff of 160. So it's not surprising—in fact, it's a quarter of the curatorial staff, right? I think there is another factor besides the internal pressure of curators. It's a brutally competitive environment. And if you don't want to do those exhibitions, you don't have to do them; but you have also to be prepared to deal with the consequence that somebody else will do them and garner audience from them. But so what?

PDM: "So what?" is too easy to say.

JNW: Competitive in terms of size of gate, or prestige, or long-term—

GDL: Competitive on every front, competitive in terms of the prestige of the institution, in terms of trustees, donors, audience. In other words, in an environment like New York where you have a very small number of outstanding trustees, they are going to gravitate to the institutions they perceive to be the most prestigious.

JC: But do you really think that the Modern and the Met are today considered prestigious by their trustees and would-be trustees because of their exhibition schedules more than their collections? Certainly the attraction of the Modern is that it is the greatest modern collection in the world; and the Met because of the breadth, depth, and quality of its collections and the gravitas of its many projects over the years.

GDL: To quote a famous director in New York, "I don't think you can decorticate it." I think it's a package, the exhibition program with the quality of the collection.

JC: More now, less now than before?

ADH: I don't think necessarily more. I remember a time when a group such as this one was sitting around a table, and in that particular case the distress was over the number of exhibitions done by the National Gallery, because the National Gallery was doing three or four exhibitions at the same time and that had a ripple effect on the rest of us in the same way that you are talking about it now.

PDM: I do remember certainly the debate about the National Gallery. Part of it was because—a lot of colleagues did not understand why, since the National Gallery gets a big fat check from the federal government once a year and does not charge admission, nor does it charge for the exhibitions—why, since they were in the luxurious position and did not have to mount all these shows in order to meet the bottom line, why did they do all of these exhibitions? This, we thought, was hubris to the nth power.

GDL: Something you said, Philippe, I think is right on target. That is, when an exhibition program is actually tied to the larger program of the institution, when temporary exhibitions clearly relate to the ongoing research activities of the museum and to the quality and character of its collection, there is a powerful, palpable, and I think one could even say legitimate relationship between the museum's ambitions, its curators and programs, and the public's ability to appreciate the museum's exhibition program as a whole. I don't think there is necessarily anything wrong with a really active exhibition program, provided that it's rooted in the museum's permanent collection, and that it's a way of amplifying the public's understanding of the museum's collection.

ADH: But going back to the point John made so eloquently in his essay: the quality of the museum visitor's experience of the individual work of art is paramount, and yet we all want a million people to come through our doors each year. How do we reconcile these apparently conflicting ambitions? I certainly don't want all of our visitors to be in our Gauguin exhibition and none in the permanent collection galleries. We're good at being competitive on the exhibition front. But we're less good at being competitive in the sense of stirring each other, challenging each other to do something better on the collections' front. In other words, we borrow ideas from each other—like what is the best audio guide, what is the best way to do this or that thing, what is the best bench, what is the best way to make sure in our new galleries that the public can slow down and take their time and really look at something without feeling pushed. But this is not really something we compete over.

JNW: That raises the question, are we encouraging our curators to compete in areas other than exhibitions? To me this is a big problem. Whom are we rewarding and for what?

JC: And not only we, but the whole apparatus of public response: the media, funders, visitors, academic colleagues.

PDM: It's a critical point, because we're saying, well, perhaps we should slow down exhibitions. I remember being a young curator in the paintings department in the Metropolitan in the 1960s, and my most exciting task had to do with either my finally seeing an article I wrote published in the museum's bulletin or a painting I had done work on acquired by the museum at auction. Try to take an exhibition away from a curator today! That is where they get visibility. It's heady stuff. They have different expectations of themselves: those who in the past actually were critical of exhibitions have found that they rather like to be at the exhibition opening and be thanked or even to be asked to say a few words. It's an opportunity and in a sense an obligation at a certain pace to publish and be seen, and the exhibition offers that opportunity and obligation.

ADH: I wonder if it isn't also partly that acquisition funds go less far than they used to. Perhaps one of the reasons that in Philadelphia we do originate more big exhibitions than other museums of our budget size is because we have a substantially smaller acquisition fund than comparable museums, and the curators already know their collections very well. And while they love their collections and have a good time seducing works out of collectors, they don't have as much opportunity to spend time pursuing that rare object that really changes the way the collection looks and feels. I suspect that that's one reason that exhibitions are more appealing than ever.

PDM: And you don't get the visibility with acquisitions that you get with exhibitions—short of the acquisitions for which the press is actually more interested in the fact that a picture got away from a New York collection and went to the West Coast or that it cost $20 or $30 million. Acquisitions mainly interest the *Gazette des Beaux-Arts* and the *Burlington Magazine*; they aren't going to make the tabloids.

GDL: Well, even when they do make the tabloids, they're one-day events. But I think that we needn't worry about exhibitions. I think on a certain level they're self-regulating. I think far more interesting is the whole question of the quality of the experience of looking at art, whether in a temporary exhibition or within the context of the permanent collection. Every one of us is attendance driven. We get judged and measured all the time, whether it's in a direct, bottom-line way or as a function of perceived success: that is, whether or not we are able to attract the same number of visitors as we did last year, or increase that number by 10 percent, 5 percent, 20 percent. It's seen by some as a failure if our attendance goes down. And yet the real measure of our success ought to be the quality of the museum experience. You cannot possibly have the kind of deep engagement with a work of art that John was talking about in a room with five hundred people jostling each other, and yet we can't get off that attendance train.

JW: Let's assume you believe that the quality of experience is really important, more important maybe than the trustees or the press assume. What

would it take to give a higher priority to the conditions and quality of viewing, of looking at works of art, especially in a large museum? Glenn, you are rebuilding MoMA partly to carve out some havens in the stream of heavy traffic going from one big exhibition to another. What would it take to create a belief strong enough to have us invest a great deal of money and ingenuity to increase the power of those relatively solitary experiences of individual works of art? I think directors have to *believe* in those solitary experiences, and with more than a sort of regretful fatalism. They have to believe in them strongly enough to throw themselves at their own boards. They have to stop simply inviting attention to the exhibitions and the attendance numbers; they have to take the time and trouble to encourage the trustees to evaluate the museum on the basis of the kinds of experiences that are much more difficult to quantify or to judge. How do you do that?

JNW: We should avoid starting off talking with our boards about exhibitions in terms of statistics, which is how financial people invariably try to set it up. Our new building project is not about new special exhibition space but about permanent collection space. So we've been giving a lot of thought to what we mean it to achieve, what the quality of the experience of the permanent collection should be. The first answer to your question, John, in my mind, is to consider the quality of the relationship between the space and the object. We can have all the educational stuff in the world in the galleries, but it comes down to the experience of the individual work of art.

GDL: You can't have an extraordinary experience without extraordinary works of art.

JNW: We are blessed with more than we can show adequately.

GDL: But Jim, I think we all show far too many works of art.

JNW: We have the objects.

GDL: No, I don't think we do; that's my point. I think if you took the truly extraordinary works of art in each of our collections, the ones that are absolutely astounding, you wouldn't have a very big museum. You'd have an extraordinary museum, but you wouldn't necessarily have a very big museum. And I think one of the issues that we are certainly grappling with is the tension between creating possibilities for extraordinary engagements with individual works of art versus providing our visitors with a history of modern art, which in our case requires another kind of presentation. Indeed, one of the reasons our galleries at MoMA get very crowded is because we put a lot into them. When I go back to what for me was probably the most epiphanic experience I've had looking at a work of art, it was Titian's *Flaying of Marsyas* [Archiepiscopal Palace, Kromeriz, Czech Republic], which I saw at the National Gallery fifteen, twenty years ago. It was all alone down that long corridor. There it was, *Flaying of Marsyas,* that single—and singular—work of art. I was lucky enough to live in Washington at the time so I could go in periodically when there was almost no one else there.

JNW: But your challenge, then, is to have twice the space and not put up any more art.

GDL: Twice the space and half the amount of art.

JNW: But my point is we all have enough great art, even if it's one painting per gallery, to fill up all the space we could ever have.

PDM: I think it's an argument that is certainly dear to all of us at this table, but we are hardly Joe Q. Public. If your argument were to be pushed to the extreme, the most highly visited museum in New York should be the Frick, which in a relatively small space has a disproportionate amount of consummate masterpieces. But the Frick is not so visited. I also suspect a great many members of the public actually go to art museums as a group activity. They like the mediation of what some of us think of as those horrid audio machines, but they love them. I may be the ultimate cynic, but I do think it is a relatively few people who approach art in the

way you and John have suggested. Yet we should make that kind of experience available.

GDL: The key is to make sure that in offering a range of experiences, you don't inadvertently make it impossible to have that one moment of wonderment or an epiphany. I agree with you, of course we approach this from an idealistic point of view. But I don't think the measure is the number of people visiting our museums or exhibitions. The measure is, or ought to be, the substance of the visit. And the social dimension of visiting a museum is as important as the cultural or the intellectual or the artistic dimension. Indeed, museums have succeeded because they can be many different things to many different people. But what really concerns me is that in the effort to serve our educational mission, to provide more and more visitor services, to meet the bottom line, we reduce the opportunities for those extraordinary moments.

JW: Let me try a music metaphor again. We are quite capable of sitting in a concert hall and having a singular, individual, powerful moving experience with 2,500 other people there. It's possible to have the same kind of experience in a museum, to a point. I have had wonderful experiences here in the Met, many, many of them with a good number of people around. I'm not being so purist as to say I have to be alone in the Barcelona chair looking at the *Autumn Rhythm* by Pollock the way we did at the Met when we were young. What I mean is that there comes a point when crowding becomes the enemy of any kind of deep experience of a work of art by any one person among the many people in the gallery.

ADH: I think there is a way to let people know that that kind of experience exists in our museums. Perhaps it's more by word of mouth than anything else. You don't want a large hundred-thousand-dollar ad in the *New York Times* saying come to the Met and have a quiet contemplative experience in the Islamic galleries. Because then indeed you would have a hundred thousand people there the next day, which might militate against your experience. I think the tendency on the part of our public is to want more

of that kind of experience. My favorite comment in the *Cézanne* exhibition in Philadelphia was an exchange between two women standing for a long time in front of the *View of l'Estaque*. They just stood there, and they were just clearly totally lost in the painting. I was standing behind them, kind of curious as to how long they were going to stand there. And after a while, one of them finally said to the other, "I wonder if Emily is having a good time at the shore." It was fantastic. You knew all of the things that were going on in their minds. It was all about the picture: the water, the light.

JC: But do you think some of this desire to slow people down and give them the opportunity to look long at a picture is hurt by the admission fees we charge? Don't they discourage short visits and long looking? The impression you get of the National Gallery, London, and now I suppose it's true of all British national museums, is that not charging allows people, and I'm distinguishing between resident visitors and tourists, allows visitors to come in and look at just a few things; to sort of drop in. Whereas admission fees seem to suggest that in order to get your money's worth, you have to stay a long time and try to see a lot, if only superficially. What role do admission fees play in our visitors' experiences of our museums?

JNW: I'm wrestling with this. I'm fascinated watching what happened in Minneapolis. You know, they eliminated admission fees. We have, just as the Met, a recommended admission fee of ten dollars, but pay what you wish; get in for a penny. But we all know, first of all, that the word of mouth out there is that it costs ten dollars to come to the Art Institute, even though that's only a recommended price. And that is a big intimidation factor. I am pushing it here, but I wonder that if we did enough research whether it would show that we might come out ahead by being free. I would always keep the special exhibitions charge—I mean, that's where you have some flexibility to make some money, and where it's most legitimate to make money, to underwrite operating costs. I don't know what is going to come out of our discussions at the Art Institute. But I think it will be demonstrated that we would be taking quite a financial risk if we eliminated the admission fee. And yet I think psychologically, in

terms of the basic mission of all these things we're talking about, it might be the single most important way, along with altering our hours, to improve the experience of our permanent collection. It might be the best thing to do. All I'd have to say is, "all right, we're going to have to absorb x deficit, you know, in the face of other deficits," and then explain to the staff how we're going to be a much better museum at the end of the day for it.

GDL: Why is it going to be a better museum?

JNW: Well, I think it will be a better experience.

GDL: Why is it going to be a better experience?

JNW: Because it will encourage, I hope, use patterns that will have a better chance of a more meaningful experience.

GDL: How much is your membership?

JNW: That's the other thing. Of course you'd like everyone to be a member. But we know the spurts in membership are tied to our very popular exhibitions.

GDL: Well, because you make the membership so expensive.

JNW: Ours is very reasonable compared to yours.

JC: It's counter-intuitive for people to buy memberships.

GDL: Well, hold on one second. What makes you say that the 80,000 or 100,000 members you have, or 70,000, it doesn't matter—what makes you say that the 50,000 members you have aren't actually having just as great an experience as someone who just walked into the museum for free? In other words, there is a community of interested, committed visitors created through your membership program and that goes to a deeper

relationship with the museum than is possible by the anonymity of free admission.

JNW: You can always be part of an elite donor club. I can offer that as part of my member package.

GDL: It's very hard to be part of an elite donor club when admission is free.

JC: I think Chicago, like the National Gallery, London, has that sense of community already; people say "it's our museum." You get a sense when you go to the Art Institute, perhaps because it's right there on Michigan Avenue; people feel like it's their museum; they are proud of it and identify with it, whether they are a member or not.

ADH: I think actually that's where the Modern is just very different as a museum. I almost don't think MoMA could be free, because I think you'd be overwhelmed with the number of people who would come; plus there's a kind of cadre of MoMA members, who have always shared a kind of esprit de corps. For Philadelphia, I wish nothing better than that we could be free. The museum once was free and now it's ten dollars, and it kills me. And I know for a fact that if we eliminated the admission charge, we would probably have at least a third again as many visitors, maybe half again as many.

GDL: But why is that good?

ADH: Because in our case, a lot of them would be repeat visitors. We're a little hard to get to. We're not right in the middle of town. But what if you could just drop in, see something, and not spend the time you'd feel you *had* to if you had paid ten dollars?

JNW: I want more attendance, not from special exhibitions but spread out more through the week. I'd like to share the experience of our collection

with more people, even free of charge. I also think down the line I'd come out ahead financially, but I can't prove it.

GDL: I think there are different factors that come into play here. On one level it's almost a moral duty that museums should be free. Our collections are part of everyone's cultural heritage. We should make them available in as broad a way as possible. And an admission fee is one of the greater barriers to attendance.

PDM: Wait a minute. Can we be both practical and philosophical? On the matter of barriers, the people who squawk most about the cost of a museum pay huge amounts of money to go to rock concerts, sports events, all of which are very expensive. I don't buy that "barrier" thing. Philosophically, what is it about a work of art that makes it mandatory that it should be available for nothing, whereas the C Sharp Minor Quartet Opus 131 of Beethoven should be paid for, that *Aida* should be paid for, that Ibsen should be paid for? What is about art that it *shouldn't* be paid for?

JNW: It's just that we need to distinguish between the more regular, drop-in kind of experience and the event kind of experience. All the things you've listed are events. You know, you go to a concert and buy a ticket ahead of time.

ADH: Because an auditorium can only seat three hundred people. If you don't buy a ticket, you're not necessarily going to get in. I mean, the free concert theory only works for Central Park. It's a matter of logistics as well as economics. If you *could* make great concerts free, you would probably have a larger audience for classical music now than you do.

JNW: Right, you can't drop into an opera, but you can drop in to look at a Titian.

JC: Jim's point is also that it may not be good business practice to charge admission fees. The *Los Angeles Times* art critic, Christopher Knight, recently

wrote an article pointing out that as a percentage of its budget, admissions income—even though the admission fee is much higher now than it was—is less significant than it once was and that with the escalation in the price of admission there has been a decrease in the numbers of visitors and members. In other words, his point was that the more museums charge, the fewer people come and the less money museums get relative to the cost of running them. You're not making more money, in fact you are losing money on the deal.[1]

JNW: Well, let me step back, because believe me, it's not as though I've worked this out and I'm ready to make a decision, because I'm not. But I think an appeal of membership, at least to my midwestern audience, would be the argument that by becoming a member you are helping us not charge an admission fee. You are in fact being a kind of philanthropist. You are helping realize democracy in the Midwest.

GDL: I would like to see that sold in New York.

JNW: That would be a real tough sell, there, I admit.

PDM: You will offer nothing to your members beside the satisfaction of knowing they're opening the museum to others?

JNW: You mean there's no benefit to membership because there is no admission fee anyway?

JC: Isn't that the irony about Minneapolis? They dropped their admission prices and membership went up?

GDL: There are a lot of other factors at play in Minneapolis besides this sort of pure equation: drop in admission, increase in attendance, ergo more shop sales. And I think every museum is unique, anyway. What works in one place doesn't work in another. Part of me wants museums to be free because

there is a sense that our collections and visitors' experiences of them belong to the public at large and should be available to anyone regardless of cost. Another part of me, though, says, why should it be free? Why should this treasured experience be free, especially for an entity that gets virtually no government funding? And by making it free, are we inadvertently devaluing it?

JNW: I've been through this with my development people, and I don't buy that argument. I really don't buy that. To me that is market fundamentalism, or a branch of it. Do you think that the population of London feels that they're getting a cheaper product because they don't have to pay to go into some of their museums?

GDL: But I think there's a tradition there. Those are state-funded institutions.

JNW: It's something to think about, but in the end I don't feel that reduces the importance or the experience, by not paying for it.

GDL: No, of course. It's a psychological issue. At the end of the day works of art speak for themselves regardless of whether you got there through a friend, on your own, and what you paid or didn't pay for seeing them.

ADH: But what we all want to do is increase the probability of somebody having the kind of epiphany in front of a work of art that we've been talking about.

GDL: But Anne, follow that logic for a moment. You have one or more works of art in a space, and there is probably some optimal number of people in that space in which great experiences can occur. Now, there are two ways of looking at it. You can try to run more people through that space, on the assumption that the more people you run through it the greater likelihood one of them is going to have a great experience, or you could actually say that the fewer people through that space, the higher likelihood that any one person will have that experience.

JNW: We're talking real estate. You don't have enough space to show all your masterpieces. Anne and I have enough space to show all our masterpieces. I want to get them through the door. There are a lots of things they can find and be alone with in my museum, things that are worth looking at.

ADH: The van der Weyden [*Crucifixion with the Virgin and Saint John the Evangelist Mourning*] awaits, and nobody is going to find it if they don't come back and back again, because it's not readily visible from the front door. You can't have everything around the front door.

JNW: And geography, and the percent of attendance that is tourists. In New York tourists are a much higher percentage of your visitors, and that might well make my midwestern model seem rather quaint.

JC: So why don't you make admission free for local residents?

JNW: That's a possibility. We could do that.

JC: We did it at Harvard by offering free admission for everyone with a Cambridge Public Library card. We couldn't ask for a driver's license because not everybody has a driver's license. A library card was evidence that they were Cambridge residents and our program promoted both the library and the art museums.

ADH: That's more or less what the Dutch museums do, the Van Gogh Museum for example. They charge the general tourist visitor as much as they can but if you can prove you're a resident, you get in free.

PDM: But really, museums aren't for everyone, wealthy or not. I would have to say that there are probably several hundred thousand wealthy people in New York who never cross our doors. They're not members and they don't come. They may go to the opera, they may go to the ballet, a lot of people have other interests. My stepfather-in-law loved music, never came to the Met, hated art. I don't go to everything either. I like to rub

shoulders in a culture in which you've seen the latest play and you've gone to the ballet, and it's all in the air nurturing us. But the nature of an artistic experience is not necessarily one that everyone seeks.

JW: Imagine that you have an endowment of $5 billion and you've just built a whole new museum after having been open in your smaller location for twenty-five years or so and have always been free to the public. What do you do as a trustee? There was a very hot, sporadic debate among the trustees of the Getty about admission fees as we built our new museum. It has finally been settled, I think maybe forever, but only fairly recently. The argument was, "Look here, this is free money. People are accustomed to paying for attractions like this. They will come, they have to drive so they've got a car, so they've got the money to pay an admission fee. So how can we *not* charge five dollars a head?" That point of view almost won out, I have to say. The debate only swerved and settled finally on free admission on the grounds that it's always been free.

Free admission is a gift to the public, that's true; and a gift that could be revoked in the future. But it was a heartfelt decision to stick with free admission and relinquish the potential income and have the Getty stand for—and hope to attain—a broadening of the audience. And the audience has sustained a high level now largely because of free admission. And the diversity of the audience is pretty much owed, it seems to me, to the attendance of a large number of people with relatively low incomes and of ethnicities who don't normally go to museums, which are normally outside their patterns of entertainment. This has an awful lot to do with the fact that they don't have to think about the expense; they can just come, free of charge.

JC: Two other questions. Philippe talked about authenticity and conservation, and the trust placed in us by the public to preserve and determine the authenticity of the things we hold in trust for them in our collections.

ADH: I think that we have to make sure that our conservators and conservation as a field in general are thoroughly enlisted in the public life of our

museums. We have found that our conservators are very eager to explain to the public—to anyone who is interested—what works of art are made of and how they were made. The public likes this; they trust this kind of information. I think we need to enlist the partnership of conservators in the whole business of projecting our mission to the public. We need to include conservators at various stages in their development in museum-wide activities of all kinds.

PDM: You raise a very interesting point in the context of transparency and the Harvard lectures on the public trust. I don't want to take a dissenting view, but I would be very hesitant to bring too much specificity, too many details about the whole cookery of conservation to the public. I feel about it I guess the same way the medical profession would about trying to explain in great detail all of the procedures in a difficult surgical intervention. And in terms of public trust, I just wonder if we aren't dealing, in the whole issue of conservation, with something too difficult and complex. I have seen many a curator utterly bemused by the discourse of a conservator not even understanding what some of the treatment is that they are approving. Perhaps to give too much of this kind of information to the public might be dangerous.

And I will give you an example. I am concerned about the museums that have deliberately made public the process of cleaning a painting or a sculpture. I remember in Baltimore a huge picture had been damaged in some sort of a flood and the museum created a small conservation studio in front of the picture with a wall and a window through which everybody could look at the conservator working. I don't think the public has any business looking at what the conservator is doing. It may appear that the conservator is repainting something and yet he's not; false impressions will be gathered by the public. I just, for me, think conservation is something that is, that should be, very important within the organization of the museum itself, but very much behind the scenes as far as the public is concerned.

GDL: I'm not as convinced of that, Philippe. I mean, certainly complex procedures are easily misinterpreted. And I don't know that one has to put conservators on public view as they work. But I think the underlying point,

and I think that was where Jim was headed, is that public trust demands the authenticity not only of the experience that is being produced at the museums we all direct, but of the actual objects themselves, and that conservation is part of that: it helps explain the authenticity of those objects. That's really the key piece to this equation.

JC: I was thinking more about, on the one hand, our obligations to preserve what is, in effect, public property and, other other hand, our responsibility to do so only judiciously. How do we make these decisions, and how and to what extent do we let the public know what we are doing?

JNW: Neil's essay dealt with this very eloquently.

ADH: But what gives the public trust in museums overall is a sense that things are being thoughtfully and responsibly handled by people who care a great deal about them. And I think that conservators by and large have an amazing ability to describe what they are doing and how they're doing it.

PDM: Let me get back to my philosophical point. Which I touched upon in my essay in a slightly different way. We want people to be able to have sufficient trust that they can abandon themselves freely to the appreciation of art as John describes it. Do you really want to introduce yet another element of doubt and questioning in the public's mind? The public has enough questions as it is. Do we want them to question, "Gee, I wonder whether they've ruined this picture or not by over-cleaning?" It's the same issue as with labels. How much information do you offer and where do you stop? On your labels, how far do you go with the whole art historical exegesis of an object? You don't present it as if you were writing for a scholarly journal. You provide the result of a great deal of research, but you don't shove all that research in their faces, just as you don't shove all the cookery of conservation in their faces, either.

JNW: On another matter, like you, Philippe, I tried in my essay to talk about the fact as we become more and more popular, famous, and powerful

institutions, that there is the danger that people will use us as a platform for their own political agendas. We can feel this coming at us from the right and the left. Obviously we need to be above politics, but at the same time we can't censor ourselves or stay out of the debate.

ADH: Don't you think that museums have in a sense always been places where people of very different views and cultural backgrounds can in fact come together? Which is, of course, different from engaging directly in political matters.

GDL: But that's more about a cultural dialogue than the kind of social engineering that I think lies beneath recent political critiques of museums. Museums live in a world that is not immune from politics. In fact, they are deeply woven into that world. But I think there is always a danger when museums engage in a larger social or political agenda. It disengages them from the practice of art history.

PDM: This raises what for me is the biggest conundrum in trying to define the public trust. I think it has to do with my trying to explain, and I certainly can't, the relish with which the slightest misstep in our museums is pounced upon and demolished by all the media and the press. Of course it has to do with what Jim said about museums becoming popular and powerful and attracting closer, more aggressive press scrutiny. But I still don't understand it. I mean, there is a minuscule percentage of works of art that may conceivably have been looted and not restituted during the Holocaust, and yet for three years we were pilloried and marched up to the gibbet by the press, who saw us as greedy hoarders of ill-gotten goods. And there was nothing we could say that would defend our case. They published exaggerated, false claims that millions of works of art were in museums illegally, as if museums had been helping themselves to stolen works of art during the Nazi era. Then the whole issue of cultural patrimony and how immediately the press was willing to suggest that museums have raped countries of origin in the Middle East, the Far East, southeast Asia, South America: the image of rapacious museums at work!

Where have we gone wrong in not projecting a message about the benefits of art museums, of all of the things that we do that are right? Did no archaeologist become an archaeologist as a result of a wonderful experience looking at a beautifully preserved work of antiquity in a museum? Should we walk in shame in all of our galleries of ancient art? Does it ultimately really not belong here? Is every Italian picture in the Louvre a national shame going back to Napoleon and before?

I think part of the public trust issue is about the dichotomy between the museum-going public and the body politic that got so excited and exercised over media stories about museum and World War II claims and cultural patrimony and so forth. I don't sense a problem of public trust with our museum-going public. I think that our public on the whole still thinks we are wonderful institutions. They come, they admire, they even look at antiquities with some degree of pleasure. But there is a divide out there. And I think one of our challenges in the future is to try to breach this divide. But why was the fire of controversy so easily kindled?

GDL: It was easily kindled for reasons that had nothing to do with museums. It was because it was an explosive issue and museums happened to be part of the tinder in the fire. What I think speaks well for museums is that we were able to demonstrate to the media, and then through the media to the public, that we were in fact acting responsibly, that whatever issues were involved with the Holocaust, restitution, and cultural patrimony were issues outside the framework of museums and that museums in fact acted and would continue to act with responsibility and diligence. The issues went away because by and large I think we were right.

JC: I wouldn't say they've gone away yet. Cultural patrimony is still a red-button issue. The Memorandum of Understanding signed recently between the United States and Italy escalated the attacks on museums and, to the extent that it became public knowledge, promoted public distrust of museums. Combine that, of course, with our association with the trade in antiquities that was bruised by Fred Schultz's conviction on the charge of conspiracy to receive stolen antiquities from Egypt. But perhaps in one

respect you're right, Philippe. Perhaps the public doesn't care, know about, or understand the implications of our government's agreement with Italy. But still the power of the press to misrepresent the actions and purposes of museums and to fuel the debate on the side of those taking a cultural nationalist and retentionist position has tremendous influence on U.S. policy makers.

PDM: That's true. That's my point. I simply wonder why we have to be reflective and defensive?

GDL: I don't think we were defensive on the Holocaust-era looted art issue. I think museums argued intelligently that they were capable of tending to their own responsibilities. Part of the reason this thing blew up was over the issue of Swiss gold and life insurance. Neither the banks nor the insurance companies wanted to be transparent over what they had and why or if they were obliged to make insurance payments. They resisted all inquiries and so attracted close media scrutiny. The media couldn't distinguish between Swiss gold and works of art. They were both just valuable assets that might rightfully belong to Holocaust-era victims or their families. We were caught in the shadow of a controversy not of our making.

JC: Still, museums flirt with celebrity status. We have press departments that work to get us in the news. We have celebrities of one kind or another on our boards. We have entertainment celebrities tape our audio guides or narrate our videos. Pictures of celebrities at museum openings are always in the papers or in our annual reports. Celebrity status feeds on the beast that is the media and it shouldn't come as a surprise that the beast sometimes bites back.

GDL: I'm not saying that public trust isn't fraying and isn't capable of fraying dramatically. I'm just saying that museums still by and large enjoy that trust, and it's something we have to nurture and be constantly vigilant about. But at least we're not in a position where it's just assumed that museums violate the public trust.

PDM: I am still uneasy with the split between the public's and the media's perception of the museum. It has to do, I think, with the two worlds that have been created by museums: the world of the museum as an experience in and of itself, and the world of experiencing works of art. I know that if you were able to listen to a few thousand people making the decision to come to 82nd and Fifth, that nine-tenths of them would say "let's go to the museum today." And I am equally sure that thirty years ago nine-tenths would have said "let's go and look at some pictures." I'm convinced of it. Our visitors come with different expectations today. It's now about "the experience of the museum," of which the art is only a small part.

And I think we are losing in the process. We did a number of focus groups and I found it a disconsolate experience to observe them in action and to look at some of the results. These were focus groups run by the *New York Times* in the tri-state area, but not in New York City, of people who seldom come to the Met. We did various different groups, and the participants said, "We want programs for children"; "We want to be able to feel comfortable walking into the museum"; "We want there to be easy access to computers"; and "We want to make sure the garage is good and safe": they talked only about the amenities. You listened to two hours of that conversation, and at no point did you get a sense that they were talking about a museum of art or of toy trains or matchbooks. The word *art* never entered the question. You didn't know what kind of museum they were talking about. I find that somewhat depressing.

GDL: Do you see that as a change, Philippe, over the twenty-five years that you've been director?

PDM: Oh, absolutely.

JC: Do you sense a pivot point at which things shifted this way? Was there some issue or societal change that actually began to move typical responses in this direction?

PDM: I think it came with the whole issue of size and complexity. Are we beginning to resemble the big conglomerates and have all of the attendant problems?

GDL: But doesn't that tie into public trust? Isn't that maybe part of the reason why the media was so quick to pounce on us, that we weren't more— and here I say this guardedly—Frick-like: small, focused, clearly devoted to works of art? To many in the media we just look like very large, wealthy organizations, and we're fair target.

PDM: Maybe we should pull back a little bit on the visibility issue.

ADH: But Philippe, would you not guess that there are more people actually savoring their experiences at the Met today than there were twenty years ago?

PDM: Yes. But what we have to do as an institution to attract and keep them causes me to turn all sorts of wheels I never had to turn before. The cost of all of this is very high. We have added large numbers of people to the administration, visitor services, development, membership, to this, that, or the other thing. The burden of maintaining this enormous machine is crushing.

GDL: Philippe's point, and that whole issue, is really germane right now. We are in a difficult moment; we are engaged in one way or another in major threshold issues like expansion, fundraising, escalation of scale. And each of these inevitably pushes us further and further in a certain direction.

JNW: And only we can determine that direction, or hope to. It makes for a very interesting job.

JC: And I think we all agree that a big part of our job today is to respect and reinvigorate the public trust in our museums, in museums as public institutions. If we don't have a clear sense of the public purpose of art museums, the pressures we've discussed will tear museums apart. We saw this happening in the 1990s and we, and many of our colleagues, were all

concerned. That's why we chose to focus on the issue of public trust. We thought it would encourage us to focus back on the core values and central purpose of art museums.

GDL: I think this is a topic absolutely germane to our profession. It isn't an abstract concept, rather something central to the success or failure of our museums and to the museum profession. And we are far from fully understanding its implications and how to respond intelligently to all the challenges we face in keeping the public trust.

JW: This is timely because there is a general sense that the public's trust in museums is, or is in danger of, being undermined because of our commercial necessities, or what some see as commercial necessities, and financial opportunities. I think in order to clarify matters for museums, trustees in particular, it's going to be necessary to reinvigorate the discussion about what art is supposed to do for individuals and for society. It seems to me that we've gotten tired of repeating the same claims, whether they're about economic benefit on one side or experiential benefits on another, and everything in between.

It seems to me that we have a rich history of caring about and using works of art in our societies, and even quite a body of literature on the subject, and a great many ideas about how to do that even more—some of which are in conflict with each other. It would be a great benefit for museums to be able to draw on fresher, sounder, historically based ideas that help us understand what the legitimate claims are about the benefits of art. It seems to me we need to clarify the basis for art museums, why it is that art museums stake their claim so urgently in our minds, and what strength we could add to that understanding. That's crucial to the public's trust in museums.

NOTES

1. Christopher Knight, "Why Pay to See Our Own Art?" *Los Angeles Times,* 9 June 2002.

Index

Page references in *italics* refer to illustrations

Photography Credits